Nikon
D7000™
Digital Field Guide

J. Dennis Thomas

WILEY

Wiley Publishing, Inc.

Nikon® D7000™ Digital Field Guide

Published by
Wiley Publishing, Inc.
10475 Crosspoint Boulevard

Indianapolis, IN 46256
www.wiley.com

Published simultaneously in Canada

ISBN: 978-0-470-64864-3

Manufactured in the United States of America

10 9 8 7 6 5 4 3 2 1

For general information on our other products and services or to obtain technical support, please contact our Customer Care Department within the U.S. at (877) 762-2974, outside the U.S. at (317) 572-3993 or fax (317) 572-4002.

Wiley also publishes its books in a variety of electronic formats. Some content that appears in print may not be available in electronic books.

Library of Congress Control Number: 2010942178

WILEY

Credits

Acquisitions Editor
Courtney Allen

Project Editor
Kristin Vorce

Technical Editor
Mike Hagen

Copy Editor
Lauren Kennedy

Editorial Director
Robyn Siesky

Editorial Manager
Rosemarie Graham

Business Manager
Amy Knies

Senior Marketing Manager
Sandy Smith

Vice President and Executive Group Publisher
Richard Swadley

Vice President and Executive Publisher
Barry Pruett

Project Coordinator
Patrick Redmond

Graphics and Production Specialists
Samantha K. Cherolis

Quality Control Technician
Laura Albert

Proofreading and Indexing
Melissa D. Buddendeck
BIM Indexing & Proofreading Services

About the Author

J. Dennis Thomas is a freelance photographer, author, and musician based out of Austin, Texas. He has nearly 25 years of experience behind the lenses of Nikon cameras. His work has been published in many regional, national, and international publications, including the magazines *Rolling Stone, SPIN, Country Weekly*, and *SXSWorld;* and his photography is syndicated by the internationally renowned agency Corbis Images. Thomas has written ten highly successful Digital Field Guides for Wiley Publishing and has more in the works.

Acknowledgments

I have a lot of people to thank at Wiley. So many people put a great amount of effort to get these books done. Courtney, you rock. Cricket, you know you do too. Carol, thanks for all the favors you've pulled for me. Kristin, you've definitely got an A+ in my book. Robyn, Lauren, and Sandy, keep up the good work! A big high five to Barry for putting together such a great team. And a huge thanks to Tom Heine, wherever you are...

This one's for you, Ashley Robin. You were there at the beginning and I hope you'll be there for the rest...

Contents

CHAPTER 3
Setting Up the Nikon D7000 65

CHAPTER 7
Working with Live View and Video 183

CHAPTER 13
Portrait Photography 239

CHAPTER 14
Still-Life, Product, and Food
Photography 253

CHAPTER 15
Stock Photography 261

CHAPTER 16
Viewing and In-camera Editing 271

APPENDIX

Introduction

Once again, Nikon has created another groundbreaking camera. The D7000 is the first camera of its kind in the Nikon lineup. Fitting in between the prosumer D90 and the professional D300s, the D7000 is the best of both worlds. The D7000 takes the ease of operation of the D90 and combines it with the toughness of the D300s. The D7000 has magnesium-alloy top and bottom plates as well as weather sealing. And with 19 scene modes to make shooting in any situation a snap, the D7000 is a great camera for those just getting into photography with an eye on becoming a pro.

Another great feature of this camera is the addition of the full 1080p High Definition video and the ability to select the shutter speed and ISO, with *full-time* auto-focus, a Nikon first that it shares with the D3100. With superb high ISO performance and amazing possibilities with the depth of field options, dSLRs like the D7000 are taking over the video industry.

This Digital Field Guide is meant to be an adjunct to the manual, explaining the camera and its functions in more detail, in a way that's easier to understand. The real-world applications in Chapters 8 through 15 take some of the most basic types of photography and break them down, showing you how pros capture these shots so you too can get great shots.

Exploring the Nikon D7000

This chapter covers the key components of the Nikon D7000. These are the features that are most readily accessible because they are situated on the outside of the camera: the buttons, knobs, switches, and dials.

Although most Nikon dSLRs are relatively similar to each other, the D7000 has had an extensive redesign. Even if you're familiar with other Nikon dSLR cameras, you may want to read through the chapter to acquaint yourself with all the new features of the D7000.

Getting to know all your camera's menus, buttons, and dials allows you to capture your images just as you envision them.

Key Components of the D7000

This section doesn't cover the menus, only the exterior controls. Although you can access many features using menu options, oftentimes you can change the same settings with just the push of a button. Knowing exactly what these buttons do can save you loads of time and keep you from missing a shot.

Top of the camera

You find some of the most important buttons and dials on the top of the D7000. This is where you can change the Shooting mode and press the Shutter Release button to take your photo.

▶ **Shutter Release button.** In my opinion, this is the most important button on the camera. Halfway pressing this button activates the camera's autofocus and light meter. Fully depressing this button releases the shutter and a photograph is taken. When the camera has been idle, and has "gone to sleep," lightly pressing the Shutter Release button wakes it up. When the image review is on, lightly pressing the Shutter Release button turns off the LCD and prepares the camera for another shot.

▶ **On/Off switch.** This switch, located around the Shutter Release button, is used to turn the camera on and off. Push the switch all the way to the left to turn off the camera. Pull the switch to the right to turn the camera on. The On/Off switch also has a momentary switch, which when pulled to the far right turns on the control panel backlight. This momentary switch can also be programmed to bring up the Info display on the monitor using Custom Settings menu (CSM) f1.

▶ **Mode dial.** This is an important dial. Rotating it allows you to quickly change your Shooting mode. You can choose the scene mode, one of the semiautomatic modes, or Manual exposure mode, which lets you pick the exposure settings.

 For a detailed description of all the exposure modes, see Chapter 2.

▶ **Release Mode dial.** The Release mode controls how the shutter is released when the button is pressed. There are seven options.

• **Single.** This allows you take a single photograph with each press of the Shutter Release button. The camera will not fire multiple frames when the button is held down.

- **CL (Continuous low speed).** When using this Release mode, pressing and holding the button allows the camera to shoot multiple frames at low speed. The frame rate for this Release mode is set in CSM d6. You can select from 1-5fps.

- **CH (Continuous high speed).** When you use this Release mode, pressing and holding the button allows the camera to shoot multiple frames at high speed. The camera shoots at the maximum frame rate of 6fps.

 The maximum frame rate is dependent on the shutter speed, buffer, and memory card speed.

- **Q (quiet mode).** This mode allows you to control the release of the reflex mirror. When you press the Shutter Release button, the reflex mirror stays up until you release the button. This allows you to take pictures more quietly by moving to a different area or covering up the camera before you release the Shutter Release button, allowing the mirror to reset.

- **Self-timer.** This activates the self-timer that allows a delay from the time the Shutter Release button is pressed and the shutter is released. The timer is set in the Remote control mode in the Shooting menu.

- **Remote control.** This allows you to use the optional ML-L3 wireless remote to release the shutter. You can change the settings in the Remote control mode in the Shooting menu.

- **Mup (Mirror up).** This option raises the reflex mirror with one press of the Shutter Release button and releases the shutter and resets the mirror with a second press of the button. You can use this to minimize camera shake from mirror movement when shooting long exposures on a tripod or when using a long telephoto lens.

▶ **Exposure Compensation button.** Pressing this button in conjunction with spinning the Main Command dial allows you to modify the exposure that is set by the D7000's light meter when it is set to Programmed Auto (P), Shutter Priority (S), or Aperture Priority (A) mode. Turning the Command dial to the right decreases exposure while turning the dial to the left increases the exposure.

 The Exposure Compensation button serves no functions when shooting in the automatic or scene modes.

▶ **Metering mode button.** Pressing this button and rotating the Main Command dial allows you to change the metering mode between Matrix, Center-weighted, and Spot metering.

▶ **Focal plane mark.** The focal plane mark shows you where the plane of the image sensor is inside the camera. The sensor is directly behind the shutter. When measuring distance for calculating flash output, you measure the subject-to-focal-plane distance.

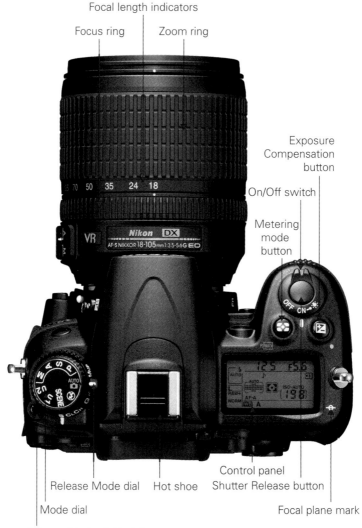

Focal length indicators

Focus ring Zoom ring

Exposure
Compensation
button

On/Off switch

Metering
mode
button

Control panel

Release Mode dial Hot shoe Shutter Release button

Mode dial Focal plane mark

Release Mode dial lock button

Image courtesy of Nikon, Inc.

1.1 Top-of-the-camera controls

▶ **Hot shoe.** This is where an accessory flash is attached to the camera body. The hot shoe has an electronic contact that tells the flash to fire when the shutter is released. A number of other electronic contacts allow the camera to communicate with the flash, enabling the automated features of a dedicated flash unit such as the SB-700.

On the kit lens, you find three key features:

▶ **Focus ring.** Rotating the focus ring allows you to focus the lens manually. The location of the focus ring varies by lens. With old AF (non AF-S) lenses, and even older manual focus lenses, you turn the ring to focus the lens. Newer AF-S lenses, such as the kit lens, have a switch labeled A and M. Select M before attempting to manually focus. If you don't switch it over first, you can damage the lens. Some higher-end AF-S lenses have a switch labeled A/M and M. With these lenses set to the A/M position, you can manually override the autofocus at any time without damaging the lens.

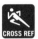

For more information on lenses and compatibility, see Chapter 4.

▶ **Zoom ring.** Rotating the zoom ring allows you to change the focal length of the lens. Prime lenses do not have a zoom ring.

▶ **Focal length indicators.** These numbers indicate which focal length in millimeters your lens is zoomed to.

Back of the camera

The back of the camera is where you find the buttons that mainly control playback and menu options, although a few buttons control some of the shooting functions. Most of the buttons have more than one function — a lot of them are used in conjunction with the Main Command dial or the Multi-selector. On the back of the camera you also find several key features, including the all-important LCD and viewfinder.

▶ **LCD Monitor.** This is the most obvious feature on the back of the camera. This 3-inch, 930,000-dot liquid crystal display (LCD) is a very bright, high-resolution screen. The LCD is where you view all your current camera settings and review your images after shooting, and it displays the video feed for Live View and video recording.

▶ **Viewfinder.** This is what you look through to compose your photographs. Light coming through the lens is reflected from a series of five mirrors (called a *pentamirror*), enabling you to see exactly what you're shooting. The rubber

eyepiece around the viewfinder gives you a softer place to rest your eye and blocks any extra light from entering the viewfinder as you compose and shoot your images.

▶ **Diopter adjustment control.** Just to the right of the viewfinder (hidden behind the eyecup) is the Diopter adjustment control. Use this control to adjust the viewfinder lens to suit your individual vision differences (not everyone's eyesight is the same). To adjust this, look through the viewfinder, and press the Shutter Release button halfway to focus on something. If what you see in the viewfinder isn't quite sharp, slide the Diopter adjustment up or down until everything appears in focus. The manual warns you not to put your finger or fingernail in your eye. I agree that this might not be a good idea.

▶ **AE-L/AF-L/Protect button.** The Auto-Exposure/Autofocus Lock button is used to lock the Auto-Exposure (AE) and Autofocus (AF). This button can be customized in the Setup menu (CSM f5) to provide AE/AF Lock AE Lock only, AF Lock only, AE Lock (hold), or AF-ON. AE Lock (hold) locks the exposure with one press of the button; the exposure is locked until the button is pressed again or the shutter is released. AF-ON engages the AF in the same way that half-pressing the shutter does. The button can also be set to FV lock when using an accessory Speedlight.

▶ **Main Command dial.** This dial is used to change a variety of settings depending on which button you are using in conjunction with it. By default, it is used to change the shutter speed when the camera is in Shutter Priority and Manual mode. It is also used to adjust exposure compensation and change the flash mode.

▶ **Live View switch/Movie Record button.** Nikon introduced this brand-new button with the D7000 and D3100 and is sure to use it on all subsequent cameras. It is a great feature that makes switching to Live View and recording video a breeze. Flipping the switch to the right activates Live View and pressing the Movie Record button starts recording video. To stop recording, simply press the button again. To exit Live View, flick the switch to the left. Quick and easy.

▶ **Multi-selector.** The Multi-selector is another button that serves a few different purposes. In Playback mode, you use it to scroll through the photographs you've taken, and you can also use it to view image information such as histograms and shooting settings. When the D7000 is in Single-point AF or Dynamic-area AF mode, you can use the Multi-selector to change the active focus point. And you use the Multi-selector to navigate through the menu options.

▶ **OK button.** When the D7000 is in the Menu mode, you press the OK button to select the menu item that is highlighted.

▶ **Focus selector lock.** This switch locks the focus point so that it cannot be moved with the Multi-selector button.

▶ **Memory card access lamp.** This light blinks when the memory card is in use. Under no circumstances should you remove the card when this light is on or blinking. You could damage your card or camera and lose any information in the camera's buffer.

▶ **Info button.** Pressing this button displays the shooting information on the monitor. Press this button twice to adjust settings in the Info menu.

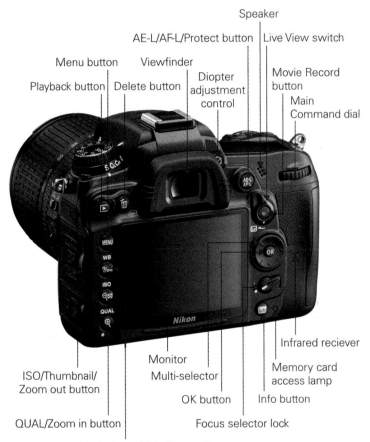

Image courtesy of Nikon, Inc.
1.2 Back-of-the-camera controls

▶ **Playback button.** Pressing this button activates the Playback mode and by default displays the most recently taken photograph. You can also view other pictures by pressing the Multi-selector left and right.

▶ **Delete button.** If you are reviewing your pictures and find some that you don't want to keep, you can delete them by pressing the Delete button, which is marked with a trashcan icon. To prevent you from accidentally deleting images, the camera displays a dialog box asking you to confirm that you want to erase the picture. Press the Delete button a second time to permanently erase the image.

▶ **Speaker.** This small speaker enables you to hear the audio recorded with the video you have shot. I must admit that the fidelity of the speaker isn't that great and it's quite hard to get an accurate representation of what the sound is going to be like when it is played back through your TV or computer speakers.

▶ **Menu button.** Press this button to access the D7000 menu options. There are a number of different menus, including Playback, Shooting, Custom Settings, and Retouch. Use the Multi-selector to choose the menu you want to view and press OK to enter the specific menu screen.

▶ **White balance/Help/Protect button.** Pressing this button and rotating the Main Command dial allows you to change the white balance (WB) settings when in Shooting mode. Rotating the Sub-command dial allows you to fine-tune the selected WB setting by adding blue or amber to make the image cooler or warmer, respectively. You can add blue (b1–b6) by rotating the dial to the right and amber (a1–a6) by rotating to the left. When you're viewing the Information Display and a question mark appears or when you're scrolling through the menu options and a question mark appears in the lower-left corner, you can press this button to get more information. When the D7000 is in Playback, press this button to protect (lock) the image from accidentally being deleted. Press it again to unlock it.

▶ **ISO/Thumbnail/Zoom out button.** In Shooting mode, pressing this button and rotating the Command dial allows you to change the ISO settings. In Playback mode, pressing this button allows you to go from full-frame playback (or viewing the whole image) to viewing thumbnails. The thumbnails can be displayed as 4, 9, or 72 images on a page. You can also view images by calendar date. When you're viewing the menu options, pressing this button displays a help screen that explains the functions of that particular menu option. This button also allows you to zoom out after you have zoomed in on a particular image.

▶ **QUAL/Zoom in button.** When the D7000 is in Shooting mode, pressing this button and rotating the Command dials allows you to quickly change the image quality and size settings. Rotating the Main Command dial changes allows you

to choose a format (RAW, JPG, or RAW+JPG) as well as the JPG compression (Basic, Normal, Fine). Rotating the Sub-command dial allows you to choose the JPG size, but has no effect when the quality is set to RAW. When reviewing your images, you can press the Zoom in button to get a closer look at the details of your image. This is a handy feature for checking the sharpness and focus of your shot. When you are zoomed in, use the Multi-selector to navigate around within the image. To view your other images at the same zoom ratio, you can rotate the Command dial. To return to full-frame playback, press the Zoom out button. You may have to press the Zoom out button multiple times, depending on how much you have zoomed in.

Front of the camera

The front of the D7000 (the lens facing you) is where you find the buttons to quickly adjust the flash settings as well as some camera-focusing options, and with certain lenses, you will find some buttons that control focusing and Vibration Reduction (VR).

▶ **Built-in flash.** This option is a handy feature that allows you to take sharp pictures in low-light situations. Although not as versatile as one of the external Nikon Speedlights, such as the SB-600 or SB-400, the built-in flash can be used very effectively and is great for snapshots. I highly recommend getting a flash diffuser if you plan on using it often. You can also use it to control off-camera Speedlights, which is great option that isn't included on some of Nikon's lesser models.

▶ **Infrared receiver.** This allows you to use the optional wireless remote, the ML-L3.

▶ **Preview button.** By default, this button stops down the aperture so that you can see in real time what the depth of field will look like. It's a customizable button that can be set to a number of different settings. You can set the button to quickly change the image quality, ISO sensitivity, white balance, or Active D-Lighting settings via the Info display. Pressing the Preview button and rotating the Command dial changes the settings. You can change the setting options in CSM f4.

▶ **Function (Fn) button.** You can set the Fn button to a number of different settings so that you can access them quickly, rather than searching through the menu options manually. You can set the button to change the image quality, ISO sensitivity, white balance, or Active D-Lighting settings via the Info display. Pressing the Fn button and rotating the Command dial changes the settings. You can change the setting options in the Setup menu in CSM f3 under the Buttons option.

▶ **Built-in microphone.** This microphone can record sound while you're recording HD video.

Built-in flash

AF-assist illuminator

Sub-command dial

Infrared reciever

Preview button

Built-in microphone

Function (Fn) button

Image courtesy of Nikon, Inc.

1.3 Front of the Nikon D7000

▶ **Sub-command dial.** The Sub-command dial is used to adjust a number of differ-
ent things, but by default, it's used to change the aperture setting. It is also used
to change various settings when used in conjunction with other buttons, such as
the Quality button.

▶ **AF-assist illuminator.** This is an LED that shines on the subject to help the
camera to focus when the lighting is dim. The AF-assist illuminator only lights
when in Single-servo AF mode (AF-S) or Full-time-servo mode (AF-A) and the
center AF point is selected. This is also lit when the camera is set to Red-Eye
Reduction flash using the camera's built-in flash.

Right side of the camera

On the right side of the camera (the lens facing you) are the output terminals on the D7000. These are used to connect your camera to a computer or to an external source for viewing your images directly from the camera. These terminals are hidden under a rubber cover that helps keep out dust and moisture.

▶ **Flash pop-up/Flash mode/FEC button.** When you're using P, S, A, or M expo-sure modes, press this button to open and activate the built-in Speedlight. Pressing this button and rotating the Command dial on the rear of the camera allows you to choose a flash mode. Depending on the Shooting mode, you can choose from among Front-Curtain Sync, Red-Eye Reduction, Red-Eye Reduction with Slow Sync, Slow Sync, and Rear-Curtain Sync. Once the flash is popped up, pressing this button in conjunction with the Exposure Compensation button and rotating the Command dial allows you to adjust the Flash Exposure Compensation (FEC). FEC allows you to adjust the flash output to make the flash brighter or dimmer depending on your needs. When you're shooting in Auto or scene modes, the flash is automatically activated and some Flash sync modes aren't available depending on the scene mode.

 • **Auto, Portrait, Child, Close-up.** When using these modes, you can select Auto-flash, Auto with Red-Eye Reduction, or set to Off.

 • **Night portrait.** With this mode you can select Auto with Slow Sync and Red-Eye Reduction, Auto with Slow Sync, or set to Off.

 • **P, A.** With these modes you can select Fill flash, Red-Eye Reduction, Slow Sync with Red-Eye Reduction, Slow Sync, or Rear-Curtain with Slow Sync.

 • **S, M.** These modes allow you to use Fill flash, Red-Eye Reduction, or Rear-Curtain Sync.

▶ **Auto-bracketing (BKT) button.** This button is used to activate the Auto-bracketing feature. Pressing the button and rotating the Main Command dial allows you to choose from a three-frame bracket (normal, under, over), or a two-frame bracket (normal, over, or normal, under). Rotating the Sub-command dial lets you choose the bracketing increments; you can choose from 0.3 to 2 EV (exposure value) in 1/3 steps.

▶ **Lens mounting mark.** Most lenses have a white mark on them to help you to line up your lens bayonet so that it can be rotated and locked into place. Use this mark to line up with the mounting mark on the lens.

▶ **Lens release button.** This button disengages the locking mechanism of the lens, allowing the lens to be rotated and removed from the lens mount.

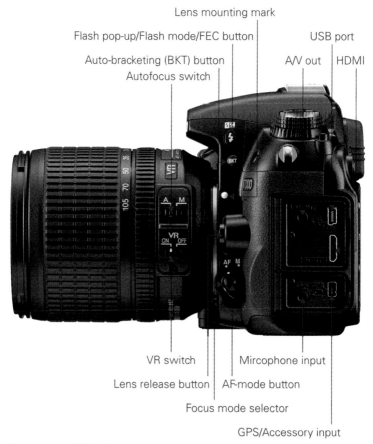

Lens mounting mark

Flash pop-up/Flash mode/FEC button

USB port

Auto-bracketing (BKT) button

A/V out HDMI

Autofocus switch

VR switch

Mircophone input

Lens release button AF-mode button

Focus mode selector

GPS/Accessory input

Image courtesy of Nikon, Inc.

1.4 The right side of the D7000

▶ **AF-mode button/Focus mode selector.** Pressing the button and rotating the Main Command dial allows you to select the AF mode; you can choose Auto (AF-A), Single-servo (AF-S), or Continuous (AF-C). Rotating the Sub-command dial allows you to select the AF-area mode. In AF-S, you can choose Single point or Auto; in AF-A or AF-C, you can select from Single point, Dynamic (9, 21, or 39), 3D-tracking, or Auto.

▶ **GPS/Accessory input.** This is an accessory port that allows you to connect the optional Nikon GP-1 for geotagging your images.

▶ **USB port.** This is where you plug in the USB cable, attaching the camera to your computer to transfer images straight from the camera to the computer. The USB cable is also used to connect the camera to the computer when using Nikon's optional Camera Control Pro 2 software.

▶ **HDMI.** This terminal is for connecting your camera to an HDTV or HD monitor. This requires a type C mini-pin HDMI cable that's available at any electronics store.

▶ **A/V out.** This connection, officially called Standard video output, is used to connect the camera to a standard TV for viewing your images on-screen. The D7000 connects with the EG-D2 video cable that is included with the D7000.

▶ **Microphone input.** You can use this input to connect an external mic, which records sound for your videos at a better quality that you can get from the built-in mic.

▶ **Autofocus switch.** This switch is used to choose between using the lens in Auto or Manual focus.

▶ **VR switch.** This allows you to turn the Vibration Reduction (VR) on or off. When you're shooting in normal or bright light, it's best to turn the VR off to reduce battery consumption.

Left side of the camera

On the left side of the camera (the lens facing you) is the memory card slot cover. Sliding this door toward the back of the camera opens it so you can insert or remove your memory cards.

Image courtesy of Nikon, Inc.
1.5 Memory card slot cover

Viewfinder Display

When looking through the viewfinder, you see a lot of useful information about the photo you are setting up. Most of the information is also shown in the Information Display, but it is less handy when you are looking through the viewfinder composing a shot. Here is a complete list of all the information you get from the viewfinder display:

▶ **Framing grid.** When this option is turned on in the Custom Settings menu (CSM) d2, you will see a grid displayed in the viewing area. Use the grid to line up elements of your composition to ensure they are straight (or not).

▶ **Focus points.** The first thing you are likely to notice when looking through the viewfinder is a small rectangle near the center of the frame. This is your active focus point. Note that only the active focus point is shown full-time when you're using the Single, Dynamic, or 3D-tracking AF setting. When the camera is set to Auto-area AF, no focus point is shown until the Shutter Release button is half-pressed and focus is achieved.

▶ **AF-area brackets.** These brackets are used to indicate where the boundaries of the AF points are. The AF system will not recognize anything that lies outside the brackets. In the middle of the AF-area brackets on the top and bottom there is a semi-circle, which is the 12mm center-weighted metering circle.

▶ **Low battery indicator.** This shows up when the battery is low. When the battery is completely exhausted, this icon blinks and the Shutter Release is disabled.

▶ **Black-and-white indicator.** This warning appears when the camera is set to the MC (monochrome) Picture Control.

▶ **No memory card indicator.** This warning appears when there is no memory card inserted in the camera.

 The No memory card, Black-and-white, and Low battery indicators can be turned off in CSM d4.

▶ **Focus indicator.** This is a green dot that lets you know whether the camera detects that the scene is in focus. When focus is achieved, the green dot lights up; if the camera is not in focus, no dot is displayed. On either side of a dot is an arrow. When the left arrow is lit, the focus is in between the camera and the subject; when the right arrow is lit the focus is falling behind the subject. Both arrows blinking indicates that the camera was unable to achieve focus.

▶ **AE Lock indicator.** When this is lit, you know that the Auto-Exposure has been locked.

▶ **Shutter speed/AF mode.** This shows how long your shutter is set to stay open, from 30 seconds (30") up to 1/8000 (8000) second. When you press the AF mode button, this shows your AF mode setting (AF-A, AF-C, AF-S).

▶ **Aperture.** This shows what your current aperture setting is. The words *aperture* and *f-stop* are used interchangeably. Your aperture setting is how wide your lens opening is.

▶ **Low battery warning.** This appears when the camera battery is low and needs to be charged.

▶ **Auto-bracketing indicator.** This appears when Auto-bracketing is engaged.

▶ **ISO sensitivity indicator.** When you press the ISO button, this indicator shows up next to the ISO sensitivity setting, letting you know that the numbers you are seeing are the ISO numbers.

▶ **K.** This lets you know that there are more than 1,000 exposures remaining on your memory card.

▶ **Flash-ready indicator.** When this is displayed, the flash, whether it is the built-in flash or an external Speedlight attached to the hot shoe, is fully charged and ready to fire at full power.

▶ **FV lock indicator.** When the FV lock indicator is on, it means you have locked in the flash exposure value. The flash value (FV) can only be locked when the Function button (or Preview) has been set to do this.

▶ **Flash sync indicator.** This indicator is displayed as a small X. This comes on when you set your camera to the sync speed in CSM e1. This is only available in Shutter Priority (S) or Manual (M) mode. To set the camera to the preset sync speed, dial the shutter speed down one setting past the longest shutter time, which is 30 seconds in S and bulb in M.

▶ **Aperture stop indicator.** This indicator is displayed when a non-CPU lens is attached that hasn't had non-CPU lens data entered. The camera displays the aperture steps in numbers. Wide open the indicator reads F0, and each stop you click

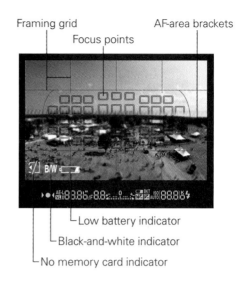

Framing grid · Focus points · AF-area brackets · Low battery indicator · Black-and-white indicator · No memory card indicator

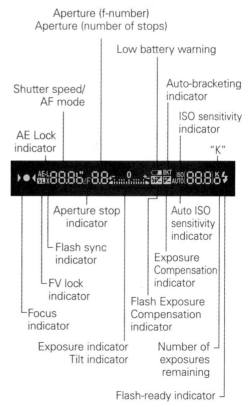

Aperture (f-number) / Aperture (number of stops) · Low battery warning · Shutter speed/AF mode · Auto-bracketing indicator · ISO sensitivity indicator · AE Lock indicator · "K" · Aperture stop indicator · Auto ISO sensitivity indicator · Flash sync indicator · Exposure Compensation indicator · FV lock indicator · Flash Exposure Compensation indicator · Focus indicator · Exposure indicator · Tilt indicator · Number of exposures remaining · Flash-ready indicator

1.6 Viewfinder display

down is another full number; for example, stop down to f/5.6 when using an f/2.8 lens and the indicator reads F2. Stop down to f/22 and it reads F6, which is 6 stops away from f/2.8.

▶ **Exposure indicator/Tilt indicator.** When the bars are in the center, you are at the proper settings to get a good exposure; when the bars are to the left, you are overexposed, and when the bars are to the right, you are underexposing your image. You can reverse this in CSM f9. This feature is especially handy when using Manual exposure. This display also doubles as the tilt indicator that allows you to ensure your camera is level, which is great when shooting land-scapes. When the camera is tilted to the right, the bars are displayed on the left. When the camera is tilted to the left, the bars are displayed on the right. When the camera is level, a single bar appears directly under the zero.

▶ **FEC indicator.** When this is displayed, Flash Exposure Compensation is on. You adjust FEC by pressing the Flash mode button and rotating the Sub-command dial.

▶ **Exposure Compensation indicator.** When this appears in the viewfinder, your camera has exposure compensation activated. You adjust exposure compensa-tion by pressing the Exposure Compensation button and rotating the Main Command dial.

▶ **Auto ISO indicator.** This is displayed when the Auto ISO setting is activated to let you know that the camera is controlling the ISO settings. You can turn on Auto ISO in the ISO sensitivity settings located in the Shooting menu.

▶ **Exposures remaining/ISO/WB/EV FEC/Active D-Lighting/AF-area mode.** This set of numbers lets you know how many more exposures can fit on the memory card. The actual number of exposures may vary according to file infor-mation and compression. When you half-press the Shutter Release button, the display changes to show how many exposures can fit in the camera's buffer before the buffer is full and the frame rate slows down. The buffer is in-camera RAM that stores your image data while the data is being written to the memory card. This also shows the WB preset recording information as well as your expo-sure compensation values, FEC values, Active D-Lighting amount, and the AF-area mode.

Control Panel

The Control Panel on the top of the camera allows you a quick way to reference some of the most important settings on your D7000.

▶ **Color temperature indicator.** This indicator is displayed to alert you that the numbers you are seeing is the color temperature in the Kelvin scale. This only appears when the camera is set to Kelvin WB and the WB button is being pressed.

▶ **Shutter speed.** By default, this set of numbers shows you the shutter speed setting. These numbers also show a myriad of other settings depending on which buttons are being pressed and what modes are activated. Here's a list:

• **Exposure compensation value.** When you press the Exposure Compensation button and rotate the Sub-command dial, the exposure value (EV) compensation number is displayed.

• **FEC value.** Pressing the Flash mode button and rotating the Sub-command dial displays the FEC value.

• **WB fine-tuning.** Pressing the WB button and rotating the Sub-command dial fine-tunes the white balance setting. A is warmer and B is cooler.

• **Color temperature.** When the WB is set to K, the panel displays the color temperature in the Kelvin scale when you press the WB button.

• **WB preset number.** When the WB is set to one of the preset numbers, pressing the WB button displays the preset number currently being used.

• **Bracketing sequence.** When the D7000 Auto-bracketing feature is activated, pressing the Function button displays the number of shots left in the bracketing sequence. This includes WB, exposure, and flash bracketing.

• **Interval timer number.** When the camera is set to use the interval timer for time-lapse photography, this displays the number of shots remaining in the current interval.

• **Focal length (non-CPU lenses).** When the camera's Function button is set to choose a non-CPU lens number when the Function button is pressed, the focal length of the non-CPU lens is displayed. You must enter the lens data in the Setup menu.

▶ **MB-D11 battery indicator.** When the MB-D11 battery grip is attached and the camera is using the battery installed in the grip, this icon is displayed.

▶ **Battery indicator.** This display shows the charge remaining on the active battery. When this indicator is blinking, the battery is dead and the shutter is disabled.

▶ **Flash mode.** These icons denote which flash mode you are using. The flash modes include Red-Eye Reduction, Red-Eye Reduction with Slow Sync, Slow Sync, and Rear-Curtain Sync. To change the Flash sync mode, press the Flash mode button and rotate the Main Command dial.

▶ **Image size.** When you're shooting JPEG, or RAW + JPEG files, this tells you whether you are recording Large, Medium, or Small files. This display is turned off when shooting RAW files.

▶ **Image quality.** This displays the type of file format you are recording. You can shoot RAW or JPEG. When you're shooting JPEG or RAW + JPEG, it displays the compression quality: FINE, NORM, or BASIC.

▶ **WB fine-tuning indicator.** When the white balance fine-tuning feature is activated, this asterisk is displayed. You can fine-tune WB by pressing the WB button and rotating the Sub-command dial.

▶ **WB setting.** This shows you which white balance setting is currently selected.

▶ **Aperture stop indicator.** This icon appears when a non-CPU lens is attached without the non-CPU lens data being entered. This indicates that the numbers next to it are not aperture settings, but aperture stops starting from F0, which is wide open.

▶ **F-stop/Aperture number.** At default settings, this displays the aperture at which the camera is set. This indicator also displays other settings as follows:

 • **Aperture (number of stops).** This shows the number of stops for a non-CPU lens with no data entered into the camera.

 • **Auto-bracketing compensation increments.** The exposure bracketing can be adjusted to over- and underexpose in 1/3-stop increments. When the Function button is set to Auto-bracketing, the number of EV stops is displayed in this area. The choices are 0.3, 0.7, or 1.0 EV. The WB Auto-bracketing can also be adjusted; the settings are 1, 2, or 3.

 • **Number of shots per interval.** When the D7000 is set to Interval Timer shooting, the number of frames shot in the interval is displayed.

 • **Maximum aperture (non-CPU lenses).** When a non-CPU lens is attached and the non-CPU lens data has been entered, the aperture setting of the specified lens is displayed.

 • **PC mode indicator.** This is displayed as PC when connected to the computer by a USB cable.

▶ **Flexible program indicator.** This asterisk appears next to the exposure mode when you're in P, or Programmed Auto, mode. It lets you know that you have changed the default auto-exposure set by the camera to better suit your creative needs.

▶ **Memory card indicator (Slot 1, Slot 2).** This is displayed when a memory card is inserted into a slot. If a number appears in the icon, the slot contains the active card and the images are being recorded to it. Both slots can be active when you're using Slot 2 as a backup or recording RAW to Slot 1 and JPG to Slot 2.

▶ **Auto ISO indicator.** This is displayed when the Automatic ISO setting is activated to let you know that the camera is controlling the ISO settings. You can activate Auto ISO in the Shooting menu.

▶ **Thousands indicator (K).** This lets you know that there are more than 1,000 exposures remaining on your memory card.

▶ **Beep indicator.** This informs you that the camera will beep when the self-timer is activated or when the camera achieves focus when in Single Focus mode.

▶ **Exposure Compensation indicator.** When this appears in the control panel, your camera has exposure compensation activated. This will affect your exposure. Adjust the exposure compensation by pressing the Exposure Compensation button and rotating the Main Command dial.

▶ **Flash sync indicator.** This indicator is displayed as an X. This comes on when you set your camera to the flash sync speed that is set in CSM e1. This is only available in S or M mode. To set the camera to the preset sync speed, dial the shutter speed down one setting past the longest shutter time, which is 30 seconds in S and bulb in M.

▶ **Flash Compensation indicator.** This icon is displayed to inform you that Flash Exposure Compensation has been applied.

▶ **AF-area mode indicator.** This lets you know what AF-area mode is selected and in use.

▶ **AF mode.** This lets you know which focus mode is being used: AF-A, AF-C, or AF-S.

▶ **Clock not set indicator.** When this appears in the control panel, the camera's internal clock needs to be set. You can find the Clock settings in the Setup menu.

▶ **Interval timer indicator.** When the camera's Interval timer option is turned on, this appears in the control panel. You set the interval timer in the Shooting menu.

▶ **Multiple exposure indicator.** This icon informs you that the camera is set to record multiple exposures. Set multiple exposures in the Shooting menu.

▶ **Auto-bracketing indicator.** When the D7000 is in the Auto-Exposure or flash bracketing setting, this appears on the control panel; when it is using WB bracketing, a WB icon also appears above the icon. You set Auto-bracketing in CSM e5.

▶ **Bracketing progress indicator.** This shows you your place in the bracketing sequence when Auto-bracketing is turned on.

▶ **GPS connection indicator.** When this icon is displayed, a GPS device has been attached to the camera using the accessory port.

▶ **Metering mode.** This displays the metering mode setting (Matrix, Center-weighted, Spot metering).

▶ **Remaining exposures.** By default the number of remaining exposures is displayed. A few other things are also displayed, depending on the mode and what buttons are being pressed, as follows:

 • **Buffer.** When the Shutter Release button is half-pressed, the amount of shots remaining until the buffer is full is displayed.

 • **Capture mode indicator.** This indicates specific settings when the camera is connected to the computer with a USB (PC), and others when using Capture Control Pro 2 or the WT-4 wireless transmitter.

 • **ISO sensitivity.** This is the ISO sensitivity setting number.

 • **Preset white balance recording.** When recording a custom WB, this flashes PRE.

 • **Active D-Lighting amount.** This only appears when Active D-Lighting is assigned to the Fn or Preview button and that button is pressed. It displays the current setting (Auto, Off, HP (Extra High), H (High), n (Normal), L (Low)).

 • **Manual lens number.** This only appears when non-CPU lens data is assigned to the Fn or Preview button and that button is pressed. It displays the number of the lens setting (n-1–n-9).

 • **HDMI-CEC connection indicator.** When your camera is connected to an HDMI device that supports HDMI-CEC (Consumer Electronics Control), this icon is displayed. This means that the Multi-selector is disabled and the HDMI device remote is controlling the playback.

Information Display

The Information Display, which I refer to as the Info display for brevity, shows some of the same shooting information that appears in the viewfinder, but there are also quite a few settings that are only displayed here. When this is displayed on the rear LCD, you can view and change the settings without looking through the viewfinder. When the camera is turned on, the Shooting info is automatically displayed on the LCD monitor.

You can also view the Info display by pressing the Info button (located on the bottom right of the camera directly under the focus selector lock). Pressing the Info button twice brings up another screen, which allows you to change some key settings on the camera. These settings are detailed in Figure 1.9.

The information remains on display until no buttons have been pushed for about 10 seconds (default) or the Shutter Release or Info button is pressed.

This display shows you everything you need to know about your camera settings. Additionally, the camera has a sensor built in that tells it when you are holding it vertically, and the Info display is shown upright no matter which way you are holding your camera.

▶ **Shooting mode.** This displays the Shooting mode that your camera is currently set to. This can be one of the scene modes, in which case the display will be the appropriate icon; or one of the semiautomatic modes, such as P, S, A, or M, in which case the display will show the corresponding letter. This display changes when the Mode dial is rotated.

▶ **Flexible program indicator.** This asterisk appears next to the exposure mode when you're in P, or Programmed Auto, mode. It lets you know that you have changed the default auto-exposure set by the camera to better suit your creative needs.

▶ **Shutter speed.** By default this displays the shutter speed setting. It also shows a few other things, as follows:

 • **Exposure compensation value.** When you press the Exposure Compensation button and rotate the Sub-command dial, the exposure value (EV) compensation number is displayed.

 • **FEC value.** Pressing the Flash mode button and rotating the Sub-command dial displays the FEC value.

 • **Number of shots in bracketing sequence.** When you press the BKT button, you look here to determine the settings.

 • **Focal length (non-CPU lenses).** When the camera's Function button is set to choose a non-CPU lens number when the Function button is pressed, the focal length of the non-CPU lens is displayed. You must enter the lens data in the Setup menu.

▶ **Exposure indicator.** When the bars are in the center, you are at the proper settings to get a good exposure; when the bars are to the left, you are overexposed; when the bars are to the right, you are underexposing your image. You can reverse this in CSM f9.

- **Exposure compensation display.** If any exposure compensation is applied, it will show that you have an under- or overexposure on the indicator.

- **Bracketing progress indicator.** When Auto-bracketing is turned on, you can use this to track your progress. The display shows a small line under the 0 (normal), the + side (overexposure), and the − side (underexposure).

- **WB bracketing.** When bracketing is set to WB, three small lines are placed on either side of the zero, indicating each shot to be taken. The line disappears when the shot has been taken.

▶ **AF-area mode indicator.** This lets you know which AF-area mode is selected and in use.

▶ **Auto ISO indicator.** This is displayed when the Automatic ISO setting is activated to let you know that the camera is controlling the ISO settings. You can activate Auto ISO in the Shooting menu.

▶ **K.** This lets you know that there are more than 1,000 exposures remaining on your memory card.

▶ **Exposures remaining/Manual lens number.** This displays the number of exposures remaining. When the Fn or Preview button is assigned to non-CPU lens data, this displays the focal length data for the selected lens.

▶ **White balance/White balance fine-tuning.** This is where your WB settings are displayed. If the WB has been changed from the default, an asterisk is shown.

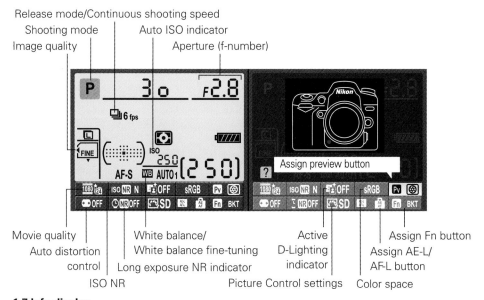

1.7 Info display

▶ **Image quality.** The image quality settings are displayed here. There are two areas: one for Slot 1 and one for Slot 2.

▶ **Image size.** This area displays the size settings for JPEG images.

▶ **Flash mode.** This is where the different flash modes and settings are displayed.

▶ **Beep indicator.** When the camera is set to beep for AF confirmation (CSM d1), a music note appears here.

▶ **Multiple exposure indicator.** This icon is displayed when the multiple exposure feature is activated.

▶ **Bracketing indicator.** This is displayed when the D7000 Auto-bracketing feature is turned on.

▶ **Interval timer indicator.** When the camera is set to shoot at intervals, this icon is shown.

▶ **Camera battery indicator.** This shows the charge remaining on the battery that is in the camera.

▶ **MB-D11 indicators.** When an optional MB-D11 battery grip is being used, this displays the type of battery being used as well as the amount of charge remaining on the battery.

▶ **GPS connection indicator.** When the option GP-1 is connected to the D7000, this GPS indicator is displayed.

▶ **Metering.** This displays the metering mode that is in use.

▶ **Autofocus mode.** This section displays the AF-mode (AF-A, AF-C, AF-S).

▶ **Copyright information.** The D7000 can be programmed to add copyright information to the EXIF (Exchangeable Image File Format) data of all your images. When this option is turned on, this is displayed.

▶ **Clock not set indicator.** When this appears, the camera's internal clock has not been set and the time and date will not appear in the EXIF data.

▶ **Image comment indicator.** You can add a line or two of text into the EXIF data using the Image comment option. This indicator informs you that this feature is on.

▶ **Release mode/Continuous shooting speed.** This displays the Release mode settings. When the camera is set to a Continuous Release mode the frames per second (fps) is also displayed.

▶ **Eye-Fi.** When an option Eye-Fi memory card is being used in the camera, this icon is displayed.

▶ **FV lock.** This appears when the flash exposure has been locked. One of the customizable buttons must be set to FV lock to activate this feature.

▶ **FEC indicator.** This indicator is shown when the Flash Exposure Compensation has been adjusted.

▶ **Exposure compensation.** This alerts you when exposure compensation has been added to the settings.

The following are adjustable settings. Pressing the Info button twice gives you access to these common settings so that you can change them quickly. Once you have selected an option, pressing OK brings up the Settings menu.

▶ **Movie quality.** This allows you to change the resolution quality of the videos.

▶ **ISO NR.** You can adjust the high ISO noise reduction settings here.

▶ **Active D-Lighting.** You can change the Active D-Lighting settings using this option.

▶ **Color space.** This allows you to change the color space from Adobe RGB to sRGB. See Chapter 3 for information on color space.

▶ **Assign Preview button.** This allows you to change the settings for the Preview button.

▶ **Auto distortion control.** You can turn this option on or off. Not all lenses are compatible with this feature. If the feature isn't available, the option is grayed out and is not selectable.

▶ **Picture Control settings.** You can quickly change the Picture Control here.

▶ **Assign AE-L/AF-L button.** You can assign different functions to the AE-L/AF-L button using this menu option.

▶ **Assign Fn button.** This is where you select the settings for the Fn button.

Nikon D7000 Essentials

After you familiarize yourself with the basic layout of the D7000 and all the various dials, switches, and buttons, you are ready to navigate to and adjust the settings that allow you to control and fine-tune the way you capture images with your camera. In this chapter, I cover some of the most commonly changed settings of the camera, such as exposure modes, metering, autofocus (AF) settings, white balance, and ISO. All these settings combined create your image, and you can tweak and adjust them to reflect your artistic vision or to simply ensure you create the best-possible images in complex scenes.

Knowing which modes and features to use in any given situation allows you to get a good exposure, no matter what.

Exposure Modes

Exposure modes dictate how the camera chooses the aperture and shutter speed as well as the metering mode. Metering modes control how the camera gathers the lighting information so that the camera can choose the appropriate settings based on the exposure mode. The four main exposure modes are Programmed Auto (P), Aperture Priority (A), Shutter Priority (S), and Manual (M). They are all you need to achieve the correct exposure, but for simplicity and ease of use Nikon also offers scene modes. In these modes, the camera chooses the correct settings for different situations. The modes designate everything from AF modes to Picture Controls, flash, and ISO settings, though you are able to adjust some of these settings.

The U1 and U2 user settings are a welcome addition to the D7000. They allow you to customize camera settings to meet specific shooting criteria. For example, if you are shooting portraits, you can program the U1 setting for outdoor natural light portraits and the U2 setting for indoor portraits with studio strobes. Of course, the settings are entirely up to you. This new option can save you untold amounts of time.

To switch among the exposure modes, simply rotate the large Mode dial on the top of the camera.

Programmed Auto

Programmed Auto mode (P) is an automatic mode that's best for shooting snapshots and scenes where you're not concerned about having complete control over the settings.

When the camera is in Programmed Auto mode, it decides the shutter speed and aperture settings for you based on a set of algorithms. The camera attempts to select a shutter speed that allows you to shoot handheld without suffering from camera shake while also adjusting your aperture so that you get good depth of field to ensure everything is in focus. When the camera body is coupled with a lens that has a CPU built in (all Nikon AF lenses have a CPU), the camera automatically knows what focal length and aperture range the lens has. The camera then uses this lens information to decide what the optimal settings should be.

This exposure mode chooses the widest aperture possible until the optimal shutter speed for the specific lens is reached. Then the camera chooses a smaller f-stop and increases the shutter speed as light levels increase. For example, when you use a 17-55mm f/2.8 zoom lens, the camera keeps the aperture wide open until the shutter

speed reaches about 1/40 second (just above minimum shutter speed to avoid camera shake). Upon reaching 1/40 second, the camera adjusts the aperture to increase depth of field.

 When you use Auto ISO with Programmed Auto, the camera tries to hold the shutter speed at the number specified in the Auto ISO sensitivity settings.

The exposure settings selected by the camera are displayed in both the LCD control panel and the viewfinder display. Although the camera chooses what it thinks are the optimal settings, the camera does not know your specific needs. You may decide that your hands are not steady enough to shoot at the shutter speed the camera has selected, or you may want a wider or smaller aperture for selective focus. Fortunately, you aren't stuck with the camera's exposure choice. You can engage what is known as *flexible program*. Flexible program allows you to deviate from the camera's selected aperture and shutter speed when you are in P mode. You can automatically engage this feature by simply rotating the Main Command dial until the desired shutter speed or aperture is achieved. This allows you to choose a wider aperture/faster shutter speed when you rotate the dial to the right, or a smaller aperture/slower shutter speed when you rotate the dial to the left. With flexible program, you can maintain the metered exposure while still having some control over the shutter speed and aperture settings.

A quick example of using flexible program would be if the camera has set the shutter speed at 1/60 second with an aperture of f/8, you're shooting a portrait, and you want a wider aperture to throw the background out of focus. By rotating the Main Command dial to the right, you can open the aperture up to f/4, which causes the shutter speed to increase to 1/250 second. This is an *equivalent exposure*, meaning you get the same exposure but the settings are different.

When flexible program is on, an asterisk appears next to the P on the LCD control panel. Rotate the Main Command dial until the asterisk disappears to return to the default Programmed Auto settings (or turn the camera off and back on).

 Programmed Auto mode is not available when you use non-CPU lenses. When you're in P mode with a non-CPU lens attached, the camera automatically selects Aperture Priority mode. The P continues to appear on the LCD control panel, but the A for Aperture Priority appears in the viewfinder display.

 In Programmed Auto mode, if there is not enough light to make a proper exposure, the camera displays Lo in place of the shutter speed setting.

Aperture Priority

Aperture Priority mode (A) is a semiautomatic mode. In this mode, you decide which aperture to use by rotating the Sub-command dial and the camera sets the shutter speed for the best exposure based on your selection. Situations where you may want to select the aperture include when you're shooting a portrait and want a large aperture (small f-stop number) to blur out the background by minimizing depth of field, and when you're shooting a landscape and want a small aperture (large f-stop number) to ensure the entire scene is in focus by increasing depth of field.

Choosing the aperture to control depth of field is one of the most important aspects of photography and allows you to selectively control which areas of your image, from foreground to background, are in sharp focus and which areas are allowed to blur. Controlling depth of field enables you to draw the viewer's eye to a specific part of the image, which can make your images more dynamic and interesting to the viewer.

 In Aperture Priority mode, if there is not enough light to make a proper exposure, the camera displays Lo in place of the shutter speed setting.

Shutter Priority

Shutter Priority mode (S) is another semiautomatic mode. In this mode, you choose the shutter speed by rotating the Main Command dial and the camera automatically sets the aperture. You can choose shutter speeds from as long as 30 seconds to as short as 1/8000 second.

 When you're in Shutter Priority mode, dialing the shutter speed past the longest shutter speed of 30 seconds sets the shutter speed to the Flash sync speed. You can set the Flash sync speed in the Custom Setting menu (CSM e1).

Shutter Priority mode is generally used for shooting moving subjects or action scenes. Choosing a fast shutter speed allows you to freeze the action of a fast-moving subject. A good example would be if you were shooting a horse race. Horses move extremely fast, so you'd need to be sure to use a fast shutter speed of about 1/1000 second to freeze the motion of the horse and prevent blur. This would allow you to capture most of the crisp details of the subject.

There are also times when you may want to use a slow shutter speed, and you can use this mode for that as well. When you shoot scenes at night, a long exposure is often preferable, and choosing your shutter speed can allow you to introduce many creative effects into your photography. I often like to shoot city skylines at night and

more often than not the skyline is located near a river. Selecting a slow shutter speed of about 2 to 4 seconds gives moving bodies of water a glasslike appearance that I find appealing. Be sure to bring along your favorite tripod for support.

Even when you shoot action, there are times when you may want to use a slower shutter speed. Panning along with a moving subject at a slower shutter speed allows you to blur the background while keeping the subject in relatively sharp focus. The blur of the background is extremely effective at portraying motion in a still photograph. I use this technique extensively when shooting motorsports.

In Shutter Priority mode, if there is not enough light to make a proper exposure, the camera displays Lo in place of the aperture setting.

Manual

When in Manual mode (M), you set both the aperture and shutter speed settings. You can estimate the exposure, use a handheld light meter, or use the electronic analog exposure display on the D7000 to determine the exposure needed.

There are a few situations where you may want to set the exposure manually:

▶ **When you want complete control over exposure.** Most times the camera decides the optimal exposure based on technical algorithms and an internal database of image information. Oftentimes, what the camera decides is optimal is not necessarily what is optimal in your mind. You may want to underexpose the image to make it dark and foreboding, or you may want to overexpose it a bit to make the colors pop (making colors bright and contrasty). When your camera is set to M, you can choose the settings and place your image in whatever tonal range you want without having to fool with exposure compensation settings.

▶ **When you use studio flash.** When you use studio strobes or external non-dedicated flash units, you don't use the camera's metering system. When using external strobes, you need a flash meter or manual calculation to determine the proper exposure. Using the Manual exposure mode, you can quickly set the aperture and shutter speed to the proper exposure; just be sure not to set the shutter speed above the rated sync speed of 1/250 second.

▶ **When you use non-CPU lenses.** When you use older non-CPU lenses, the camera is automatically set to Aperture Priority with the camera choosing the shutter speed. Switching to Manual allows you to select both the shutter speed and aperture while using the camera's analog light meter that appears in the viewfinder display.

Auto modes

The D7000 has two fully automatic, or Auto, modes that do all the work for you. These are simple grab-and-go settings to use when you're in a hurry or you just don't want to be bothered with changing the settings. The Auto modes control everything from shutter speed and aperture to ISO sensitivity and white balance.

You can override the Auto ISO setting using the Information Display menu. You can also override the Auto ISO if the Function button is set to ISO. The override remains in effect unless the camera is changed to P, S, A, or M and returned to one of the scene modes. When you change back to a scene mode from P, S, A, or M, the Auto ISO function is again activated.

Auto

The Auto mode is basically a point-and-shoot mode. The camera takes complete control over the exposure. The camera's meter reads the light, the color, and the brightness of the scene and runs the information through a sophisticated algorithm. The camera uses this information to determine what type of scene you are photographing and chooses the settings that it deems appropriate for the scene.

If there isn't enough light to make a proper exposure, the camera's built-in flash pops up when the Shutter Release button is half-pressed for focus. The flash fires when the shutter is released, resulting in a properly exposed image.

This mode is great for taking snapshots, when you simply want to concentrate on capturing the image and let the camera determine the proper settings.

Auto (flash off)

This mode functions in the same way as the Auto setting, except that it disables the flash, even in low-light situations. In instances when the lighting is poor, the camera's AF-assist illuminator lights up to provide sufficient light to achieve focus. The camera uses the focus area of the closest subject to focus on.

This setting is preferable when you want to use natural or ambient light for your subject or in situations where you aren't allowed to use flash, such as museums, or events where the flash may cause a distraction, such as weddings.

Scene modes

Sometimes the Auto mode isn't going to give you settings that suit your needs, especially when you are shooting under difficult situations or when you have special

circumstances. The scene modes take into account different lighting situations and modify the way the camera meters the light. Scene modes also control the focus points, the flash settings, and the aperture, shutter speed, and ISO sensitivity settings.

The camera also determines if there is enough light to make an exposure and activates the built-in flash if the light is insufficient. Some scene modes, such as Landscape, also make sure that the flash is not used, even in low-light situations.

Nikon has added 13 more scene modes than were previously available on any dSLR with the exception of the D5000. These additional modes serve to cover almost every possible shooting scenario.

The scene modes in the D7000 allow you to capture the image with the settings that are best for what you are photographing. The camera has the parameters programmed into it; you simply rotate the Mode dial to Scene and choose the setting from the menu option on the LCD by rotating the Main Command dial.

When you use scene modes, you cannot adjust the white balance (WB) and Active D-Lighting settings. Although each scene mode has default settings for ISO, AF-area, AF modes, and flash modes, you can change them. These settings return to default when you turn the camera off or turn the Mode dial to another setting.

Portrait

This scene mode is for taking pictures of people. The camera automatically adjusts the colors to provide natural-looking skin tones. The camera focuses on the closest subject. It also attempts to use a wide aperture, if possible, to reduce the depth of field. This draws attention to the subject of the portrait, leaving distracting background details out of focus.

The built-in flash and AF-assist illuminator automatically activate in low-light situations.

Landscape

This mode is used for taking photos of far-off vistas. The camera automatically adjusts the colors to apply brighter greens and blues to skies and foliage. The camera also automatically focuses on the closest subject and uses a smaller aperture to provide a greater depth of field to ensure focus throughout the entire image.

In this mode, the camera automatically disables the AF-assist illuminator and the flash.

Child

This mode is for taking portraits or candid shots of children. The camera automatically adjusts the colors to provide more saturation while still providing a natural skin tone. The camera automatically focuses on the closest subject and uses a fairly small aperture to capture background details. The built-in flash is automatically activated when the light is low.

Sports

This mode uses a fast shutter speed to freeze the action of moving subjects. The camera focuses continuously as long as you have the Shutter Release button half-pressed. The camera also uses Predictive Focus Tracking based on information from all the focus areas in case the main subject moves from the selected focus point.

The camera disables the built-in flash and AF-assist illuminator when this mode is selected.

 To shoot a quick sequence shot, rotate the Release Mode dial to Continuous mode.

Close-up

This scene mode is used for close-up or macro shots. It uses a fairly wide aperture to provide a soft background while giving the main subject a sharp focus. In this mode, the camera focuses on the subject in the center of the frame, although you can use the Multi-selector to choose one of the other focus points to create an off-center composition.

When light is low, the camera automatically activates the built-in flash. Be sure to remove your lens hood when using the flash on close-up subjects because the lens hood can cast a shadow on your subject by blocking the light from the flash.

Night Portrait

This mode is for taking portraits in low-light situations. The camera automatically activates the flash and uses a longer shutter speed to capture the ambient light from the background. This balances the ambient light and the light from the flash, giving you a more natural effect. You may want to use a tripod when you use this feature to prevent blurring from camera shake that can occur during longer exposure times.

Night Landscape

This mode disables the flash, sets a small aperture, and uses a long shutter speed to capture ambient light. The AF-assist illuminator is automatically turned off. You will definitely need a tripod when using this mode.

Party/Indoor

This option activates the built-in flash and uses the Red-Eye Reduction feature. Use this mode for capturing snapshots with people in them while retaining some of the ambient light.

Beach/Snow

Sand and snow present a tricky situation for your camera's light meter, and often cause the camera to underexpose the scene, making the snow or sand appear a dingy, dull gray. This scene mode adds some exposure compensation to ensure the sand or snow appears a natural, gleaming white.

Sunset

This mode captures the intense shades of color that occur during the sunset or sunrise. The camera boosts color saturation to enhance this effect. The flash is turned off, and the camera focuses at the center of the frame. A tripod is recommended when using this mode.

Dusk/Dawn

This mode is similar to the Sunset mode. It is intended for *after* the sun sets or *before* it rises. The color saturation is boosted more to accent the colors that are less visible when the sun has already set (or has yet to rise) and there is little light available. In this mode, the flash is turned off. A tripod is strongly recommended when using this mode.

Pet Portrait

This mode is obviously for taking photos of pets. A faster shutter speed is used to freeze any movement a frisky pet might make. The AF-assist illuminator is disabled in this mode.

Candlelight

This mode gives you more natural colors when photographing under candlelight, which can be difficult on standard Auto WB settings. The camera also uses wide aperture settings. The flash is disabled.

Blossom

This mode is for shooting landscapes in which large fields of colorful flowers appear. The colors are boosted for a more vibrant look. The built-in flash is disabled in this mode.

Autumn Colors

When this mode is selected, the camera automatically boosts the saturation of the reds, oranges, and yellows in the image because those are the most prevalent colors in fall foliage. The built-in flash is disabled in this mode.

Food

Use this mode when photographing food items. The colors are boosted and the camera selects a fairly wide aperture. When the lighting is low, the built-in flash is automatically activated.

Silhouette

In this mode, the camera sets the exposure for the bright part of the scene to silhouette the dark subject against a bright background. This option is best when shooting during dusk or dawn.

High Key

Use this setting when shooting a light subject against a light background. The camera applies some exposure compensation to slightly overexpose and add some brightness to the scene.

Low Key

Use this setting when photographing dark subjects on a dark background. This mode also punches up the highlights just a bit to get good definition between the shadows and highlights.

Metering Modes

The D7000 has three metering modes — Matrix, Center-weighted, and Spot metering — to help you get the best exposure for your image. You can change the modes by pressing the metering mode button just behind the Shutter Release button (on the left side) and rotating the Main Command dial (you can see the metering

mode icon on the LCD control panel or the Info display). Metering modes determine how the camera's light sensor collects and processes the information used to determine exposure. Each of these modes is useful for different types of lighting situations.

Matrix

The default metering system that Nikon cameras use is a proprietary system called 3D Color Matrix Metering II, or just Matrix metering. Matrix metering reads a wide area of the frame and sets the exposure based on the brightness, contrast, color, and composition. Then the camera runs the data through sophisticated algorithms and determines the proper exposure for the scene. When you use a Nikkor D- or G-type lens, the camera also takes the focusing distance into consideration.

For more on lenses and lens specifications, see Chapter 4.

The D7000's 2016-pixel RGB (Red, Green, Blue) sensor measures the intensity of the light and the color of a scene. The sensor debuts with the D7000 and is a great improvement over the 1005-pixel sensor of previous camera models. After the Matrix meter takes the measurement, the camera compares the information to information from 30,000 images stored in its database. The D7000 determines the exposure settings based on the findings from the comparison.

Image courtesy of Nikon, Inc.

2.1 The 2016-pixel RGB sensor in the D7000

In simple terms, it works like this: You're photographing a portrait outdoors, and the sensor detects that the light in the center of the frame is much dimmer than the edges. The camera takes this information along with the focus distance and compares it to the ones in the database. The images in the database with similar light and color patterns and subject distance tell the camera that this must be a close-up portrait with flesh tones in the center and sky in the background. From this information, the camera decides to expose primarily for the center of the frame although the background may be over- or underexposed. The RGB sensor also takes note on the quantity of the colors and uses that information.

The Matrix meter of the D7000 performs several ways automatically, based on the type of Nikon lens that you use.

▶ **3D Color Matrix Metering II.** As mentioned earlier, this is the default metering system that the camera employs when a G- or D-type lens is attached to the camera. Most lenses made since the early to mid-1990s are these types of lenses. The only difference between the G- and D-type lenses is that on the G-type lens there is no aperture ring. When you use the Matrix metering method, the camera decides the exposure setting mostly based on the brightness and contrast of the overall scene and the colors of the subject matter as well as other data from the scene. It also takes into account the distance of the subject and which focus point is used, as well as the lens focal length, to further decide which areas of the image are important to getting the proper exposure. For example, if you're using a wide-angle lens with a distant subject with a bright area at the top of the frame, the meter takes this into consideration when setting the exposure so that the sky and clouds don't lose critical detail.

▶ **Color Matrix Metering II.** This type of metering is used when a non-D- or G-type CPU lens is attached to the camera. Most AF lenses made from about 1986 to the early to mid-1990s fit into this category. The Matrix metering recognizes this and the camera uses only brightness, subject color, and focus information to determine the right exposure.

▶ **Color Matrix Metering.** This type of metering is engaged when a non-CPU lens is attached to the camera and when the focal length and maximum aperture are specified using the non-CPU data in the D7000 Setup menu. The exposure is then calculated solely on the brightness of the scene and the subject color. If a non-CPU lens is attached and no lens information is entered, the camera's meter defaults to Center-weighted metering.

Matrix metering is suitable for use with most subjects, especially when you're in a particularly tricky or complex lighting situation. Given the large amount of image data in the Matrix metering database, the camera can make a fairly accurate assessment about what type of image you are shooting and adjust the exposure accordingly. For example, for an image with a high amount of contrast and brightness across the top of the frame, the camera tries to expose for the scene so that the highlights retain detail. Paired with Nikon's Active D-Lighting, your exposures will have good dynamic range throughout the entire image.

Center-weighted

When the camera's metering mode is switched to Center-weighted, the meter takes a light reading of the whole scene, but bases the exposure settings mostly on the light falling on the center of the scene. The camera determines about 75 percent of the

exposure from a circular pattern in the center of the frame and 25 percent from the area around the center.

By default, the circular pattern is 8mm in diameter, but you can choose to make the circle bigger or smaller depending on the subject. Your choices are 6, 8, 10, or 13mm and are found in Custom Settings menu (CSM) b4.

There is also a setting for Average. When set to Average, the camera takes a reading of the full frame and decides on an average setting. (I'm not sure why the Average option is included in the Center-weighted menu because it's not center-weighted at all.) Averaging meters were one of the first types of meters used in SLR cameras and although they worked okay in moderately tricky lighting situations, you had to know when to use your exposure compensation or your image would come out flat and, well, average. An example of this is a snowy landscape — the averaging meter takes a look at all that white and wants to make it an 18 percent gray, causing the snow to look dingy. You have to know to adjust your exposure compensation +1 or 2 stops. Unless you're photographing something that is uniform in color and has very little contrast, I advise staying away from using the Average setting.

On the other hand, true Center-weighted metering is a very useful option. It works great when you are shooting photos with the main subject in the middle of the frame. This metering mode is useful when photographing a dark subject against a bright background, or a light subject against a dark background. It works especially well for portraits where you want to preserve the background detail while exposing correctly for the subject.

With Center-weighted metering, you can get consistent results without worrying about the adjustments in exposure settings that sometimes result when using Matrix metering.

You can change the center-weighted circle diameter in CSM b4, which I explain in more detail in Chapter 3.

Spot

In Spot metering mode, the camera does just that: meters only a spot. This spot is only 3mm in diameter and only accounts for 2 percent of the frame. The spot is linked to the active focus point, which is good, so you can focus and meter your subject at the same time, instead of metering the subject, pressing AE-L (Auto-Exposure Lock), and then recomposing the photo. The D7000 has 39 focus points, so it's like having 39 spot meters to choose from throughout the scene.

Choose Spot metering when the subject is the only thing in the frame that you want the camera to expose for. You select the spot meter to meter a precise area of light within the scene. This is not necessarily tied to the subject. For example, when you photograph a subject on a completely white or black background, you need not be concerned with preserving detail in the background; therefore, exposing just for the subject works out perfectly. This mode works well for concert photography, where the musician or singer is lit by a bright spotlight. You can capture every detail of the subject and just let the shadow areas go black.

 When you use a non-CPU lens with Spot metering, the center spot is automatically selected.

Focus Modes

The Nikon D7000 has four focus modes: Auto (AF-A) Continuous (AF-C), Single (AF-S), and Manual (M). Each mode is useful for specific types of shooting conditions, from sports to still-life photographs. Nikon has changed the focus mode selector switch from previous models. You can switch from Manual to AF simply by flipping the switch. To switch between AF-A, AF-C, or AF-S, press the button in the center of the switch and rotate the Main Command dial. Looking through the viewfinder you can see which mode the camera is set to.

How the D7000 autofocus works

The D7000 has a completely new AF system, the Multi-CAM 4800 DX with 39 focus points, 9 of which are cross type sensor, providing the ability to detect contrast for focusing purposes.

Simplified, the Multi-CAM 4800DX AF works by reading contrast values from a sensor inside the camera's viewing system. The D7000 employs two sensor types: cross and horizontal. As you may have guessed, cross-type sensors are shaped like a cross while horizontal sensors are shaped like a horizontal line. You can think of them like plus and minus signs. Cross-type sensors are able to read the contrast in two directions, horizontally and vertically. Horizontal sensors can only interpret contrast in one direction. (When the camera is positioned in portrait orientation, the horizontal sensors are positioned vertically.)

Cross-type sensors can evaluate for focus much more accurately than horizontal sensors, but horizontal sensors can do it a bit more quickly (provided that the contrast

runs in the right direction). Cross-type sensors require more light to work properly so horizontal sensors are also included in the array to speed up the AF, especially in low-light situations.

Phase detection

The AF system on the D7000 works by using *phase detection*, which is determined by a sensor in the camera's body. Phase detection is achieved by using a beam splitter to divert light that is coming from the lens to two optical prisms that send the light as two separate images to the AF sensor in the D7000. This creates a type of rangefinder where the base is the same as the diameter or aperture of the lens. The larger the length of the base, the easier it is for the rangefinder to determine whether the two images are "in phase" or in focus. This is why lenses with wider maximum apertures focus faster than lenses with smaller maximum apertures. This is also why the AF usually can't work with slower lenses coupled with a teleconverter, which reduces the effective aperture of the lens. The base length of the rangefinder images is simply too small to allow the AF system to determine the proper focusing distance. The AF sensor reads the contrast, or phase difference between the two images that are being projected on it. This is the primary way that the D7000 AF system works. This type of focus is also referred to as SIR-TTL, or Secondary Image Registration-Through the Lens, given the AF sensor relies on a secondary image, as opposed to the primary image that is projected into the viewfinder from the reflex mirror.

Contrast detection

Contrast detection focus is only used by the D7000 when you use Live View mode and video. This is the same method smaller compact digital cameras use to focus. Contrast detection focus is slower and uses the image sensor itself to determine whether the subject is in focus. It is a relatively simple operation in which the sensor detects the contrast between different subjects in the scene. The camera does this by moving the lens elements until sufficient contrast is achieved between the pixels that lie under the selected focus point. With contrast detection, a greater area of the frame can be focused upon, meaning you can set the focus area to anywhere within the scene.

Continuous (AF-C)

When the camera is set to Continuous AF (AF-C), the camera continues to focus as long as the shutter is pressed halfway (or the AE-L/AF-L button is set to AF-ON in CSM f5). If the subject moves, the camera activates Predictive Focus Tracking. Predictive Focus allows the camera to track the subject and maintain focus by attempt-ing to predict where the subject will be when the shutter is released. When the camera

is in AF-C mode, it fires when the Shutter Release button is fully depressed, whether the subject is in focus or not. This custom AF setting is known as Release Priority. If you want to be sure that the scene is in focus before the shutter is released, you can change the setting to Focus Priority. When the Focus Priority option is selected, the camera continues to focus while the Shutter Release button is pressed but the shutter releases only when the subject is in focus. This may cause your frame rate to slow down. You can choose between Focus and Release Priority in CSM a1. This is the AF-C mode you want to use when shooting sports or any subject that may be moving erratically.

Single (AF-S)

In Single AF, or AF-S mode (not to be confused with the lens designation), the camera focuses when the Shutter Release button is pressed halfway. When the camera achieves focus, the focus locks. The focus remains locked until the shutter is released or the Shutter Release button is no longer pressed. By default, the camera does not fire unless focus has been achieved (Focus Priority), but you can change this to Release Priority in CSM a2. This allows you to take a photo whether the camera has achieved focus or not. I recommend sticking with Focus Priority for the Single-servo AF (AF-S) mode and using Release Priority for Continuous-servo AF (AF-C) mode. The AF-S mode is the best mode to use when shooting portraits, landscapes, or other photos in which the subject is relatively static.

Using this mode helps ensure that you have fewer out-of-focus images.

Auto (AF-A)

This focus mode was originally introduced with Nikon's entry-level cameras, but has moved up to the D7000. When you use this mode the D7000's AF system automatically selects AF-C or AF-S by determining whether the subject is moving. This mode works adequately when shooting snapshots, but I wouldn't count on it to work perfectly in situations where focus is critical.

Manual (M)

When set to Manual (M) mode, the AF system on the D7000 is off. You achieve focus by rotating the focus ring of the lens until the subject appears sharp as you look through the viewfinder. You can use the Manual focus setting when shooting still-life photographs or other nonmoving subjects, when you want total control of the focus, or simply when you are using a non-AF lens. You may want to note that the camera shutter releases regardless of whether the scene is in focus.

When using the Manual focus setting, the D7000 offers a bit of assistance in the way of an electronic rangefinder. The rangefinder shows that you are in focus by displaying a green dot in the lower-left corner of the viewfinder. In addition the rangefinder has two arrows, one on either side of the green dot. If the arrow to the right is lit the focus is behind the subject; the arrow to the left indicates that the focus is in front of the subject. You still need to choose a focus point so that the camera can determine where the subject is in the frame so that the rangefinder can work properly.

Autofocus Area Modes

The D7000 has four AF-area modes to choose from: Single-point AF, Dynamic-area AF, 3D-tracking, and Auto-area AF. Each one is useful in different situations and can be modified to suit your needs for various shooting situations. To change the AF-area mode, press the AF mode button and rotate the Sub-command dial.

As discussed earlier in the chapter, the D7000 employs an impressive 39 separate AF points. The 39 AF points can be used individually in Single-area AF mode or they can be set to use in groups of 9, 21, or 39 in Dynamic-area AF mode.

The D7000 can also employ 3D-tracking, which enables the camera to automatically switch focus points and maintain sharp focus on a moving subject as it crosses the frame. 3D-tracking is made possible by the camera recognizing color and light information and using it to track the subject.

Nikon's Scene Recognition System uses the 2016-pixel RGB sensor to recognize color and lighting patterns in order to determine the type of scene that you are photographing. This enables the AF to work faster than in previous Nikon dSLRs, and it also helps the D7000 achieve more accurate exposure and white balance.

Single-point AF

Single-point AF area mode is the easiest mode to use when you shoot slow-moving or completely still subjects. You can press the Multi-selector up, down, left, right, or diagonally to choose one of the AF points. The camera only focuses on the subject if it is in the selected AF area. Once the point is selected, you can lock it in by rotating the focus point lock switch right below the Multi-selector.

By default, Single-area AF allows you to choose from any one of the 39 AF area points. Sometimes selecting from this many points can slow you down; this is why the D7000 also allows you to change the number of selectable points to a more widely spaced

array of 11 focus points. Anyone who has used a D90 will be immediately familiar with the 11-point pattern. You can choose the amount of focus points in CSM a6.

Switching from 39 points to 11 points can speed up your shooting process when using Single-area AF mode. I often use 11 points when shooting concerts because I don't need to be super accurate on my focus point; this allows me to move the focus point to the preferred area in less than half of the button pushes it takes when using 39 points.

Dynamic-area AF

Dynamic-area AF mode also allows you to select the AF point manually, but unlike Single-area AF, the remaining unselected points remain active; this way if the subject happens to move out of the selected focus area, the camera's highly sophisticated autofocus system can track it throughout the frame. You can set the Dynamic-area AF to function with 9, 21, or 39 points by pressing the AF-mode button and rotating the Sub-command dial. The easiest way to see which mode you're selecting is by looking in the viewfinder. You can also see the mode in the LCD control panel and the Info display.

When you set the focus to AF-S, or Single AF, mode (discussed earlier in the chapter), the mode operates exactly the same as if you were using Single-area AF. To take advantage of Dynamic-area AF, the camera must be set to the AF-C, or Continuous AF, mode.

9 points

When your D7000 is set to the 9-point option, you can select any one of the camera's 39 AF points to be the primary focus point. If your subject moves out of the selected point, the AF system uses the eight AF points immediately surrounding the selected point to achieve focus. Use this setting for more predictable sports such as baseball. Baseball players typically run in a straight line and you don't need many points for AF coverage.

21 points

As with the 9-point area AF mode, you can select the primary focus point from any one of the 39 points. The camera then uses information from the surrounding 20 points if the subject moves away from the selected focus area. The 21-point area gives you a little more leeway with moving subjects because the active AF areas are in a larger pattern. This mode is good for shooting sports with a lot of action, such as

soccer or football. Players are a bit more unpredictable and the larger coverage helps you maintain focus when the player cuts left or right. However, the 21-point coverage isn't so large that the camera's AF doesn't tend to jump to other players.

39 points

The 39-point area AF mode gives you the widest area of active focus points. You can select the primary focus point the same way you do with the 9-point and 21-point options. The camera then keeps the surrounding 38 points active in case the subject leaves the selected focus area. This mode is best for situations where there is a lone subject against a plain background, such as a bird, or even an airplane, against a plain blue sky or a single person against a simple background.

 When using Dynamic-area AF with 21 or 39 points, you may notice that AF takes a little longer to work given the processor in the D7000 has to sample more points.

3D-tracking

This mode has all 39 AF points active. You select the primary AF point, but if the subject moves, the camera uses 3D-tracking to automatically select a new primary AF point. 3D-tracking is accomplished by the camera using distance and color information from the area immediately surrounding the focus point. The camera uses this information to determine what the subject is, and if the subject moves, the camera selects a new focus point. This mode works very well for subjects moving unpredictably; however, you need to be sure that the subject and the background aren't similar in coloring. When you photograph a subject that has a color that is similar to the background, the camera may lock focus on the wrong area, so use this mode carefully.

Auto-area AF

Auto-area AF is exactly what it sounds like: The camera automatically determines the subject and chooses one or more AF points to lock focus. Due to the D7000's Scene Recognition System, when the camera is used with Nikkor D- or G-type lenses, it is able to recognize human subjects. This means that the camera has a better chance of focusing where you want it than accidentally focusing on the background when shooting a portrait. Normally, I tend not to use a fully automatic setting such as this, but I find it works reasonably well when you shoot candid photos. When the camera is set to Single-servo AF (AF-S) mode, the active AF points light up in the viewfinder for about 1 second when the camera attains focus; when it is set to Continuous AF (AF-C) mode, no AF points appear in the viewfinder.

 If you're really curious about knowing which AF point was selected, you can view the AF point while reviewing the image on your LCD. To do this, go to the Playback menu, select Display mode, and select the focus point under Basic photo info. Be sure to highlight Done and press OK to lock in the setting. When the image is played back, the active focus points will be overlaid. The focus points can also be viewed with Nikon Capture NX 2 and ViewNX 2 software.

ISO Sensitivity

ISO, which stands for *International Organization for Standardization,* is the rating for the speed of film, or in digital terms, the sensitivity of the sensor. The ISO numbers are standardized, which allows you to be sure that when you shoot at ISO 100, you get the same exposure no matter what camera you are using.

You can set the ISO very quickly on the D7000 by pressing and holding the ISO button and rotating the Main Command dial until the desired setting appears in the LCD control panel. As with other settings for controlling exposure, the ISO can be set in 1/3- or 1/2-stop increments. You can choose the ISO increments in CSM b1.

The D7000 has a native ISO range of 100 to 6400. In addition to these standard ISO settings, the D7000 also offers some settings that extend the available range of the ISO so you can shoot in very bright or very dark situations. These are labeled as H (high speed). By default, the H option is set in 1/3-stop adjustments up to H1. The options are as follows:

▶ **H0.3, H0.7, and H1.0.** These settings give you up to ISO 12800 in 1/3 steps.

▶ **H2.** This setting isn't adjustable. You get one H2 setting that is equivalent to ISO 25600.

You can also set the ISO in the Shooting menu under the ISO sensitivity settings option.

 When CSM b1 is set to half step, you have the option of selecting H0.5.

 Using the H settings will not produce optimal results. It can cause your images to have increased amounts of digital noise.

Auto ISO

The D7000 also offers a feature where the camera adjusts the ISO automatically for you when there isn't enough light to make a proper exposure. Auto ISO is meant to free you from making decisions about when to raise the ISO. You can set the Auto ISO in the Shooting menu under the ISO sensitivity settings option.

Be default, when Auto ISO is turned on the camera will choose the ISO settings from the native ISO range of 100-6400 in 1/3 stop settings. If you manually raise the shutter speed, however, the camera will not choose any settings lower than what the ISO is set to. For example, if you manually change the ISO setting to 800 by pressing the ISO button and rotating the Main Command dial, the Auto ISO feature will not select an ISO setting lower than ISO 800 no matter how bright the scene is.

Additionally, the D7000 allows you to set the maximum sensitivity of the Auto ISO feature. This enables you to decide how high your ISO settings go so that you can more easily control the noise in your images. For the most part, I set the maximum sensitivity to 3200.

Initially I was skeptical of this feature, but I began using it when the D700 was released and I have continued to use it on all subsequent models because Nikon's images are excellent at high ISO settings on all current cameras.

Be sure to set the following options in the Shooting menu/ISO sensitivity settings:

▶ **Maximum sensitivity.** Choose an ISO setting that allows you to get an acceptable amount of noise in your image. If you're not concerned about noisy images, then you can set it all the way up to H2. If you need your images to have less noise, you can choose a lower ISO; you can choose any setting from ISO 200 to H2 in one-stop increments.

▶ **Minimum shutter speed.** This setting determines when the camera adjusts the ISO to a higher level. At the default, the camera bumps up the ISO when the shutter speed falls below 1/30 second. If you're using a longer lens or you're photographing moving subjects, you may need a faster shutter speed. In that case, you can set the minimum shutter speed up to 1/4000 second. On the other hand, if you're not concerned about camera shake, or if you're using a tripod, you can set a shutter speed as slow as 1 second.

 The minimum shutter speed is only taken into account when using Programmed Auto or Aperture Priority modes.

Noise reduction

Noise starts appearing in images taken with the D7000 when you're shooting above ISO 1600 or using long exposure times. For this reason, most camera manufacturers have built-in noise reduction (NR) features. The D7000 has two types of NR: Long exposure NR and High ISO NR. Each one approaches the noise differently to help reduce it.

 For more detailed information on digital noise, see Chapter 5.

Long exposure NR

When Long exposure NR is turned on, the camera runs a noise reduction algorithm to any shot taken with a long exposure (8 seconds or more). Basically how this works is the camera takes another exposure, this time with the shutter closed, and compares the noise from this dark image to the original one. The camera then applies the NR. The noise reduction takes about the same amount of time to process as the length of the shutter speed; therefore, expect just about double the time it takes to make one exposure. While the camera is applying NR, the LCD control panel blinks the message "Job nr." You cannot take additional images until this process is finished. If you switch the camera off before the NR is finished, no noise reduction is applied.

You can turn Long exposure NR on or off by accessing it in the Shooting menu.

High ISO NR

When High ISO NR is turned on, any image shot at ISO 800 or higher is run through the noise reduction algorithm.

This feature works by reducing the coloring in the chrominance of the noise and combining that with a bit of softening of the image to reduce the luminance noise. You can set how aggressively this effect is applied by choosing the High, Normal, or Low settings.

You may also want to be aware that High ISO NR slows down the processing of your images; therefore the capacity of the buffer can be reduced, causing your frame rate to slow down when you're in Continuous shooting mode.

When the High ISO NR is set to off, the camera still applies NR to images shot at 1600 and higher, although the amount of NR is less than when the camera is set to Low with NR on.

 When shooting in NEF (RAW), no actual noise reduction is applied to the data, but NR is tagged in the file. For the in-camera NR to be applied to the final image the RAW file must be opened and edited using Nikon software.

For the most part, I do not use either of these in-camera NR features. In my opinion, even at the lowest setting, the camera is very aggressive in the NR, and for that reason, there is a loss of detail. For most people, this is a minor quibble and not very noticeable, but for me, I'd rather keep all the available detail in my images and apply noise reduction in post-processing. This way I can decide how much to reduce the chrominance and luminance rather than letting the camera do it. The camera doesn't know whether you're going to print the image at a large size or just display it on-screen. I say it's better to be safe than sorry.

 Photoshop's Adobe Camera Raw and other image-editing software includes their own proprietary Noise Reduction.

White Balance

Light, whether from sunlight, a light bulb, a fluorescent light, or a flash, has a specific color. This color is measured using the Kelvin scale, and the measurement is also known as *color temperature*. The white balance (WB) allows you to adjust the camera so your images can look natural no matter what the light source. Given white is the color that is most dramatically affected by the color temperature of the light source, this is what you base your settings on; hence the term *white balance*. You can change the white balance in the Shooting menu or by pressing the WB button on the top of the camera and rotating the Main Command dial.

The term *color temperature* may sound strange to you. "How can a color have a temperature?" you might ask. Once you know about the Kelvin scale, things make a little more sense.

What is Kelvin?

Kelvin is a temperature scale, normally used in the fields of physics and astronomy, where absolute zero (0K) denotes the absence of all heat energy. The concept is based on a mythical object called a *black body radiator*. Theoretically, as this black body radiator is heated, it starts to glow. As it is heated to a certain temperature, it

glows a specific color. It is akin to heating a bar of iron with a torch. As the iron gets hotter it turns red, then yellow, and then eventually white before it reaches its melting point (although the theoretical black body does not have a melting point).

The concept of Kelvin and color temperature is tricky as it is the opposite of what you likely think of as *warm* and *cool* colors. For example, on the Kelvin scale, red is the lowest temperature, increasing through orange, yellow, white, and to shades of blue, which are the highest temperatures. Humans tend to perceive reds, oranges, and yellows as warmer and white and bluish colors as colder. However, physically speaking, as defined by the Kelvin scale, the opposite is true.

White balance settings

Now that you know a little about the Kelvin scale, you can begin to explore the white balance settings. The reason that white balance is so important is it helps ensure that your images have a natural look. When you're dealing with different lighting sources, the color temperature of the source can have a drastic effect on the coloring of the subject. For example, a standard light bulb casts a very yellow light; if the color temperature of the light bulb is not compensated for by introducing a bluish cast, the subject can look overly yellow and not quite right.

In order to adjust for the colorcast of the light source, the camera introduces a colorcast of the complete opposite color temperature. For example, to combat the green color of a fluorescent lamp, the camera introduces a slight magenta cast to neutralize the green.

Here are the D7000's white balance settings:

▶ **Auto.** This setting is good for most circumstances. The camera takes a reading of the ambient light and makes an automatic adjustment. This setting also works well when you're using a Nikon CLS compatible Speedlight because the color temperature is calculated to match the flash output. I recommend using this setting as opposed to the Flash WB setting. In addition you can choose from two Auto settings in the Shooting menu under the WB settings.

 • **Auto1 Normal.** This is your standard setting. It attempts to get a neutral white balance setting.

 • **Auto2 Keep warm lighting colors.** This is a brand new feature introduced with the D7000. This gives the image a slightly warmer tone than with the regular Auto1 setting. This can actually make a lot of images look a little

more natural in some cases. I recommend using this option outside at high noon, but I don't recommend using it under incandescent lighting as it can cause the images to look a little too yellow.

▶ **Incandescent.** Use this setting when the lighting is from a standard household light bulb.

▶ **Fluorescent.** Use this setting when the lighting is coming from a fluorescent-type lamp. You can also adjust for different types of fluorescent lamps, including high-pressure sodium and mercury-vapor lamps. To make this adjustment, go to the Shooting menu and choose White Balance, and then choose fluorescent. From there, use the Multi-selector to choose one of the seven types of lamps.

▶ **Direct sunlight.** Use this setting outdoors in the sunlight.

▶ **Flash.** Use this setting when using the built-in Speedlight, a hot-shoe Speedlight, or external strobes.

▶ **Cloudy.** Use this setting under overcast skies.

▶ **Shade.** Use this setting when you are in the shade of trees or a building or even under an overhang or a bridge — any place where the sun is out but is being blocked.

▶ **Choose color temp.** This setting allows you to adjust the white balance to a particular color temperature that corresponds to the Kelvin scale. You can set it anywhere from 2500K (Red) to 10000K (Blue).

▶ **Preset manual.** This setting allows you to choose a neutral object to measure for the white balance. It's best to choose an object that is either white or light gray. There are some accessories that you can use to set the white balance. One accessory is a gray card, which is included with this book. Simply put the gray card in the scene and balance off of it. Another accessory is the Expodisc. You attach it to the front of your lens like a filter, and then point the lens at the light source and set your WB. This setting (PRE) is best used under difficult lighting situations, such as when there are two light sources lighting the scene (mixed lighting). I usually use this setting when photographing with my studio strobes.

Figures 2.2 to 2.8 show the difference that white balance settings can make to your image.

2.2 Auto, 4850K

2.3 Incandescent, 2850K

2.4 Fluorescent, 3800K

2.5 Flash, 5500K

2.6 Daylight, 5500K

2.7 Cloudy, 6500K

2.8 Shade, 7500K

Picture Controls

With the release of the D3 and the D300, Nikon introduced its Picture Control System. The D7000 is also equipped with this handy option. This feature allows you to quickly adjust your image settings, including sharpening, contrast, brightness, saturation, and hue based on your shooting needs. This is great for photographers who shoot with more than one camera and do batch processing to their images. It allows both cameras to record the images with the same settings so global image correction can be applied without worrying about differences in color, tone, saturation, and sharpening.

Picture Controls can also be saved to one of the memory cards and imported into Nikon's image-editing software, Capture NX 2 or ViewNX 2. You can then apply the settings to RAW images or even to images taken with other camera models. You can also save and share these Picture Control files with other Nikon users, either by importing them to Nikon software or loading them directly to another camera.

The D7000 comes with six Picture Controls already loaded on the camera, and you can customize up to nine Picture Control settings in-camera.

Right out of the box the D7000 comes with six Picture Controls installed:

▶ **SD.** This is the Standard setting. It applies slight sharpening and a small boost of contrast and saturation. This is the recommended setting for most shooting situations.

▶ **NL.** This is the Neutral setting. It applies a small amount of sharpening and no other modifications to the image. This setting is preferable if you do extensive post-processing to your images.

▶ **VI.** This is the Vivid setting. It gives your images a fair amount of sharpening, and the contrast and saturation is boosted highly, resulting in brightly colored images. This setting is recommended for printing directly from the camera or CF card as well as for shooting landscapes. Personally, I feel that this mode is a little too saturated and often results in unnatural color tones. This mode is not ideal for portrait situations, as skin tones are not typically reproduced with accuracy.

▶ **MC.** This is the Monochrome setting. As the name implies, this option makes the images monochrome. This doesn't simply mean black and white; you can also simulate photo filters and toned images such as sepia, cyanotype, and more. You can also adjust the settings for sharpening, contrast, and brightness.

▶ **PT.** This is the Portrait setting. It gives you just a small amount of sharpening, which gives the skin a smoother appearance. The colors are muted just a bit to help achieve realistic skin tones.

▶ **LS.** This is the Landscape setting. Obviously, this setting is for shooting land-scapes and natural vistas. It appears to me that this is very close to the Vivid Picture Control with a little more boost added to the blues and greens.

You can customize all the Original Picture Controls to fit your personal preferences. You can adjust the settings to your liking, giving the images more sharpening and less contrast or a myriad of other options.

 Although you can adjust the Original Picture Controls, you cannot save over them, so there is no need to worry about losing them.

There are a few different customizations to choose from:

▶ **Quick adjust.** This option works with SD, VI, PT, and LS. It exaggerates or de-emphasizes the effect of the Picture Control in use. Quick adjust can be set from ±2.

▶ **Sharpness.** This controls the apparent sharpness of your images. You can adjust this setting from 0 to 9, with 9 being the highest level of sharpness. You can also set this to Auto (A) to allow the camera's imaging processor to decide how much sharpening to apply.

▶ **Contrast.** This setting controls the amount of contrast your images are given. In photos of scenes with high contrast (sunny days), you may want to adjust the contrast down; in scenes with low contrast, you may want to add some contrast by adjusting the settings up. You can set this from ±3 or to A.

▶ **Brightness.** This adds or subtracts from the overall brightness of your image. You can choose 0 (default) + or –.

▶ **Saturation.** This setting controls how vivid or bright the colors in your images are. You can set this between ±3 or to A. This option is not available in the MC setting.

 The Brightness and Saturation option is unavailable when Active D-Lighting is turned on.

▶ **Hue.** This setting controls how your colors look. You can choose ±3. Positive numbers make the reds look more orange, the blues look more purple, and the greens look more blue. Choosing a negative number causes the reds to look more purple, the greens to look more yellow, and the blues to look more green. This setting is not available in the MC Picture Control setting. I highly recommend leaving this in the default setting of 0.

▶ **Filter Effects.** This setting is only available when you set your D7000 to MC. The monochrome filters approximate the types of filters traditionally used with black-and-white film. These filters increase contrast and create special effects. The options are

- **Yellow.** Adds a low level of contrast. It causes the sky to appear slightly darker than normal and anything yellow to appear lighter. It is also used to optimize contrast for brighter skin tones.

- **Orange.** Adds a medium amount of contrast. The sky will appear darker, giving greater separation between the clouds. Orange objects appear light gray.

- **Red.** Adds a great amount of contrast, drastically darkening the sky while allowing the clouds to remain white. Red objects appear lighter than normal.

- **Green.** Darkens the sky and lightens any green plant life. This color filter can be used for portraits as it softens skin tones.

▶ **Toning.** Toning adds a color tint to your monochrome (black and white) images. Toning options are

- **B&W.** The black-and-white option simulates the traditional black-and-white film prints done in a darkroom. The camera records the image in black, white, and shades of gray. This mode is suitable when the color of the subject is not important. You can use it for artistic purposes or, as with the sepia option, to give your image on antique or vintage look.

2.9 Black-and-white

53

- **Sepia.** The sepia color option duplicates a photographic toning process that is done in a traditional darkroom using silver-based black-and-white prints. Sepia-toning a photographic image requires replacing the silver in the emulsion of the photo paper with a different silver compound, thus changing the color, or *tone*, of the photograph. Antique photographs generally underwent this type of toning; therefore the sepia color option gives the image an antique look. The images look reddish-brown.

2.10 Sepia

You may want to use this option to convey a feeling of antiquity or nostalgia to your photograph. This option works well with portraits as well as still-life and architectural images. You can also adjust the saturation of the toning from 1 to 7, with 4 being the default and the middle ground.

- **Cyanotype.** The cyanotype is another old photographic printing process. When the image is exposed to the light, the chemicals that make up the cyanotype turn deep blue. This method was used to create the first blueprints and was later adapted to photography. The images taken while in this setting are in shades of cyan. Because cyan is considered to be a cool color, this mode is also referred to as cool. You can use this mode to make very interesting and artistic images. You can also

2.11 Cyanotype

adjust the saturation of the toning from 1 to 7, with 4 being the default setting.

- **Color toning.** You can also choose to add colors to your monochrome images. Although this is similar to the sepia and cyanotype toning options, this type of toning isn't based on traditional photographic processes. It is simply adding a colorcast to a black-and-white image. There are seven color options you can choose from: red, yellow, green, blue-green, blue, purple-blue, and red-purple. As with sepia and cyanotype, you can adjust the saturation of these toning colors.

2.12 Green toning

To customize an Original Picture Control, follow these steps:

1. **Go to the Set Picture Control option in the Shooting menu.** Press the Multi-selector right.

2. **Choose the Picture Control you want to adjust.** Choosing the NL or SD option allows you to make smaller changes to the effect because they have relatively low settings (contrast, saturation, etc.). To make larger changes to color and sharpness, choose the VI mode. To make adjustments to monochrome images, choose MC. Press the Multi-selector right.

3. **Press the Multi-selector up or down to highlight the setting you want to adjust (sharpening, contrast, brightness, and so on).** When the setting is highlighted, press the Multi-selector left or right to adjust the settings. Repeat this step until you've adjusted the settings to your preferences.

4. **Press OK to save the settings.**

To return the Picture Control to the default setting, follow the preceding Steps 1 and 2 and press the Delete button. A dialog box appears, asking for confirmation. Select Yes to return to the default setting or No to continue to use the Picture Control with the current settings.

 When the original Picture Control settings have been altered, an asterisk is displayed with the Picture Control setting (SD*, VI*, and so on).

To save a Custom Picture Control, follow these steps:

1. **Go to the Manage Picture Control option in the Shooting menu.** Press the Multi-selector right.

2. **Press the Multi-selector up or down to select Save/edit.** Press the Multi-selector right.

3. **Choose the Picture Control to edit.** Press the Multi-selector right.

4. **Press the Multi-selector up or down to highlight the setting you want to adjust (sharpening, contrast, brightness, and so on).** When the setting is highlighted, press the Multi-selector left or right to adjust the settings. Repeat this step until you've adjusted the settings to your preferences.

5. **Press OK to save the settings.**

6. **Use the Multi-selector to highlight the Custom Picture Control you want to save to.** You can store up to nine Custom Picture Controls; they are labeled C-1 through C-9. Press the Multi-selector right.

7. **When the Rename Menu appears, press the Zoom out button and press the Multi-selector left or right to move the cursor to any of the 19 spaces in the name area of the dialog box.** New Picture Controls are automatically named with the Original Picture Control name and a two-digit number (for example, STANDARD _02 or VIVID_03).

8. **Press the Multi-selector (without pressing the Zoom out button) to select letters in the keyboard area of the dialog box.** Press the Multi-selector center button to set the selected letter and press the Delete button to erase the selected letter in the Name area. Once you type the name you want, press OK to save it. The Custom Picture Control is then saved to the Picture Control menu and can be accessed through the Set Picture Control option in the Shooting menu.

To return the Picture Control to the default setting, follow the preceding Steps 1 through 3 and press the Delete button. A dialog box appears, asking for confirmation; select Yes to return to the default setting or No to continue to use the Picture Control with the current settings.

You can rename or delete your Custom Picture Controls at any time by using the Manage Picture Control option in the Shooting menu. You can also save the Custom Picture Control to your memory card so that you can import the file to Capture NX 2, or ViewNX 2.

To save a Custom Picture Control to the memory card, follow these steps:

1. **Go to the Manage Picture Control option in the Shooting menu.** Press the Multi-selector right.

2. **Press the Multi-selector up or down to highlight the Load/save option.** Press the Multi-selector right.

3. **Press the Multi-selector up or down to highlight the Copy to card option.** Press the Multi-selector right.

4. **Press the Multi-selector up or down to select the Custom Picture Control to copy.** Press the Multi-selector right.

5. **Select a destination on the memory card to copy the Picture Control file to.** There are 99 slots in which to store Picture Control files. The Custom Picture Controls are saved to the Primary memory card.

6. **After you choose the destination, press the Multi-selector right.** A message appears confirming that the file has been stored to your memory card.

After you copy your Custom Picture Control file to your card, you can import the file to the Nikon software by mounting the memory card to your computer using a card reader or USB camera connection. See the software user's manual for instructions on importing to the specific program.

You can also upload Picture Controls that are saved to a memory card to your camera. Follow these steps:

1. **Go to the Manage Picture Control option in the Shooting menu.** Press the Multi-selector right.

2. **Press the Multi-selector up or down to highlight the Load/save option.** Press the Multi-selector right.

3. **Press the Multi-selector up or down to highlight the Copy to camera option.** Press the Multi-selector right.

4. **Select the Picture Control to copy.** Press OK or the Multi-selector right to confirm.

5. **The camera then displays the Picture Control settings.** Press OK. The camera automatically displays the Save As menu.

6. **Select an empty slot to save to (C-1 through C-9).**

7. **Rename the file if necessary.** Press OK.

JPEG

JPEG, which stands for *Joint Photographic Experts Group*, is a method of compressing photographic files as well as the name of the file format that supports this type of compression. The JPEG is the most common type of file used to save images on digital cameras. Due to the small size of the file that is created and the relatively good image quality it produces, JPEG has become the default file format for most digital cameras.

The JPEG compression format was developed because of the immense file sizes that digital images produce. Photographic files contain millions upon millions of separate colors and each individual color is assigned a number; therefore the files contain vast amounts of data, which makes them quite large. In the early days of digital imaging, the huge file sizes and relatively small storage capacity of computers made it almost impossible for most people to store images. Less than 10 years ago, a standard laptop hard drive was only about 5GB. For people to efficiently store images, a file that could be compressed without losing too much of the image data during reconstruction was needed. Enter the Joint Photographic Experts Group. This group of experts came in and designed what is now affectionately known as the JPEG.

JPEG compression is a very complicated process involving many mathematical equations, but the steps involved can be explained quite simply. The first thing the JPEG process does is break down the image into 8 × 8-pixel blocks. The RGB color information in each 8 × 8 block is then treated to a color space transform where the RGB values are changed to represent luminance and chrominance values. The luminance value describes the brightness of the color while the chrominance value describes the hue.

Once the luminance and chrominance values have been established, the data is run through what is known as the *Discrete Cosine Transform* (DCT). This is the basis of the compression algorithm. Essentially the DCT takes the information for the 8 × 8

block of pixels and assigns it an average number because, for the most part, the changes in the luminance and chrominance values will not be drastic in such a small part of the image.

The next step in the process is *quantizing* the coefficient numbers that were derived from the luminance and chrominance values by the DCT. Quantizing is basically the process of rounding off the numbers. This is where file compression comes in. How much the file is compressed depends on the *quantization matrix*. The quantization matrix defines how much the information is compressed by dividing the coefficients by a quantizing factor. The larger the number of the quantizing factor, the higher the quality (therefore, the less compression). This is basically what is going on in Photoshop when you save a file as a JPEG and the program asks you to set the quality; you are simply defining the quantizing factor.

Once the numbers are quantized, they are run through a binary encoder that converts the numbers to the ones and zeros our computers love so well. You now have a compressed file that is on average about one-fourth of the size of an uncompressed file.

The one important consideration with JPEG compression is that it is what's known as a *lossy* compression. When the numbers are quantized, they lose information. For the most part, this loss of information is imperceptible to the human eye. A bigger issue to consider with JPEGs comes from what is known as *generation loss*. Every time a JPEG is opened and resaved, a small amount of detail is lost. After multiple openings and savings, the image's quality starts to deteriorate, as less and less information is available. Eventually the image may start to look pixilated or jagged (this is known as a *JPEG artifact*). Obviously, this can be a problem, but the JPEG would have to be opened and resaved many hundreds of times before you would notice a drop in image quality, provided you save at high-quality settings.

Image Size

When saving to JPEG format, the D7000 allows you to choose an image size. Reducing the image size is like reducing the resolution on your camera; it allows you to fit more images on your card. The size you choose depends on what your output is going to be. If you know you will be printing your images at a large size, you definitely want to record large JPEGs. If you're going to print at a smaller size (8 × 10 or 5 × 7), you can get away with recording at the Medium or Small setting. Image size is expressed in pixel dimensions. The large JPEG setting records your images at 4928 × 3264 pixels;

this gives you a file that is equivalent to 16.2 megapixels. Medium size gives you an image of 3696 × 2448 pixels, which is in effect the same as a 9-megapixel camera. The small size gives you a dimension of 2464 × 1632 pixels, which gives you about a 4-megapixel image.

You can quickly change the image size by pressing the QUAL button and rotating the Sub-command dial on the front of the camera. You can also change the image size in the Shooting menu by selecting the image size menu option.

You can only change image size when using the JPEG file format. RAW files are recorded only at the largest size.

Image Quality

With JPEGs, in addition to the size setting, which changes the pixel dimension, you have the Quality setting, which is the setting that decides how much of a compression ratio is applied to your JPEG image. Your choices are Fine, Normal, and Basic. JPEG Fine files are compressed to approximately 1:4, Normal files are compressed to about 1:8, and Basic files are compressed to about 1:16. To change the image quality setting, simply press the QUAL button and rotate the Main Command dial. Doing this scrolls you through all the file-type options available, including RAW, Fine (JPEG), Normal (JPEG), and Basic (JPEG). You will also be able to shoot RAW and JPEG simultaneously with all the JPEG compression options available (RAW + Fine, RAW + Normal, or RAW + Basic).

NEF (RAW)

Nikon's RAW files are referred to as NEF in Nikon literature. NEF stands for *Nikon Electronic File*. RAW files contain all the image data acquired by the camera's sensor. When a JPEG is created, the camera applies different settings to the image, such as WB, sharpness, noise reduction, and so on. When the JPEG is saved, the rest of the unused image data is discarded to help reduce file size. With a RAW file, this image data is saved so it can be used more extensively in post-processing. In some ways the RAW file is like a *digital negative* because the RAW files are used in the same way as a traditional photographic negative; that is, you take the RAW information and process it to create your final image.

Although some of the same settings are tagged to the RAW file (WB, sharpening, saturation, and so on), these settings aren't fixed and applied like they are in the JPEG file. This way when you import the RAW into your favorite RAW converter you can make changes to these settings without detrimental effects.

Capturing your images in RAW allows you to be more flexible when post-processing your images and generally gives you more control over the quality of the images.

The D7000 offers a few options for saving NEF (RAW) files. They include compression and bit depth. Like JPEGs, RAW files can be compressed to save space so that you can fit more images on your memory card. You can also choose to save the RAW file with more bit depth, which can give you more available colors in your image file.

Type

Under the NEF (RAW) recording option in the Shooting menu, you can choose the type of compression you want to apply to the NEF (RAW) file or you can choose none at all. Keep in mind that with the D7000 you can save an NEF file in 12-bit or 14-bit, which will affect the number of files you can capture.

You have two options:

▶ **Lossless compressed.** Unlike JPEG compression, this algorithm loses no data information when the file is closed and stored. When the file is opened, the algorithm reverses the compression scheme and the exact same data that was saved is retrieved. This is the camera's default setting for storing RAW files. You will get a file size that is approximately 15 to 40 percent of the size of an uncompressed RAW file. You can fit about 200 of these files on a 4GB CF or SD card in Compressed NEF (RAW) 12-bit capture.

▶ **Compressed.** Similar to JPEG compression, with this algorithm some of the image data is lost when these types of files are compressed. The complex algorithms they use to create these files actually run two different compression schemes to the same file. Given our eyes perceive changes in the darker areas of images more than in the lighter areas, the image data for the shadow areas are compressed using a lossless compression while the midtones and lighter are compressed using a lossy method. This compression scheme has very little impact on the image data and allows you to be sure that you retain all your shadow detail. Using this compression scheme, your file size will be about 30 to 60 percent of the size of an uncompressed file. You can fit about 276 of these files on a 4GB CF or SD card in Compressed NEF (RAW) 12-bit capture.

Bit depth

Simply put, bit depth is how many separate colors your sensor can record. The term *bit depth* is derived from digital terminology. A bit is the smallest unit of data; it is expressed in digital language as either a 1 or a 0. Most digital images saved as JPEG or TIFF are recorded in 8 bits, or 1 byte per channel (each primary color being a separate color: red, green, and blue [RGB]), resulting in a 24-bit image. For each 8 bits there are 256 possible colors; multiply this by 3 channels and you get more than 16 million colors, which is plenty enough information to create a realistic-looking digital image. By default, the D7000 records its RAW files using a bit depth of 12 bits per channel, giving you a 36-bit image. What this means is that your sensor can recognize far more shades of color, which gives you a smoother gradation in tones, allowing the color transitions to be much smoother. In addition to the 12-bit setting, the D7000 offers the option of recording your NEF (RAW) files at 14 bits per channel, which gives you even more color information to deal with when processing your images.

All this comes with a cost: the higher the bit depth, the more information contained in the file. This makes your files bigger, especially when the camera is shooting 14-bit NEF (RAW) files, which can result in larger files. When shooting at 14 bits, the camera has much more image data to contend with, so your top frame rate is reduced by just a bit.

I find that for most applications, shooting NEF (RAW) files at 12 bits is more than enough color information. I only switch to 14 bits when shooting portraits, especially when the portraits are low-key. This helps me get much smoother transitions from the shadow areas to the highlights.

NOTE The Nikon D7000 uses a 14-bit A/D converter, so its theoretical maximum dynamic range is 14 stops. High bit depth really only helps minimize image posterization because actual dynamic range is limited by noise levels. A high bit-depth image does not necessarily mean that the image contains more colors; it just means it has the capacity to store more color data. If a digital camera has a high-precision A/D converter, it does not necessarily mean it can record a greater dynamic range. In reality, the dynamic range of a digital camera does not even come close to the A/D converter's theoretical maximum; 5 to 9 stops is generally all you can expect from the camera due to imaging sensor limitations.

RAW versus JPEG

This issue has always created a controversy in the digital imaging world: Some people say that RAW is the only way to have more flexibility in processing images, and others say if you get it right in-camera then you don't need to use RAW images. For what it's worth, both factions are right in their own way.

Choosing between RAW and JPEG basically comes down to your goal for final output or what you're using the images for. Remember that you don't have to choose one file format and stick with it. You can change the settings to suit your needs as you see fit, or you can even choose to record both RAW and JPEG simultaneously.

Some reasons to shoot JPEGs include

▶ **Small file size.** JPEGs are much smaller in size than RAW files; therefore you can fit many more of them on your memory card and later on your hard drive. If space limitations are a problem, shooting JPEG allows you to get more images in less space.

▶ **Printing straight from camera.** Some people like to print their images straight from the camera or memory card. RAW files can't be printed without first being converted to JPEG (which you can do in-camera with the D7000).

▶ **Continuous shooting.** Given JPEG files are smaller than RAW files, they don't fill up the camera's buffer as quickly, allowing you longer bursts without the frame rate slowing down.

▶ **Less post-processing.** If you're confident in your ability to get the image exactly as you want it at capture, you can save yourself time by not having to process the image in a RAW converter and save straight to JPEG.

▶ **Snapshot quality.** If you're just shooting snapshots of family events or if you only plan to post your images on the Internet, saving as JPEG will be fine.

Some reasons to shoot RAW files include

▶ **16-bit images.** The D7000 can capture RAW images in 12- or 14-bit. When converting the file using a RAW converter such as Adobe Camera Raw (ACR) or Capture NX 2, you can save your images with 16-bit color information. When the information is written to JPEG in the camera, the JPEG is saved as an 8-bit file. This gives you the option of working with more colors in post-processing. This can be extremely helpful when you're trying to save an under- or overexposed image. Bit depth is discussed in more detail earlier in the chapter.

continued

continued

▶ **White balance.** Although the WB that the camera was set to is tagged in the RAW file, it isn't fixed in the image data. Oftentimes, the camera can record a WB that isn't quite correct. This isn't always noticeable by looking at the image on the LCD screen. Changing the WB on a JPEG image can cause posterization and usually doesn't yield the best results. Because you have the RAW image data on hand, changing the WB settings doesn't degrade the image at all.

▶ **Sharpening and saturation.** As with WB, these settings are tagged in the RAW file but not applied to the actual image data. You can add sharpening and saturation (or other options, depending on your software).

▶ **Image quality.** Because the RAW file is an unfinished file, it allows you the flexibility to make many changes in the details of the image without any degradation to the quality of the image.

Setting Up the Nikon D7000

One of the great things about an upper-level camera like the D7000 is that it's highly customizable. You can tailor the D7000 options to fit your shooting style, help refine your workflow, or modify the camera settings to fit different shooting scenarios. You can assign a number of buttons to the functions you use most often. Using the My Menu feature, you can create your own personal list of menu options so that you don't have to scroll through all the menu options to get to the ones you access most frequently. Most of these options are used to change things that you don't need to change very often or quickly.

Customizing your camera settings allows you to be completely familiar with your camera, so you don't miss a shot.

Accessing Menus

You access the menus by pressing the Menu button on the back of the camera. Use the Multi-selector to scroll through the toolbar on the right side of the LCD screen. When the desired menu is highlighted in yellow, press the OK button or Multi-selector right to enter the menu. Pressing the Menu button again or tapping the Shutter Release button exits the Menu mode screen and readies the camera for shooting.

Playback Menu

You manage the images stored on your memory cards in the Playback menu. The Playback menu is also where you control how the images are displayed and what image information is displayed during review. Ten options are available from the Playback menu; I explain them in the following sections.

Delete

The Delete option allows you to delete selected images from your memory card or to delete all the images at once.

To delete selected images, follow these steps:

1. **Press the Multi-selector right, highlight Selected (this is the default), and press the Multi-selector to the right again.** The camera displays an image selection screen. You can now select the image you want to delete.

2. **Press the Multi-selector left or right to choose the image.** You can also use the Zoom in button to review the image close up before deleting. Press the Multi-selector up or down to highlight the image you want to delete,

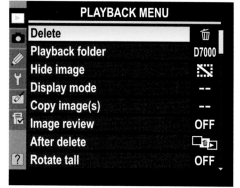

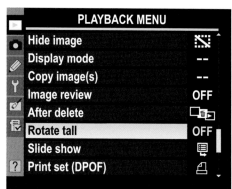

3.1 The D7000 Playback menu

and then press the center Multi-selector button to set the image for deletion; more than one image can be selected. When the image is selected for deletion, a small trashcan icon appears in the right-hand corner of the LCD screen.

3. **Press the OK button to erase the selected images.** The camera will ask you for confirmation before deleting the images.

4. **Select Yes, and then press the OK button to delete them.** To cancel the deletion, highlight No (default), and then press the OK button.

To delete all images, follow these steps:

1. **Use the Multi-selector to high-light All, and then press the OK button.** The camera will ask you for confirmation before deleting the images.

2. **Select Yes, and then press the OK button to delete them.** To cancel the deletion, highlight No (default), and then press the OK button.

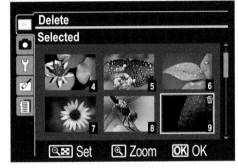

3.2 **Selecting images to delete**

Playback folder

The Playback folder menu allows you to choose which folder or folders to display images from. The Nikon D7000 automatically creates folders to store your images in. The main folder that the camera creates is called DCIM; within this folder, the camera creates a subfolder to store the images. The first subfolder the camera creates is called 100ND7000. After shooting 999 images (or if there's an image with the file-name DSC_9999), the camera automatically creates another folder called 101ND7000, and so on. Keep in mind that if you have used the memory card in another camera and have not formatted it, folders from that camera appear on the card. You have three memory card formatting choices:

▶ **ND7000.** This is the default setting. The camera only plays back images from folders that the D7000 created, ignoring folders from other cameras that may be on the memory card.

▶ **All.** This option plays back images from all folders that are on the memory card whether the D7000 created them or not.

▶ **Current.** This option displays images only from the folder that the camera is currently saving to. This feature is useful when you have multiple folders from different sessions. Using this setting allows you to preview only the most current images. You can change the current folder using the Active folder option in the Shooting menu.

Hide image

The Hide image option hides images so that they can't be viewed during playback and are protected from being deleted. To hide selected images, press the Multi-selector right, highlight Select/set (default), and then press the Multi-selector right. Use the Multi-selector to highlight the thumbnail images you wish to hide. Then press the OK button.

To display the hidden images, highlight Deselect all. The camera then asks you for confirmation before revealing the images. Select Yes, and then press the OK button to display them during playback. To cancel and continue hiding the images, highlight No (default), and then press the OK button.

Display mode

The Display mode settings allow you to customize the information that appears when you're reviewing the images that are stored on your memory card. Enter the Display mode menu by pressing the Multi-selector right. Then use the Multi-selector to highlight the option you wish to set. When the option is highlighted, press the Multi-selector right or the OK button to set the display feature. The feature is set when a check mark appears in the box to the left of the setting. Be sure to scroll up to Done and press the OK button to set the feature. If you don't do this step, the information will not appear in the display. The Display mode options include

▶ **Focus point.** Set this option to overlay the focus point on the image you are reviewing. No focus point will be displayed if the camera did not achieve focus or if Continuous Autofocus (AF-C) was used in conjunction with Auto-area AF.

▶ **Highlights.** This option shows any highlights that are blown out by causing them to blink on and off. If this happens, you may want to apply some exposure compensation or adjust your exposure. To view the highlight information in each separate color channel (RGB), press and hold the Thumbnail button while pressing the Multi-selector left or right.

▶ **RGB histogram.** Turn on this option to view the separate histograms for the Red, Green, and Blue channels along with a standard luminance histogram. The

highlights are also displayed. You can choose to view the highlights in each separate channel by pressing the Thumbnail button and pressing the Multi-selector left or right.

▶ **Data.** This option allows you to review the shooting data (metering, exposure, lens focal length, and so on).

Generally, the only Display mode option that I use is the RGB histogram. It allows me to view the histograms and the highlight detail all at once.

Copy image(s)

The Copy image(s) option allows you to copy images from memory card Slot 1 to Slot 2 and vice versa. To do this, follow these steps:

1. **Choose the Select source option from the menu.** Press the Multi-selector right to view the options. Press the Multi-selector up/down to highlight Slot 1 or Slot 2. Press OK or the Multi-selector button when ready.

2. **Next choose the Select image(s) option from the menu.** Press the Multi-selector right to view the options. The menu displays a list of the available folders on the card. Select the folder you want to copy from and press the Multi-selector right. This brings up the Default image selection submenu.

3. **From the Default image selection submenu, select one of the three options.** These options determine which images (if any) are selected by default. Once you determine which selection method you wish to use, press OK. This brings up a thumbnail display of all the images on the card. Use the Multi-selector to browse the images. When an image is highlighted, press the Multi-selector center button to set or unset the image for copying. When the image is selected for transfer, a check mark appears in the upper-left corner of the thumbnail. You can use the Zoom in button to take a closer look at the highlighted image. Press the OK button when you are finished making your selections. There are three options:

 • **Deselect all.** As you might surmise, this option selects no images for transfer. Manually select any images you wish to copy.

 • **Select all images.** This selects all images for transfer. Manually deselect any images you don't want to copy.

 • **Select protected images.** This selects only images that have been protected by pressing the Protect (key) button. You can manually select or deselect any other images.

Image review

The Image review option allows you to choose whether the image appears on the LCD screen immediately after the image is taken. When this option is turned off (the default), you can view the image by pressing the Playback button.

After delete

After delete allows you to choose which image is displayed after you have deleted an image during playback. The options include

▶ **Show next.** This is the default setting. The next image taken is displayed after the selected image is deleted. If the image deleted is the last image, the previous image is displayed.

▶ **Show previous.** After the selected image is deleted, the one taken before it is displayed. If the first image is deleted, the following image is displayed.

▶ **Continue as before.** This option allows you to continue in the order that you were browsing the images. If you were scrolling through them as they were shot, the next image is displayed (Show next). If you were scrolling through them in reverse order, the previous image is shown (Show previous).

Rotate tall

The D7000 has a built-in sensor that can tell whether the camera was rotated while the image was taken. The Rotate tall setting rotates images that are shot in portrait orientation so they display upright on the LCD screen. I usually turn this option off because the portrait orientation image appears substantially smaller when displayed upright on the LCD screen. The options include

▶ **On.** The camera automatically rotates the image to be viewed while holding the camera in the standard upright position. When this option is turned on (and the Auto image rotation is set to On in the Setup menu), the camera orientation is recorded for use in image-editing software.

▶ **Off (default).** When Auto image rotation is turned off, images taken in portrait orientation are displayed on the LCD screen sideways, in landscape orientation.

Slide show

This option allows you to display a slide show of images from the current active folder. You can use this setting to review the images that you have shot without having to use the Multi-selector. You can choose an interval of 2, 3, 5, or 10 seconds.

While the slide show is in progress, you can use the Multi-selector to skip forward or back (left or right), and view shooting information or histograms (up or down). You can also press the Menu button to return to the Playback menu, press the Playback button to end the slide show, or press the Shutter Release button lightly to return to the Shooting mode.

Pressing the OK button while the slide show is in progress pauses the slide show and offers you the option to restart the slide show, change the frame rate, or exit the slide show. Use the Multi-selector up and down to make your selection, and then press the OK button.

Print set (DPOF)

DPOF stands for *Digital Print Order Format*. This option allows you to select images to print directly from the camera. This can be used with PictBridge-compatible printers or DPOF-compatible devices such as a photo kiosk at your local photo printing shop. To create a print set, follow these steps:

 Only JPG images can be used to create a DPOF set.

1. **Use the Multi-selector to choose the Print set (DPOF) option, and then press the Multi-selector right to enter the menu.**

2. **Use the Multi-selector to highlight Select/set, and then press the Multi-selector right to view thumbnails.** Press the Zoom in button to view a larger preview of the selected image.

3. **Press the Multi-selector right or left to highlight an image to print.** When you've highlighted the desired image, press the Protect (key) button and the Multi-selector up to set the image and choose the number of prints you want. You can choose from 1 to 99. The number of prints and a small printer icon appear on the thumbnail. Continue this procedure until you have selected all the images that you want to print. Press the Protect button and the Multi-selector down to reduce the number of prints and to remove it from the print set. You can also set the image to be printed by pressing the Multi-selector center button while the thumbnail is highlighted.

4. **Press the OK button.** A menu appears with three options:

 • **Done (default).** Press the OK button to save and print the images as they are.

- **Data imprint.** Press the Multi-selector right to set the Data imprint option. A small check appears in the box next to the menu option. When this option is set, the shutter speed and aperture setting appear on the print.

- **Date imprint.** Press the Multi-selector right to set the Date imprint option. A small check appears in the box next to the menu option. When this option is set, the date the image was taken appears on the print.

5. **If you choose to set the imprint options, be sure to return to the Done option and press the OK button to complete the print set.**

Shooting Menu

The shooting controls that you find yourself using most often have dedicated buttons to access them, such as ISO, QUAL, and WB. You can also set these features in the Shooting menu. There are also other settings here that you will use quite often, such as Picture Controls, Active D-Lighting, and Noise Reduction.

Reset shooting menu

Choosing the Reset shooting menu option resets the Shooting values to the camera default settings. Only use this option if you want to start from scratch. This option resets all the Shooting values, including file naming, color space, and any exposure fine-tuning you may have set, so reset with caution.

Storage folder

As I discussed earlier, the D7000 automatically creates folders in which to store your images. The camera creates a folder named ND7000, and then stores the images in subfolders starting with folder 100. You can choose to change the folder that the camera is saving to from 100 up to 999. You can use this option to separate different subjects into different folders. When I shoot Sports Car Club of America (SCCA) races, there are different groups of cars. I use a different folder for each group to make it easier to sort through the images later. If there are five groups, I start out using folder 101, then folder 102 for the second group, and so on. This makes it so much easier to keep your images sorted, which can be a real timesaver during post-processing.

When selecting the active storage folder, you can choose a new folder number or you can select a folder that has already been created. When you format your memory card, all preexisting folders are deleted, and the camera creates a folder with

whatever number the active storage folder is set to. So if you set it to folder 105, when the card is formatted, the camera will create folder 105ND7000; it does not start from the beginning with folder 100. If you want to start with folder 100, you need to be sure to change the active storage folder back to 100 and then format your card.

To change the storage folder setting, follow these steps:

1. **Go to the Shooting menu.** Using the Multi-selector, choose Storage folder and then press the Multi-selector center button to view options.

2. **Select folder by number (default) to start a new folder.** Press the Multi-selector right. Press the Multi-selector up and down to change the numbers and left or right to change place in the number sequence. If there's already a folder created for a certain number, a small icon appears to the left of the number. This tells you if the folder is empty, partially full, or full.

3. **Press the OK button or the Multi-selector center button to save changes.**

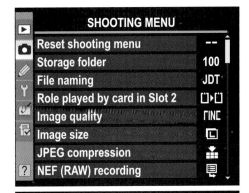

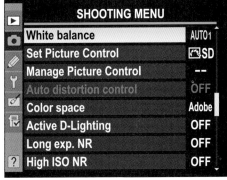

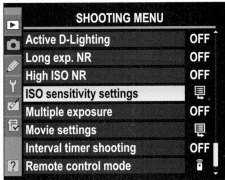

3.3 The Shooting menu is shown here in three sections so you can see all the available options.

You can also choose from a list of folders that have already been created. Simply choose the Select folder from list option from the Storage folder menu. A list of available folders is displayed. Highlight the desired folder using the Multi-selector and press the OK button to make the folder active.

File naming

When image files are created, the D7000 automatically assigns a filename. The default filenames start with DSC_ followed by a four-digit number and the file extension (DSC_0123.jpg) when you're using the sRGB color space. When you're using the Adobe RGB color space, the filenames start with _DSC followed by a four-digit number and the file extension (_DSC0123.jpg).

The File naming menu option allows you to customize the filename by replacing the DSC prefix with any three letters of your choice. For example, I customized mine so that the filename reads JDT_0123.jpg.

To customize the filename, follow these steps:

1. **Highlight the File naming option in the Shooting menu.** Press the Multi-selector right to enter the menu. The menu shows a preview of the filename (sRGB: DSC_1234 / Adobe RGB: _DSC1234).

2. **Press the Multi-selector right to enter a new prefix within the text entry screen.** You will notice that this text entry screen doesn't have lowercase letters or any punctuation marks. This is because the file-naming convention only allows for files to be named using capital letters and the numbers 0 through 9.

3. **Use the Multi-selector to choose the letters and/or numbers.** Press the OK button when you finish.

Role played by card in Slot 2

The Role played by card in Slot 2 menu option determines the function of your secondary card slot. You have three items to choose from:

▶ **Overflow.** If this option is selected when the Slot 1 card is full, the camera automatically switches to the card in Slot 2. If the Slot 1 is replaced with a blank card, the camera automatically switches back to writing to the primary card. This is the option I usually choose.

▶ **Backup.** When this option is selected, the camera automatically writes two copies of the images: one to Slot 1 and one to Slot 2.

▶ **RAW Slot 1/JPEG Slot 2.** When this option is chosen and the image quality is set to RAW + JPEG, RAW files are saved to the primary card and JEPGs to the secondary card.

Image quality

The Image quality menu option allows you to change the image quality of the file. You can choose from these options:

▶ **NEF (RAW) + JPEG fine.** This option saves two copies of the same image, one in RAW and one in JPEG with a 1:4 ratio compression.

▶ **NEF (RAW) + JPEG normal.** This option saves two copies of the same image, one in RAW and one in JPEG with a 1:8 ratio compression.

▶ **NEF (RAW) + JPEG basic.** This option saves two copies of the same image, one in RAW and one in JPEG with a 1:16 ratio compression.

▶ **NEF (RAW).** This option saves the images in RAW format.

▶ **JPEG fine.** This option saves the images in JPEG with a 1:4 ratio compression.

▶ **JPEG normal.** This option saves the images in JPEG with a 1:8 ratio compression.

▶ **JPEG basic.** This option saves the images in JPEG with a 1:16 ratio compression.

You can also change these settings by pressing the QUAL button and rotating the Main Command dial to choose the file type and compression setting. You can view this setting on the LCD control panel on the top of the camera.

 For more detailed information on image quality, compression, and file formats, **CROSS REF** see Chapter 2.

Image size

The Image size menu option allows you to choose the size of the JPEG files. You change the image size depending on the intended output of the file. This option is not available when the image quality is set to RAW only. The choices are as follows:

▶ **Large.** This setting gives you a full resolution image of 4928 × 3264 pixels, equivalent to 16 megapixels.

▶ **Medium.** This setting gives you a resolution of 3696 × 2448 pixels, equivalent to 9 megapixels.

▶ **Small.** This setting gives your images a resolution of 2464 ×1632 pixels, equivalent to 4 megapixels.

 You can also change the image size for JPEG by pressing the QUAL button and rotating the Sub-command dial. The settings are shown on the LCD control panel on the top of the camera.

JPEG compression

The JPEG compression menu allows you to set the amount of compression applied to the images when they're recorded in the JPEG file format. The options include

- **Size Priority.** With this option the JPEG images are compressed to a relatively uniform size. Image quality can vary depending on the amount of image information in the scene you photographed. To keep the file sizes similar, some images must be compressed more than others.

- **Optimal Quality.** This option provides the best compression algorithm. The file sizes vary with the information contained in the scene recorded. Use this mode when image quality is a priority.

NEF (RAW) recording

The NEF (RAW) recording menu option enables you to set the amount of compression applied to RAW files. It is also where you choose the bit depth of the RAW file. Use the Type submenu (accessed from the RAW recording menu) to choose the compression. The options include

- **Lossless compressed.** This is the default setting. The RAW files are compressed, reducing the file size from 20 percent to 40 percent with no apparent loss of image quality.

- **Compressed.** The RAW file is compressed by 40 percent to 55 percent. Some file information is lost.

Use the NEF (RAW) bit depth submenu to choose the bit depth of the RAW file. You have two options:

- **12 bit.** This records the RAW file with 12 bits of color information.

- **14 bit.** This records the RAW file with 14 bits of color information. The file size is significantly larger, but there is much more color information for smoother color transitions in your images.

White balance

You can change the white balance (WB) options using this menu option. Changing the WB settings through this menu option allows you to fine-tune your settings with more precision and gives you a few more options than you get when using the dedicated WB button located on the top of the camera. You can select a WB setting from the standard settings (Auto [Normal or Keep warm lighting colors], Incandescent, Fluorescent, Direct sunlight, Flash, Cloudy, Shade) or you can choose to set the WB according to color temperature by selecting a Kelvin temperature from 2500K to 10000K. You can also choose to select from a preset WB that you have set.

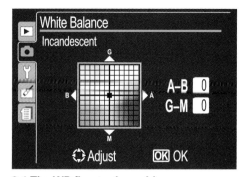

3.4 The WB fine-tuning grid

Using standard WB settings

To select one of the standard WB settings, choose the White balance option from the Shooting menu, and use the Multi-selector button to highlight the preferred setting; then press the Multi-selector right or the Multi-selector center button. This brings up a new screen that gives you the option to fine-tune the standard setting. Displayed on this screen is a grid that allows you to adjust the color tint of the WB setting selected. The horizontal axis of the grid allows you to adjust the color from amber to blue, making the image warmer or cooler, while the vertical axis of the grid allows you to change the tint by adding a magenta or green cast to the image. Using the Multi-selector, you can choose a setting from 1 to 6 in either direction; additionally, you can add points along the horizontal and vertical axes simultaneously. For example, you can add 4 points of amber to give it a warmer tone and also add 2 points of green, shifting the amber tone more toward yellow.

Choosing the fluorescent setting brings up some additional menu options: You can choose between seven different lighting types:

▶ **Sodium-vapor.** These types of lights are often found in streetlights and parking lots. They emit a distinct deep yellow color.

▶ **Warm-white fluorescent.** These types of lights give a white light with a bit of an amber cast to add some warmth to the scene. They burn at around 3000K, similar to an incandescent bulb.

▶ **White fluorescent.** These types of lights cast a very neutral white light at around 5200K.

▶ **Cool white fluorescent.** As the name suggests, these types of lights are a bit cooler than a white fluorescent lamp and have a color temperature of 4200K.

▶ **Day white fluorescent.** These types of lights approximate sunlight at about 5500K.

▶ **Daylight fluorescent.** These types of lights give you about the same color as daylight. This lamp burns at about 6300K.

▶ **High temp. mercury-vapor.** These types of lights vary in temperature depending on the manufacturer and usually run between 4200K and 5200K.

Color Temperatures in the Kelvin Scale

10000 –
9000 –
8000 –
7000 –
6000 –
5000 –
4000 –
3000 –
2000 –
1000 –

3.5 The Kelvin color temperature scale

 Sunlight and daylight are quite different color temperatures. Sunlight is light directly from the sun and is about 5500K. Daylight is the combination of sunlight and skylight and has a color temperature of about 6300K.

Choosing a color temperature

Using the K white balance option, you can choose a specific color temperature, assuming that you know the actual color temperature. Some light bulbs and fluorescent lamps are calibrated to put out light at a specific color temperature; for example there are daylight balanced light bulbs that burn at a color temperature of 5000K. As with the other settings, you get the option of fine-tuning the setting using the grid.

Setting a preset white balance

Preset white balance (WB) allows you to make and store up to five custom WB settings. You can use this option when shooting in mixed lighting; for example, in a room with an incandescent light bulb and sunlight coming in through the window, or when the camera's Auto White balance isn't quite getting the correct color.

You can set a custom white balance two ways: from a direct measurement, which is when you take a reading from a neutral-colored object (a gray card works the best for this) under the light source; or by copying it from an existing photograph, which allows you to choose a WB setting directly from an image that is stored on your memory card.

The camera can store up to five presets that are labeled d-0 through d-4. When taking a direct measurement, the camera automatically stores the preset image to d-0, so if you want to save a previous measurement, be sure to copy it over to one of the presets d-1 through d-4 before taking another measurement. I cover saving these presets later in this section.

Direct measurement

To take a direct measurement and save it to d-0 (default), follow these steps:

1. **Place a neutral object (preferably a gray card, which is included with the book) under the light source you want to balance for.**

2. **Press the WB button located on the top left of the camera body and rotate the Main Command dial until the PRE is displayed on the LCD control panel.**

3. **Release the WB button for a moment, and then press and hold it until the LCD control panel shows a blinking PRE.** This stays displayed for about 6 seconds.

4. **Looking through the viewfinder, frame the reference object.** Press the Shutter Release button as if you were taking a photo.

5. **If the camera is successful in recording the WB, GOOD flashes in the control panel.** If the scene is too dark or too bright, the camera may not be able to set the WB; in this case, No Gd flashes on the LCD control panel. You may need to change your settings to adjust the exposure settings on your camera. If the result was unsuccessful, repeat Steps 2 through 5 until you obtain results that are acceptable to you.

If you plan on using this preset to take pictures right away, be sure that your preset WB is set to d-0. Do this by pressing the WB button and rotating the Sub-command dial until d-0 is displayed on the LCD control panel.

If you want to save the current preset WB setting for future use, you need to copy the setting to another preset (d-1 through d-4). If you don't save this, the next time you make a preset, the d-0 slot will be overwritten. To save a preset, follow these steps:

1. **Press the Menu button.** Use the Multi-selector to choose White balance from the Shooting menu.

2. **Select Preset manual from the White balance menu.** Press the Multi-selector button right to view the preset choices.

3. **Use the Multi-selector to highlight one of the four available presets: d-1, d-2, d-3, or d-4. Press the Multi-selector center button.** This brings up a menu.

4. **Use the Multi-selector to highlight Copy d-0.** Press the OK button to copy the setting.

The D7000 also allows you to add a comment to any of the presets. You can use this to remember the details of your WB setting. For example, if you have a set of photo-graphic lights in your studio, you can set the WB for these particular lights and type photo lights into the comment section. You can enter up to 36 characters (including spaces). To enter a comment on a WB preset, follow these steps:

1. **Press the Menu button.** Use the Multi-selector to choose White balance from the Shooting menu.

2. **Select Preset manual from the White balance menu.** Press the Multi-selector button right to view the preset choices.

3. **Use the Multi-selector to highlight one of four presets: d-1, d-2, d-3, or d-4.** Press the Multi-selector center button. The preset menu is displayed.

4. **Use the Multi-selector to highlight Edit comment.** Press the Multi-selector right. This brings up the text entry screen.

5. **Enter your text and press the OK button to save the comment.**

Copy white balance from an existing photograph

As I mentioned previously, you can also copy the white balance setting from any photo saved on the memory card that's inserted into your camera. Follow these steps:

 If you have particular settings that you like, you may consider saving the images on a small 256MB memory card. This way, you always have your favorite WB presets saved and don't accidentally erase them from the camera.

1. **Press the Menu button.** Use the Multi-selector to choose White balance from the Shooting menu.

2. **Select Preset manual from the White balance menu.** Press the Multi-selector button right to view the preset choices.

3. **Use the Multi-selector to highlight one of the four available presets: d-1, d-2, d-3, or d-4.** Press the Multi-selector center button. This brings up a menu. Note that d-0 is not available for this option.

4. **Use the Multi-selector to highlight Select image.** The LCD screen displays thumbnails of the images saved to your memory card. Use the Multi-selector directional buttons to scroll through the images. You can zoom in on the high-lighted image by pressing the Zoom in button.

5. **Press the Multi-selector center button to set the image to the selected pre-set (d-1, d-2, d-3, or d-4).** Press the OK button to save the setting. This brings up the fine-tuning graph. Adjust the colors if necessary. Press the OK button to save changes.

Once you have your presets in order, you can quickly choose between them by follow-ing these easy steps:

1. **Press the WB button located on top of the camera.**

2. **Rotate the Main Command dial until PRE appears on the LCD control panel.**

3. **Continue to press the WB button and rotate the Sub-command dial.** The top right of the LCD control panel displays the preset option from d-0 through d-4.

Set Picture Control

Nikon has included Picture Controls in the D7000. These controls allow you to choose how the images are processed and you can also use them in Nikon's image-editing software Nikon ViewNX 2 and Nikon Capture NX 2. These Picture Controls allow you to get the same results when you use different cameras that are compatible with the Nikon Picture Control System. Six standard Nikon Picture Controls are available in the D7000: Standard (SD), Neutral, (NL), Vivid (VI), Monochrome (MC), Portrait (PT), and Landscape (LS).

You can adjust all the standard Nikon Picture Controls to suit your specific needs or tastes. In the color modes, you can adjust the sharpening, contrast, brightness, hue, and saturation. In MC mode, you can adjust the filter effects and toning. After you have adjusted the Nikon Picture Controls, you can save them for later use. You can do this in the Manage Picture Control option described in the next section.

 When you save to NEF, the Picture Controls are imbedded into the metadata. Only Nikon's software can use these settings. When you open RAW files using a third-party program such as Adobe Camera Raw in Photoshop, the Picture Controls are not used.

Manage Picture Control

This menu is where you can edit, save, and rename your Custom Picture Controls. There are four menu options:

▶ **Save/edit.** In this menu, you choose a Picture Control, make adjustments to it, and then save it. You can rename the Picture Control to help you remember what adjustments you made or to remind you of what you are using the Custom Picture Control for. For example, I have one named ultra-VIVID, which has the contrast, sharpening, and saturation boosted as high as it can go. I sometimes use this setting when I want crazy, oversaturated, unrealistic-looking images for abstract shots or light trails.

▶ **Rename.** This menu allows you to rename any of your Custom Picture Controls. You cannot, however, rename the standard Nikon Picture Controls.

▶ **Delete.** This menu gives you the option of erasing any Custom Picture Controls you have saved. This menu only includes controls you have saved or down-loaded from an outside source. The standard Nikon Picture Controls cannot be deleted.

▶ **Load/save.** This menu allows you to upload Custom Picture Controls to your camera from your memory card, delete any Picture Controls saved to your mem-ory, or save a Custom Picture Control to your memory card to export to Nikon ViewNX 2 or Capture NX 2 or to another camera that is compatible with Nikon Picture Control.

 For detailed information on creating and managing Picture Controls, see Chapter 2.

The D7000 also allows you to view a grid graph that shows you how each of the Picture Controls relate to each other in terms of contrast and saturation. Each Picture Control is displayed on the graph represented by a square icon with the letter of the Picture Control it corresponds to. Custom Picture Controls are denoted by the number of the custom slot it has been saved to. Standard Picture Controls that have been modified are displayed

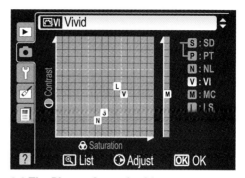

3.6 The Picture Control grid

with an asterisk next to the letter. Picture Controls that have been set with one or more auto settings are displayed in green with lines extending from the icon to show you that the settings will change depending on the images.

To view the Picture Control grid, select the Set Picture Control option from the Shooting menu. Press the OK button and the Picture Control list is displayed. Press the Thumbnail/Zoom out button to view the grid. Once the Picture Control grid is displayed, you can use the Multi-selector to scroll though the different Picture Control settings. Once you have highlighted a setting, you can press the Multi-selector right to adjust the settings or press the OK button to set the Picture Control. Press the Menu button to exit back to the Shooting menu or tap the Shutter Release button to ready the camera for shooting.

Auto distortion control

Most lenses are prone to some sort of image distortion. With wide-angle lenses, it's barrel distortion, which makes things along the edges of the frame bow out (like a barrel); with telephoto lenses, it's the opposite: Things along the edges of the frame bow inward.

When Auto distortion control is set to On, the distortion common with these types of lenses is reduced automatically. It's recommend that you only use this feature when using Nikon G- or D-type lenses.

Color space

Color space simply describes the range of colors, also known as the *gamut*, a device can reproduce. You have two choices of color spaces with the D7000: sRGB and Adobe RGB. The color space you choose depends on what the final output of your images will be.

▶ **sRGB.** This is a narrow color space, meaning that it deals with fewer colors and also less-saturated colors than the larger Adobe RGB color space. The sRGB color space is designed to mimic the colors that can be reproduced on computer monitors.

▶ **Adobe RGB.** This color space has a much broader color gamut than is available with sRGB. The Adobe gamut was designed for dealing with the color spectrum that can be reproduced with most high-end printing equipment.

This leads to the question of which color space you should use. As I mentioned earlier, the color space you use depends on what the final output of your images is going to be. If you take pictures, download them straight to your computer, and typically only view them on your monitor or upload them for viewing on the Web, then sRGB is fine. The sRGB color space is also useful when you are printing directly from the camera or memory card without doing any post-processing.

If you are going to have your photos printed professionally or you intend to do a bit of post-processing to your images, using the Adobe RGB color space is recommended. It gives you subtler control over the colors than is possible when using a narrower color space like sRGB.

For the most part, I capture my images using the Adobe RGB color space. I then do my post-processing and make a decision on the output. Anything that I know I will be posting to the Web, I convert to sRGB; anything destined for my printer, I save as Adobe RGB. I usually end up with two identical images saved with two different color spaces. Because most Web browsers don't recognize the Adobe RGB color space, any images saved as Adobe RGB and posted on the Internet usually appear dull and flat.

Active D-Lighting

Active D-Lighting is a setting that is designed to help ensure that you retain highlight and shadow detail when shooting in a high-contrast situation, such as in direct bright sunlight, which can cause dark shadows and bright highlight areas. Active D-Lighting basically tells your camera to underexpose the image a bit; this underexposure helps keep the highlights from becoming blown out and losing detail. The D7000 also uses a subtle adjustment to avoid losing any detail in the shadow area that the underexposure may cause.

 Active D-Lighting is a different setting than the D-Lighting option found in the Retouch menu. For more information on standard D-Lighting, see Chapter 16.

Using Active D-Lighting changes all the Picture Control brightness and contrast settings to Auto; adjusting the brightness and contrast is how Active D-Lighting keeps detail in the shadow areas.

Active D-Lighting has six settings, which are pretty self-explanatory. These settings are Auto, Extra high, High, Normal, Low, and Off.

In my experience, using Active D-Lighting works, but the changes it makes are very subtle. For general shooting, I recommend setting Active D-Lighting to Auto and forgetting about it. I prefer to shoot in RAW, and although the settings are saved to the metadata for use with Nikon software, I'd rather do the adjustment myself in Photoshop, so I turn this feature off.

When using Active D-Lighting, the camera takes some extra time to process the images, and your buffer will fill up more quickly when you're shooting continuously, so expect shorter burst rates.

Long exp. NR

The Long exp. NR menu option allows you to turn on Noise Reduction (NR) for exposures of 8 seconds or longer. When this option is on, after taking a long exposure photo, the camera runs an NR algorithm, which reduces the amount of noise in your image, giving you a smoother result. Expect the camera to take double the time to save the image to the card given it first runs the NR algorithm.

 If you turn the camera off before the NR has finished processing, the image is saved without NR applied.

High ISO NR

The High ISO NR menu option allows you to choose how much NR is applied to images that are taken at higher ISO settings. There are four settings:

▶ **High.** This setting applies NR fairly aggressively. A fair amount of image detail can be lost when you use this setting.

▶ **Normal.** This is the default setting. Some image detail may be lost when you use this setting.

▶ **Low.** A small amount of NR is applied when you select this option. Most of the image detail is preserved when you use this setting.

▶ **Off.** When you choose this setting, no NR is applied to images taken between ISO 100 and 800; however, a very small amount of NR is applied to images shot at ISO 1600 and higher.

ISO sensitivity settings

The ISO sensitivity settings menu option allows you to set the ISO. This is the same as pressing the ISO button and rotating the Main Command dial. You also use this menu to set the Auto ISO parameters.

Multiple exposure

The Multiple exposure menu option allows you to record multiple exposures in one image. You can record from two to ten shots in a single image. This is an easy way to get off-the-wall multiple images without using image-editing software like Adobe Photoshop. To use this feature, follow these steps:

1. **Select Multiple exposure from the Shooting menu, and then press the Multi-selector right.**

2. **Select the Number of shots menu option, and then press the Multi-selector right.**

3. **Press the Multi-selector up or down to set the number of shots.** Press the OK button when the number of shots selected is correct.

4. **Select the Auto gain option, and then press the Multi-selector right.**

5. **Set the gain, and then press the OK button.** Using Auto gain enables the camera to adjust the exposure according to the number of images in the multiple exposures. This is the recommended setting for most applications. Setting the gain to Off does not adjust the exposure values and can result in an overexposed image. The Gain-off setting is recommended only in low-light situations. When you have selected the desired setting, press the OK button.

6. **Use the Multi-selector to highlight Done, and then press the OK button.** This step is very important. If you do not select Done, the camera will not be in Multiple exposure mode.

7. **Take your pictures.** Once the selected amount of images has been taken, the camera exits Multiple exposure mode and returns to the default shooting setting. To do additional multiple exposures, repeat the steps.

When the Release mode is set to Continuous, the multiple exposures are recorded in one single burst; when the camera is set to all other Release modes (except Self-timer), it records one image each time the Shutter Release button is pressed.

Movie settings

This Movie settings menu option is where you choose the different settings used for shooting video. See Chapter 7 for detailed information on using the Movie settings options.

Interval timer shooting

The Interval timer shooting menu option allows you to set the camera's time-lapse photography option. You use this option to set your camera to shoot a specified number of shots at specified intervals throughout a set period of time. You can use this interesting feature to record the slow movements of plants or animals, such as a flower opening or a snail crawling. Another option is to set up your camera with a wide-angle lens and record the movement of the sun or moon across the sky.

Naturally you need a tripod to do this type of photography and it's highly recommended that you use Nikon's EH-5a AC power supply to be sure that your camera battery doesn't die in the middle of your shooting. At the very least, you should use an MB-D11 with an extra battery.

After you record your series of images, you can use image-editing software to combine the images and create an animated GIF file. You can set these options:

▶ **Starting time.** You can set the camera to start photographing three seconds after the settings have been completed (Now) or to start photographing at a predetermined time in the future.

▶ **Interval.** This determines how much time is elapsed between each shot. You can set hours, minutes, and seconds.

▶ **Number of intervals.** This sets how many times you want photos to be shot.

▶ **Shots per interval.** This sets how many shots are taken at each interval.

▶ **On or Off.** This starts or stops the camera from shooting with the current settings.

Do not select the Self-timer or Remote release modes when using the interval timer.

Remote Control Mode

The Remote control mode menu option allows you to set the shutter release options when using the optional wireless remote, the Nikon ML-L3. You have three options:

▶ **Delayed remote.** This option puts a two-second delay on the shutter release after the button on the ML-L3 is pressed.

▶ **Quick response remote.** When this option is set, the shutter is released as soon as the camera achieves focus.

▶ **Remote mirror up.** When this option is set, it takes two button presses on the ML-L3 to complete a shutter cycle. The first button press flips up the reflex mirror, and the second button press releases the shutter. This option is used to prevent blur from camera shake caused by the mirror moving. Use this feature when shooting long exposures on a tripod.

Custom Settings Menu (CSM)

The Custom Settings menu (CSM) is where you really start customizing your D7000 to shoot to your personal preferences. This is the heart and soul of the camera. The CSM is probably the most powerful menu in the camera. The next sections explain the menu settings available in the CSM, including Autofocus, Metering/exposure, Timers/ AE Lock, Shooting/display, Bracketing/ flash, and Controls.

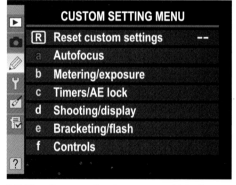

	CUSTOM SETTING MENU	
▣ R	Reset custom settings	--
a	Autofocus	
b	Metering/exposure	
c	Timers/AE lock	
d	Shooting/display	
e	Bracketing/flash	
f	Controls	

3.7 The Custom Settings menu (CSM)

 If you're unsure of any menu option, pressing the Protect/Help button displays a screen that describes the function.

Reset custom settings

As you might imagine, you use this option to restore the camera's default settings.

CSM a – Autofocus

The CSM submenu controls how the camera performs its autofocus (AF) functions. Because focus is a very critical operation, this is a very important menu. You have eight options to choose from, which I describe in the following sections.

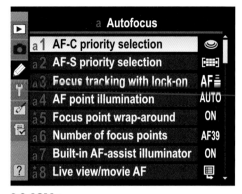

3.8 CSM a

a1 – AF-C priority selection

AF-C priority selection sets how the camera's AF functions when in Continuous Autofocus (AF-C) mode. You can choose from two modes:

▶ **Release.** This is the default setting. It allows the camera to take a photo whenever you press the Shutter Release button, regardless of whether the camera has achieved focus or not. This setting is best for fast action shots or for times when it's imperative to get the shot whether it's in sharp focus or not.

▶ **Focus.** This allows the camera to take photos only when the camera achieves focus and the focus indicator (the green dot in the lower-left corner of the viewfinder) is lit. This is the best setting for slow-moving subjects, where you want to be absolutely sure that your subject will be in focus, but you still want to fire off sequential shots.

a2 – AF-S priority selection

AF-S priority selection sets how the camera's AF functions when in Single-servo Autofocus (AF-S) mode. You can choose from these two settings:

▶ **Release.** This setting allows the camera to take a photo whenever you press the Shutter Release button, regardless of whether the camera has achieved focus or not.

▶ **Focus.** This is the default setting. This allows the camera to take photos only when the camera achieves focus and the focus indicator (the green dot in the lower-left corner of the viewfinder) is displayed.

a3 – Focus tracking with lock-on

When you're photographing in busy environments, things often cross your path, resulting in the camera refocusing on the wrong subject. Focus tracking with lock-on allows the camera to hold focus for a time before switching to a different focus point. This helps stop the camera from switching focus to an unwanted subject passing through your field of view.

You can choose Long (5), Normal (3), or Short delay (1) times with settings 2 and 4 in between. You can also set Focus tracking with lock-on to Off, which allows your camera to quickly maintain focus on a rapidly moving subject. Normal is the default setting.

a4 – AF point illumination

The AF point illumination menu option allows you to choose whether the active AF point is highlighted in red momentarily in the viewfinder when the AF is activated. When the viewfinder grid is turned on, the grid is also highlighted in red. When the option is set to Auto, which is the default, the focus point is lit only to establish contrast from the background when it is dark. When this option is set to On, the active AF point is highlighted, even when the background is bright. When this option is set to Off, the active AF point is not highlighted in red; it appears in black.

a5 – Focus point wrap-around

When you use the Multi-selector to choose your AF point, the Focus point wrap-around menu option allows you to continue pressing the Multi-selector in the same direction and wrap around to the opposite side or stop at the edge of the focus point frame (no wrap).

a6 – Number of focus points

The Number of focus points menu option allows you to choose the number of available focus points when using AF. You can set 39 points, which allows you to choose all the D7000's available focus points. You can also set 11 points, which allows you to choose from only 11 focus points, similar to the D90. Using the 11-point option enables you to select your focus points much more quickly than if you were using the 39-point option. The 39-point option allows you to more accurately choose where in the frame the camera will focus on.

a7 – Built-in AF-assist illuminator

The AF-assist illuminator lights up when there isn't enough light for the camera to focus properly. In certain instances, you may want to turn this option off, such as when shooting faraway subjects in dim settings (concerts or plays). When set to On, the AF-assist illuminator lights up in a low-light situation only when in AF-S mode or Auto-area AF. When you're in Single-point AF or Dynamic-area AF mode, the center AF point must be active.

When set to Off, the AF-assist illuminator does not light at all.

a8 – Live view/movie AF

You use the Live view/movie AF setting to adjust the AF settings for the Live view and video functions of the D7000. If you're upgrading from a D90 or a D5000, a lot has changed. There are two options, each of which brings up a submenu.

▶ **Autofocus mode.** This setting controls how the camera autofocuses. There are two options to choose from:

 ● **Single-servo AF (AF-S).** When this option is selected, the camera achieves focus; it is locked as long as the Shutter Release button remains half-pressed.

 ● **Full-time-servo AF (AF-F).** When this option is activated, the camera continuously focuses on the subject until the Shutter Release button is half-pressed. Half-pressing the shutter disables AF-F and engages AF-S.

▶ **AF-area mode.** This setting controls how the AF point is selected. There are four options: Face-priority AF, Wide-area AF, Normal-area AF, and Subject-tracking AF.

For more detailed information on AF-area modes, see Chapter 7.

CSM b – Metering/exposure

You use the Metering/exposure submenu to change the settings that control exposure and metering. These settings allow you to adjust the exposure, ISO, and exposure compensation adjustment increments. Setting the increments to 1/3 stops allows you to fine-tune the settings with more accuracy than setting them to 1/2. There are five options to choose from.

b1 – ISO sensitivity step value

You use the ISO sensitivity step value option to control whether the ISO is set in 1/3- or 1/2-step increments. Setting the ISO using smaller increments allows you to fine tune your sensitivity with more precision, giving you more control over keeping high ISO noise to a minimum.

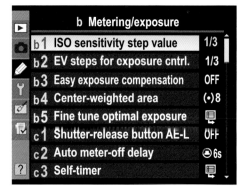

3.9 The CSM b menu

b2 – EV steps for exposure cntrl.

The EV steps for exposure cntrl. option determines how the shutter speed, aperture, and auto-bracketing increments are set. The choices here are also 1/3 or 1/2 step. Choosing a smaller increment provides a much less drastic change in exposure and allows you to get a more exact exposure in critical situations.

b3 – Easy exposure compensation

By default, to set the exposure compensation, you must first press the Exposure Value (EV) button and use the Main Command dial to add or subtract from the selected exposure. If you tend to use exposure compensation frequently, you can save yourself time by using Easy exposure compensation. When this function is set to On, it's not necessary to press the EV button to adjust the exposure compensation. Simply rotate the Main Command dial when in Aperture Priority mode or the Sub-command dial when in Programmed Auto or Shutter Priority mode to adjust the exposure compensation. The exposure compensation is then applied until you rotate the appropriate Command dial until the Exposure Compensation indicator disappears from the LCD control panel.

If you choose to use Easy exposure compensation, probably the best setting to use is the On (Auto reset) setting. This allows you to adjust your exposure compensation while shooting, but returns the exposure compensation to the default (0) when you turn the camera off or the camera's exposure meter turns off. If you've ever accidentally left exposure compensation adjusted and ended up with incorrectly exposed images the next time you used your camera, you will appreciate this helpful feature.

When Easy exposure compensation is set to Off, exposure compensation is applied normally by pressing the Exposure Compensation button and rotating the Main Command dial.

b4 – Center-weighted area

The Center-weighted area menu option allows you to choose the size of your Center-weighted metering area. You can choose from four sizes: 6, 8, 10, or 13mm. You also have the option of setting the meter to Average.

Choose the spot size depending on how much of the center of the frame you want the camera to meter for. The camera determines the exposure by basing 75 percent of the exposure on the circle.

b5 – Fine tune optimal exposure

If you find that your camera's metering system consistently over- or underexposes your images, you can adjust it to apply a small amount of exposure compensation for every shot. You can apply a different amount of exposure fine-tuning for each of the metering modes: Matrix, Center-weighted, and Spot metering.

You can set the EV ±1 stop in 1/6-stop increments.

 When Fine tune optimal exposure is on, there is no warning indicator that tells **CAUTION** you that exposure compensation is being applied.

CSM c – Timers/AE Lock

The Timers/AE lock submenu controls the D7000's various timers as well as the Auto-Exposure Lock (AE-L) setting. There are five options to choose from.

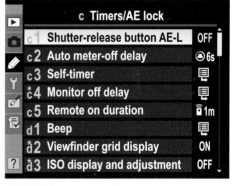

3.10 **CSM c menu options**

c1 – Shutter-release button AE-L

When the Shutter-release button AE-L option is set to Off (the default), the camera only locks exposure when you press the AE-L/AF-L (Auto-Exposure/ Autofocus Lock) button. When the option is set to On, the auto-exposure settings are locked when you half-press the camera's Shutter Release button.

c2 – Auto meter-off delay

The Auto meter-off delay menu option determines how long the camera's exposure meter is active before turning off when no other actions are being performed. You can

choose 4, 6, 8, 16, or 30 seconds; or 1, 5, 10, or 30 minutes. You can also specify for the meter to remain on at all times while the camera is on (no limit).

c3 – Self-timer

The Self-timer menu option applies a delay when the shutter is released after you press the Shutter Release button. This is handy when you want to do a self-portrait and need some time to get yourself into the frame. You can also use the self-timer to reduce the camera shake that happens when you press the Shutter Release button on long exposures. You can set the delay to 2, 5, 10, or 20 seconds.

You can also set the Number of shots option so that the camera can fire off multiple frames with one press of the Shutter Release (up to nine consecutive frames). The Interval between shots setting allows you set the amount of time that lapses between each frame. You can choose from 0.5, 1, 2, or 3 seconds.

c4 – Monitor off delay

The Monitor off delay menu option controls how long the LCD screen remains on when no buttons are being pushed. Because the LCD screen is the main source of power consumption for any digital camera, choosing a shorter delay time is usually preferable. You can set the monitor to turn off after 4, 10, or 20 seconds; 1, 5, or 10 minutes for Playback, Menus, or Information display; or 5, 10, 15, 20, or 30 minutes for Live View. You can set different times for the following monitor functions.

▸ **Playback.** This option controls how long the images are displayed when you preview the images by pressing the Playback button.

▸ **Menus.** This option controls how long the Menu options are displayed.

▸ **Information display.** This option controls how long the Info display is shown.

▸ **Image review.** This option controls how long the image is displayed after an image is shot. If Image review is turned off, this option isn't used.

▸ **Live View.** This option controls how long the monitor stays on when using Live View.

c5 – Remote on duration

The Remote on duration menu option controls how long the camera stays active while waiting for a signal from the wireless remote ML-L3 before deactivating remote mode and going to sleep. You can choose from 1, 5, 10, or 15 minutes.

CSM d – Shooting/display

You use the CSM d submenu Shooting/display to make changes to some of the minor shooting and display details. You have 14 options to choose from.

d1 – Beep

When the Beep menu option is on, the camera omits a beep when the self-timer is counting down or when the AF locks in Single Focus mode. You can set the volume from 1 to 3, with 1 being barely audible and 3 being the loudest, or to Off. You can also change the pitch to Low or High.

For most photographers, this option is the first thing they turn off when they take the camera out of the box. Although the beep can help when you're shooting in Self-timer mode, for the most part, it's pretty annoying, especially if you are photographing in a relatively quiet area. This is actually the first Nikon camera to have Beep set to Off as the default setting. When the camera is set to Quiet release mode the beep is automatically turned off no matter what this option is set to.

d2 – Viewfinder grid display

The handy Viewfinder grid display menu option displays a grid in the viewfinder to assist you with composition of the photograph. I like to keep this option turned on so I can line up things and be sure I keep my horizons level.

d3 – ISO display and adjustment

The ISO display and adjustment menu option allows you to replace the remaining exposures display with the ISO setting. It also allows you to select a feature called Easy ISO, which enables you to change the ISO setting quickly by rotating the Main Command dial when in Aperture Priority mode or the Sub-command dial when in Shutter Priority or Programmed Auto mode. Easy ISO is disabled when you're in Manual exposure mode.

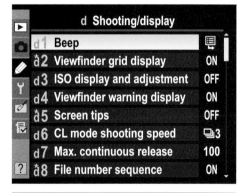

3.11 CSM d shown in two images so all options are visible

 Easy exposure compensation is disabled when the Easy ISO feature is activated.

d4 – Viewfinder warning display

Turning on the Viewfinder warning display menu option allows a few different warnings to be displayed in the viewfinder. A warning is shown when the battery is low, when the Monochrome (MC) Picture Control is selected, and if there is no memory card in the camera.

d5 – Screen tips

When the Screen tips menu option is turned on, the camera displays descriptions of the menu options available when using the Quick Settings Display. The menu options in the display are pretty self-evident, so I have this option turned off.

d6 – CL mode shooting speed

The CL mode shooting speed menu option allows you to set the maximum frame rate in Continuous Low mode. You can set the frame rate between 1 and 5 frames per second (fps). This setting limits your burst rate for shooting slower-moving action. This is a handy option to use when you don't necessarily need the highest frame rate, such as when you're shooting action that isn't moving very fast but also isn't moving slow.

 The CL mode shooting speed menu option also determines the frame rate for interval timer photography when you're using the Single frame setting.

d7 – Max. continuous release

The Max. continuous release menu option sets the maximum number of images that can be captured in a single burst when the camera is set to Continuous shooting mode. You can set this anywhere from 1 to 100. Setting this option doesn't necessarily mean that your camera is going to capture 100 frames at the highest frame rate speed. When you're shooting continuously, especially at a high frame rate, the camera's buffer can get full and cause the frame rate to slow down or even stop while the buffer transfers data to the memory card. How fast the buffer fills up depends on the image size, compression, and the speed of your memory card. With the D7000's large file sizes, I find it beneficial to use a faster card to achieve the maximum frame rate for extended periods.

d8 – File number sequence

The D7000 names files by sequentially numbering them. The File number sequence menu option controls how the sequence is handled. When it is set to Off, the file numbers reset to 0001 when a new folder is created, a new memory card is inserted, or the existing memory card is formatted. When the option is set to On, the camera continues to count up from the last number until the file number reaches 9999. The camera then returns to 0001 and counts up from there. When this menu option is set to Reset, the camera starts at 0001 when the current folder is empty. If the current folder has images, the camera starts at one number higher than the last image in the folder.

d9 – Information display

The Information display menu option controls how the Shooting info display on the LCD screen is colored. When the option is set to Auto (default), the camera automatically sets it to White on Dark or Dark on White to maintain contrast with the background. The setting is automatically determined by the amount of light coming in through the lens. You can also elect that the information be displayed consistently no matter how dark or light the scene is. You can choose B (black lettering on a light background) or W (white lettering on a dark background).

d10 – LCD illumination

When the LCD illumination menu option is set to Off (default), the LCD control panel (and the panel on a Speedlight if attached) is lit only when the power switch is turned all the way to the right, engaging the momentary switch. When the option is set to On, the LCD control panel is lit as long as the camera's exposure meter is active, which can be quite a drain on the batteries (especially for the Speedlight).

d11 – Exposure delay mode

Turning the Exposure delay mode menu option on causes the shutter to open about one second after you press the Shutter Release button and the reflex mirror has been raised. This option is for shooting long exposures with a tripod where camera shake from pressing the Shutter Release button and the vibration from the mirror raising can cause the image to be blurry.

d12 – Flash warning

The Flash warning menu option enables a warning when the light is low and flash is recommended. The flash indicator will blink in the viewfinder.

d13 – MB-D11 battery type

When you're using the optional MB-D11 battery pack with AA batteries, use the MB-D11 battery type menu option to specify which type of batteries are being used to ensure optimal performance. Your choices include

▶ **LR6 (AA alkaline).** These are standard, everyday AA batteries. I don't recommend using them because they don't last very long in the D7000.

▶ **HR6 (AA NiMh).** These are standard nickel-metal hydride rechargeable batteries available at most electronics stores. I recommend buying several sets of these. If you do buy these batteries, be sure to buy the ones that are rated at least 2500 mAh (milliampere-hour) for longer battery life.

▶ **FR6 (AA Lithium).** These lightweight batteries are nonrechargeable, but last up to seven times longer than standard alkaline batteries. These batteries cost about as much as a good set of rechargeable batteries.

d14 – Battery order

You use the Battery order menu option to set the order in which the batteries are used when the optional MB-D11 battery grip is attached. Choose MB-D11 to use the battery grip first, or choose D7000 to use the camera battery first. If you're using AA batteries in the MB-D11 only as a backup, set this option to use the camera battery first.

CSM e – Bracketing/flash

You use the Bracketing/flash submenu to set the controls for the built-in Speedlight. Some of these options also affect external Speedlights. This submenu is also where the controls for Bracketing images are located. There are six choices.

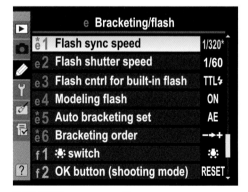

3.12 CSM e menu options

e1 – Flash sync speed

You use the Flash sync speed menu option to determine what shutter speed your camera uses to sync with the Speedlight. You can set the sync speed between 1/60 and 1/250 second. When using an optional SB-900, SB-800, SB-700 or SB-600, you can also set the sync to

1/250 (Auto FP) or 1/320 (Auto FP); this allows you to use faster shutter speeds of up to 1/8000 (when using an accessory Speedlight) to maintain wider apertures in bright situations if needed.

e2 – Flash shutter speed

The Flash shutter speed menu option lets you decide the slowest shutter speed that is allowed when you do flash photography using Front-Curtain Sync or Red-Eye Reduction mode when the camera is in Programmed Auto or Aperture Priority exposure mode. You can choose from 1/60 second all the way down to 30 seconds.

When the camera is set to Shutter Priority mode or the flash is set to any combination of Slow Sync, this setting is ignored.

e3 – Flash cntrl for built-in flash

The Flash cntrl for built-in flash menu option has submenus nested within it. Essentially, this option controls how your built-in flash operates. The four submenus are as follows:

▶ **TTL.** This is the fully auto flash mode. You can make minor adjustments using Flash Exposure Compensation (FEC).

▶ **Manual.** You choose the power output in this mode. You can choose from Full power all the way down to 1/128 power.

▶ **Repeating flash.** This mode fires a specified number of flashes.

▶ **Commander mode.** You use this mode to control a number of off-camera Creative Lighting System (CLS)-compatible Speedlights.

For more information on flash photography, see Chapter 6 or pick up a copy of the *Nikon Creative Lighting System Digital Field Guide, 2nd Edition* (Wiley, 2010).

e4 – Modeling flash

This option allows you to set the flash to emit a modeling light. When you use the built-in flash or an optional Speedlight, pressing the Depth-of-field preview button fires a series of low-power flashes that allows you to preview what the effect of the flash is going to be on your subject. When you use CLS and Advanced Wireless Lighting with multiple Speedlights, pressing the button causes all the Speedlights to emit a modeling flash. You can set this to On or Off.

e5 – Auto bracketing set

The Auto bracketing set menu option allows you to choose how the camera brackets when Auto-bracketing is turned on. You can choose for the camera to bracket AE and flash, AE only, Flash only, WB bracketing, or ADL (Active D-Lighting) bracketing. WB bracketing is not available when the image quality is set to record RAW images.

e6 – Bracketing order

The Bracketing order menu option determines the sequence in which the bracketed exposures are taken. When the option is set to N (default), the camera first takes the metered exposure, next the underexposures, and then the overexposures. When this option is set to (– ➛ +) the camera starts with the lowest exposure, increasing the exposure as the sequence progresses.

CSM f – Controls

The Controls submenu allows you to customize some of the functions of the different buttons and dials of your D7000. There are ten options to choose from.

f1 – Switch

You can rotate the On/Off button past the On setting and it acts as a momentary switch. You can use the Switch menu option to light up the LCD control panel (LCD backlight) or you can light up the LCD control panel and display the Info display on the rear LCD screen (Both).

f2 – OK button (Shooting mode)

OK button (Shooting mode) menu option allows you to set specific options for pressing the center button of the Multi-selector. The options are as follows:

▶ **Select center focus point.** This allows you to automatically select the center focus point by pressing the center button of the Multi-selector.

▶ **Highlight selected focus point.** This causes the active focus point to light up in the viewfinder when you press the center button of the Multi-selector.

▶ **Not used.** The center button has no effect when in Shooting mode.

f3 – Assign Fn button

The Assign Fn button chooses what functions the Function button performs when you press it. Be aware that not all options are available depending on which particular

setting you choose. You can choose from two Function button options: Fn button press and Fn button + command dials. You can also access this setting using the Quick Settings menu. The options include

▶ **Preview.** If you want to use the Depth-of-field preview button for another function, you can reassign it to this button. This option closes down the aperture so you can see in real time what effect the aperture will have on the image's depth of field. This function is cancelled when you select a function for Fn button + command dials. If you choose this setting for button press only, the function for Fn button + command dials are deactivated.

▶ **FV lock.** When you press the Fn button, the camera fires a preflash to determine the proper flash to determine the proper

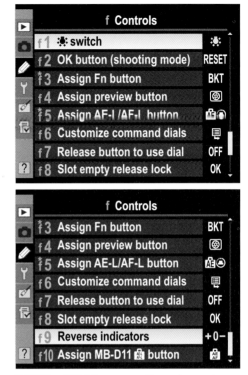

3.13 The CSM f menu options shown in two sections

flash exposure value and locks the setting, allowing you to meter the subject and then recompose the shot without altering the flash exposure. This function is cancelled when you select a function for Fn button + command dials. If you choose this setting for button press only, the function for Fn button + command dials will be deactivated.

▶ **AE/AF Lock.** The focus and exposure locks when you press and hold the button.

▶ **AE Lock only.** The exposure locks when you press and hold the button. Focus continues to function normally.

▶ **AE Lock (hold).** The exposure locks until you press the button a second time or turn off the exposure meter.

▶ **AF Lock only.** The focus locks while you press and hold the button. The AE continues as normal.

▶ **Flash off.** With this option, the built-in flash (if popped up) or an additional Speedlight will not fire when the shutter is released as long as the Function button is pressed. This allows you to quickly take available light photos without having to turn off the flash. This is quite handy, especially when you're shooting weddings and events.

▶ **Bracketing burst.** The camera fires a burst of shots when you press and hold the Shutter Release button while in Single shot mode when Auto-bracketing is turned on. The number of shots fired depends on the Auto-bracketing settings. When in Continuous shooting mode, the camera continues to run through the bracketing sequence as long as you hold the Shutter Release button.

▶ **Active D-Lighting.** Pressing the Fn button and rotating the Main Command dial allows you to change the Active D-Lighting settings.

▶ **+ NEF (RAW).** Pressing the Function button when this is activated and the camera is set to record JPEGs allows the camera to simultaneously record a RAW file and a JPEG. Pressing the button again allows the camera to return to recording only JPEGs. This function is cancelled when you select a function for Fn. button + command dials. If you choose this setting for button press only, the function for Fn. button + command dials will be deactivated.

▶ **Matrix metering.** This allows you to automatically use Matrix metering no matter what the Metering Mode dial is set to.

▶ **Center-weighted.** This allows you to automatically use Center-weighted metering no matter what the Metering Mode dial is set to.

▶ **Spot metering.** This allows you to automatically use Spot metering no matter what the Metering Mode dial is set to.

▶ **Framing grid.** This allows you to turn the framing grid on or off.

▶ **Viewfinder virtual horizon.** This displays a level in place of the electronic exposure meter in the viewfinder. Press once to display it and once again to turn it off.

▶ **Access top item in My Menu.** This brings up the top item set in the My menu option. You can use this to quickly access your most used menu option. This function is cancelled when you select a function for Fn button + command dials. If you choose this setting for button press only, the function for Fn button + command dials will be deactivated.

▶ **1 step spd/aperture.** When the Function button is pressed, the aperture and shutter speed are changed in 1-stop intervals.

▶ **Choose non-CPU lens number.** Press the Function button and rotate the Main Command dial to choose one of your presets for a non-CPU lens.

▶ **Playback.** This allows the Fn button to act as the Playback button. Pressing the Fn button displays the last image shot. You can then use the Multi-selector to scroll through the images as normal.

▶ **Start movie recording.** When you're using Live View, this allows you to start video recording by pressing the Fn button. This also disables the OK button for video recording.

f4 – Assign preview button

The Assign preview button menu option allows you to assign a function to the Depth-of-field preview button. The choices are exactly the same as that of the Function button.

f5 – Assign AE-L/AF-L button

The Assign AE-L/AF-L button menu option allows you to assign a function to the AE-L/AF-L button. Locking these settings allows you to focus, meter, or both on a subject and recompose without losing focus or exposure settings (depending on which setting you select). You have six choices: AE/AF lock, AE lock only, AF lock only, AE lock (Hold), AF-ON, and FV lock.

f6 – Customize command dials

The Customize command dials menu option allows you to control how the Main Command and Sub-command dials function. The options include

▶ **Reverse rotation.** This causes the settings to be controlled in reverse of what is normal. For example, by default, rotating the Sub-command dial right makes your aperture smaller. By reversing the dials, you get a larger aperture when rotating the dial to the right.

▶ **Change main/sub.** This switches the functions of the Main Command dial to the front of the camera and the Sub-command dial to the rear.

▶ **Aperture setting.** This allows you to change the aperture only using the aperture ring of the lens. Note that most newer lenses have electronically controlled apertures (Nikkor G lenses) and do not have an aperture ring. When this setting is used with a lens without an aperture ring, the Sub-command dial controls the aperture by default.

▶ **Menus and playback.** This allows you to use the command dials to scroll the menus and images in much the same fashion the Multi-selector is used. In Playback mode, the Main Command dial is used to scroll through the preview images and the Sub-command dial is used to view the shooting information and/ or histograms. When in Menu mode, the Main Command dial functions the same as the Multi-selector up and down and the Sub-command dial operates the same as the Multi-selector left and right.

f7 – Release button to use dial

When changing the Shooting mode, exposure compensation, flash mode, WB, QUAL, or ISO, you must press and hold the corresponding button and rotate the Command dial to make changes. The Release button to use dial menu option allows you to press and release the button, make your setting changes using the Command dial, and then press the button again to lock in the settings.

f8 – Slot empty release lock

The Slot empty release lock menu option controls whether the shutter will release when no memory card is present in the camera. When this option is set to Enable release, the shutter fires and the image is displayed in the LCD screen and is tempo-rarily saved. When it is set to Release locked, the shutter will not fire. If you happen to be using Camera Control Pro 2 shooting tethered directly to your computer, the camera shutter will release no matter what this option is set to.

f9 – Reverse indicators

The Reverse indicators menu option allows you to reverse the indicators on the electronic light meter displayed in the viewfinder and on the LCD control panel on the top of the camera. The default setting showing the overexposure on the left and the underexposure on the right can seem counterintuitive. Reversing these makes more sense to some people (including me). This option also reverses the display for the Auto-bracketing feature.

f10 – Assign MB-D11 AE-L/AF-L button

The Assign MB-D11 AE-L/AF-L button menu option allows you to set different options for the AE-L/AF-L button when using the MB-D11 battery grip. The options are as follows:

▶ **AE/AF Lock.** The focus and exposure lock when you press and hold the button.

▶ **AE Lock only.** The exposure locks when you press and hold the button. Focus continues to function normally.

▶ **AF Lock only.** The focus locks while you press and hold the button. The AE continues as normal.

▶ **AF-ON.** This sets the AE-L/AF-L button to initiate AF when pressed. This disables the Shutter Release button for autofocusing.

 When you use the MB-D11 AE-L/AF-L button for autofocusing, the Vibration Reduction (VR) function is not activated

▶ **AE Lock (hold).** The exposure locks until you press the button a second time or turn off the exposure meter.

▶ **FV lock.** This option allows you to lock the Flash exposure. The camera fires a preflash to determine the proper flash exposure value and locks the setting, allowing you to meter the subject and then recompose the shot without altering the flash exposure. The flash exposure is locked with one button press and unlocked with a second press.

▶ **Same as Fn button.** This sets the AE-L/AF-L button to the same option as the camera's Fn button.

Setup Menu

The Setup menu contains a smattering of options, most of which you won't change very frequently. Some of these settings include Time zone and date and Video mode. A couple other options are the Clean image sensor and Battery info, which you may want to access from time to time. There are 24 different options.

Format memory card

Formatting your card allows the camera to save the data in a more orderly fashion so that the data isn't fragmented. It's a good idea to format your card every time you download the images to your computer (just be sure all the files are successfully transferred before formatting). Formatting the card helps protect against corrupt data. Simply deleting the images leaves the data on the card and allows it to be overwritten; sometimes this older data can corrupt the new data as it is being written. Formatting the card gives your camera a blank slate on which to write.

You can also format the card using the much more convenient two-button method (pressing and holding the Delete and Metering mode buttons simultaneously).

Save user settings

This is one of the nicest features introduced with the D7000. Save user settings allows you to save all your settings so that they can be recalled instantly by the simple twist of the Mode dial. If you do one certain type of photography a lot, you will appreciate this feature.

Reset user settings

The Reset user settings option returns the user settings (U1 and U2 on the mode dial) to the camera default settings.

LCD brightness

The LCD brightness menu sets the brightness of your LCD screen. You may want to make the screen brighter when viewing images in bright sunlight or make it dimmer when viewing images indoors or to save battery power. You can adjust the LCD ±3 levels. The menu shows a graph with ten bars from black to gray on to white. In the optimal setting, you can see a distinct change in color tone in each of the ten bars. If the last two bars on the right blend together, your LCD is too bright; if the last two bars on the left side blend together, your LCD is too dark.

3.14 **The Setup menu shown combines three images (screens) so all options are visible.**

Clean image sensor

This great feature was released with the D300 and added to the D7000. With the Clean image sensor feature, the camera uses ultrasonic vibration to help remove any dust or debris off the filter in front of the sensor. This helps keep some of the dust off

of your sensor but is not going to keep it absolutely clean forever. You may have to have the sensor professionally cleaned periodically.

You can choose Clean now, which cleans the image sensor immediately, or you can choose one of four separate options for cleaning that you access in the Clean at startup/shutdown submenu option. They include Clean at startup, Clean at shutdown, Clean at startup and shutdown, and Cleaning off.

Lock mirror up for cleaning

The Lock mirror up for cleaning menu option locks up the mirror so the image sensor can be safely accessed for inspection or for additional cleaning. The sensor is also powered down to reduce any static charge that may attract dust. Although it's fairly easy and some people prefer to clean their own sensors, I recommend taking your camera to an authorized Nikon service center for any sensor cleaning while the camera is under warranty. Any damage you cause by improperly cleaning the sensor will not be covered by warranty and can lead to a very expensive repair bill.

Video mode

There are two options in this menu: NTSC (National Television System Committee) and PAL (Phase Alternating Line). Without getting into too many specifics, these are types of standards for the resolution of televisions. All of North America, including Canada and Mexico, use the NTSC standard, while most of Europe and Asia use the PAL standard. Check your television owner's manual for the specific setting if you plan to view your images on a TV directly from the camera.

HDMI

The D7000 has an HDMI (High-Definition Multimedia Interface) output that allows you to connect your camera to an HD TV to review your images. There are five settings: 480p, 576p, 720p, 1080i, and Auto. The Auto feature automatically selects the appropriate setting for your TV. Before plugging your camera in to an HD TV I recommend reading your TV's owner's manual for specific settings. When the camera is attached to an HDMI device, the LCD screen on the camera is automatically disabled.

You can also set the Device control to On or Off when connecting to High-Definition Multimedia Interface–Consumer Electronic Control (HDMI-CEC) devices. These devices allow you to use the remote control of your HDMI device in the same way as you would the Multi-selector when playing back images.

Flicker reduction

When shooting under certain types of light, most notably fluorescent and mercury vapor, the video tends to flicker due to the normal fluctuation of the electrical cycle. There are two options under the Flicker reduction menu setting: 50 hertz (Hz) and 60 Hz. In the United States and North America, the proper setting is 60 Hz, and in Europe, the correct setting is 50 Hz.

Time zone and date

You set the camera's internal clock under the Time zone and date menu option. You also select a time zone, choose the date display options, and turn the daylight saving time options on or off.

Language

You use the Language menu option to set the language that the menus and dialog boxes display.

Image comment

You can use the Image comment menu option to attach a comment to the images taken by your D7000. You can enter the text using the Input comment menu. You can view the comments in Capture NX 2 or ViewNX 2 software or in the photo info on the camera. Setting the Attach comment option applies the comment to all images taken until this setting is disabled. Comments you may want to attach include your name or the location where the photos were taken.

Auto image rotation

The Auto image rotation setting tells the camera to record the orientation of the camera when the photo is shot (portrait or landscape). This allows the camera as well as image-editing software to show the photo in the proper orientation so you don't have to take the time in post-processing to rotate images shot in portrait orientation.

Image Dust Off ref photo

The Image Dust Off ref photo menu option allows you to take a Dust Off reference photo that shows any dust or debris that may be stuck to your sensor. Capture NX 2 then uses the image to automatically retouch any subsequent photos where the specks appear.

To use this feature, either select Start or Clean sensor and then start. Next you are instructed by a dialog box to take a photo of a bright featureless white object that is about 10 centimeters from the lens. The camera automatically sets the focus to infinity. You can only take a Dust off reference photo when using a CPU lens. It's recommended to use at least a 50mm lens, and when using a zoom lens, zoom all the way in to the longest focal length.

Battery info

The handy little Battery info menu allows you to view information about your batteries. It shows you the current charge of the battery as a percentage and how many shots have been taken using that battery since the last charge. This menu also shows the remaining charging life of your battery before it is no longer able to hold a charge. I find myself accessing this menu quite a bit to keep a real-time watch on my camera's power levels. AA batteries cannot provide the camera with data. The menu options are as follows:

▶ **Bat. meter.** This tells you the percentage of remaining battery life from 100% to 0%. When the MB-D11 is attached and loaded with AA batteries, a percentage is not shown but there is a battery indicator that shows full, 50%, and 0% power levels.

▶ **Pic. meter.** This tells you how many shutter actuations the battery has had since its last charge. This option is not displayed for the MB-D11 when you're using AA batteries.

▶ **Charging life.** This is a gauge that goes from 0 to 4, telling you how much working life you have left in your battery given Li-Ion batteries have a finite life. This option is not shown for AA batteries. When shooting outside in temperatures below 41° F (5° C), this gauge may temporarily show that the battery life has lost some of its charging life. When it is brought back to a normal operating temperature of about 68° F the gauge will read correctly.

Wireless transmitter

The Wireless transmitter menu option is used to change the settings of the optional WT-4 wireless transmitter. You cannot access this menu option when the WT-4 is not attached. See the instructions for WT-4 wireless transmitter for more information.

Copyright information

The Copyright information menu option is a great feature that allows you to imbed your name and copyright information directly into the EXIF (Exchangeable Image File Format)

data of the image as it is being recorded. Enter the information using the text entry screen. You can turn this option on or off without losing the actual information. You may want to turn this option off when doing work for hire, when you get paid to take the photos but relinquish all copyright and ownership to the person who hired you.

Save/load settings

The Save/load settings menu option allows you to save the current camera settings to a memory card. You can then store this memory card somewhere or transfer the file to your computer. You can also load these settings back to your camera in case of an accidental reset or load them onto a second D7000 to duplicate the settings quickly.

GPS

You use the GPS menu to adjust the settings of an optional GPS (Global Positioning System) unit, which can be used to record longitude and latitude to the images' EXIF data. The GPS is connected to the camera's accessory terminal. Nikon makes a dedicated GPS attachment, the GP-1.

Virtual horizon

The Virtual horizon menu option is a handy feature, similar to a heads-up display in a fighter plane, that allows you to check if your camera is level. The feature uses a sensor inside the camera to determine whether it's level. When the camera is completely level, the Virtual horizon is displayed in green. If you shoot a lot of landscapes and your tripod doesn't have a level, you're in luck — this is the perfect tool for you. You can also view the Virtual horizon display directly overlaid on the Live View screen by pressing the Info button repeatedly when using Live View mode.

Non-CPU lens data

Non-CPU lenses are manual focus lenses that don't have a CPU chip built in that enables the lens and camera to communicate data back and forth. The Non-CPU lens data menu option enables you to enter focal length and aperture data for up to nine different lenses.

Different features within the camera require focal length and aperture information to function properly. First, if information about the lens isn't entered, it won't show in the EXIF data. Second, when a non-CPU lens is attached to the camera, the metering mode automatically defaults to Center-weighted. Entering the lens data enables you to use Color Matrix metering (3D Color Matrix Metering II requires a D- or G-type CPU lens). Third, entering the lens data allows the Auto-zoom feature to work with the

SB-600, SB-700, SB-800, or SB-900. Finally, you also need to enter the lens data for the SB-800 or SB-900 flash to function properly using the Auto Aperture setting. To set the lens data when using a non-CPU lens, follow these steps:

1. **Use the Multi-selector to select non-CPU lens data from the Setup menu, and then press the Multi-selector right.**

2. **Press the Multi-selector left or right button to select a lens number from 1 to 9 to set the information.** Press the Multi-selector down.

3. **Select the focal length of your non-CPU lens.** You can use a lens from as wide as 6mm to as long as 4000mm. Press the Multi-selector down.

4. **Choose the maximum aperture of your lens.** You can choose from f/1.2 to f/22.

5. **Use the Multi-selector to highlight Done, and then press the OK button to save the lens data.**

AF fine tune

The AF fine tune menu option allows you to adjust the AF to fit a specific lens. Lenses are manufactured to tight specifications, but sometimes lens elements can shift a few microns due to impact or general wear and tear. These small abnormalities can cause the lens to shift its plane of focus behind or in front of the imaging sensor. This is usually a rare occurrence, but it's a possibility.

You can now fine-tune the camera's AF to correct for any focusing problems. This feature can save you the time and hassle of sending your lens in for calibration. Another good thing about this feature is that if you're using a CPU lens, the camera remembers the fine-tuning for that specific lens and adjusts it for you automatically. Here's a brief rundown on how to adjust the AF fine-tuning:

1. **Using the Multi-selector, choose AF fine tune from the Setup menu and then press the OK button.**

2. **Turn AF fine tune on by selecting AF fine tune (On/Off) in the menu, Highlight On, and then press the OK button.**

3. **Highlight Saved value and then press the OK button.**

4. **Press the Multi-selector up and down to adjust the plane of focus.** You have to use a little guesswork. Determine if the camera is focusing behind the subject or in front of it and, if so, how far?

5. **Once the plane of focus is adjusted, press the OK button.**

6. **Set the Default.** This should be set to 0. Press the OK button.

 The saved value stores separate tuning values for each individual lens. This is the value that will be applied when the specific lens is attached and the AF fine tune option is turned on.

 When the AF fine tune is on and a lens without a stored value is attached, the camera will use the default setting. This is why I recommend setting the default to 0 until you can determine whether the lens needs fine-tuning or not.

Each CPU lens you fine-tune is saved into the menu. To view them, select List Saved Values. From there you can assign a number to the saved values from 0 to 99 (although the camera only stores 12 lens values). Possibly you could use the number to denote what lens you're using; for example, use the number 50 for a 50mm lens, the number 85 for an 85mm lens, and so on.

The best thing to do when attempting to fine-tune your lenses is to set them up one by one and do a series of test shots. You need to do your test shots in a controlled manner so there are no variables to throw off your findings.

First, get an AF test chart. You can find these on the Internet or you can send me an e-mail through my Web site (http://deadsailorproductions.com) and I can send you one to print out. An AF test chart has a spot in the center that you focus on and a series of lines or marks set at different intervals. Assuming you focus on the right spot, the test chart can tell you whether your lens is spot on, back focusing, or front focusing. The test chart needs to be lit well for maximum contrast. Not only do you need the contrast for focus, but also it makes it much easier to interpret the test chart. Using bright, continuous lighting is best, but flash can work as well. Lighting from the front is usually best.

Next, set your camera Picture Control to ND (Neutral). Ensure that all in-camera sharpening is turned off and contrast adjustments are at zero. This is to be sure that you are seeing actual lens sharpness, not sharpness created by post-processing.

Lay the AF test chart on a flat surface. This is important: There must be no bumps or high spots on the chart or your results won't be accurate. Mount the camera on a tripod and adjust the tripod head so that the camera is at a 45° angle. Be sure that the camera lens is just about at the minimum focus distance to ensure the narrowest depth of field. Set the camera to Single-servo AF mode and use Single-area AF mode and the center AF point. Focus on the spot at the center of the AF test chart. Be sure not to change the focus point or move the tripod while making your tests. Set the camera to Aperture Priority and open the aperture to its widest setting to achieve a

narrow depth of field. (This makes it easier to figure out where the focus is falling — in the front or the back.) Use a Nikon ML-L3 remote control release, Mirror lock up, exposure delay or the self-timer to be sure there is no blur from camera shake. The first image should be shot with no AF fine-tuning.

Look at the test chart. Decide whether the camera is focusing where it needs to be or if it's focusing behind or in front of where it needs to be. Next, you can make some large adjustments to the AF fine-tuning (+5, –5, +10, –10, +15, –15, +20, –20), taking a shot at each setting. Be sure to defocus and refocus after adjusting the settings to ensure accurate results. Compare these images and decide which setting brings the focus closest to the selected focus point. After comparing them, you may want to do a little more fine-tuning; to –7 or +13, for example.

This can be a tedious and time-consuming project. That being said, most lenses are already spot on and it probably isn't necessary to run a test like this on your lens unless it is extremely noticeable that the lens is consistently out of focus.

Eye-Fi upload

This option is only available when using an Eye-Fi wireless SD card, which allows you to upload your images straight from your camera to your computer using your wireless router.

Firmware version

The Firmware version menu option displays which firmware version your camera is currently operating under. Firmware is a computer program that is embedded in the camera that tells it how to function. Camera manufacturers routinely update the firmware to correct for any bugs or to make improvements to the camera's functions. Nikon posts firmware updates on its Web site at www.nikonusa.com.

Retouch Menu

With the D300, Nikon started offering in-camera editing features on a professional-level dSLR. Formerly, this type of feature was only available on compact digital cameras and consumer-level dSLRs. These in-camera editing options, which you access through the Retouch menu, make it simple for you to print straight from your camera without downloading the images to your computer or using any image-editing software.

The Retouch menu options vary from cropping your image to adjusting the color balance to eliminating red-eye. And remember, your original images are untouched so you can experiment with these features all you want without worrying about ruining your original. The software doesn't change the existing image; rather, it saves a JPEG copy of the retouched image, leaving the original image untouched.

My Menu/Recent Settings

This tab can be set to Recent settings, which saves your 20 most recently used settings for quick access. You can also remove the settings by using the Multi-selector to highlight the setting and pressing the Delete (trashcan) button. You can also choose to set the tab to My Menu, which allows you to program in your most frequently used settings for quick access.

To add items, simply select the Add items tab, scroll through the menus and press OK when the desired menu item is highlighted. To remove items from My Menu, select the Remove items tab. A list will be shown with available menu items; scroll through it and use the Multi-selector to select the items to remove. Scroll up to Done and press OK to save changes.

Info Display Settings

The Info Display Settings option allows you access to several of the most commonly changed menu items. To show the Info Display, press the Info button on the bottom right rear of the camera. This displays the Shooting info screen on the rear LCD. While the shooting information is displayed, press the Info button again. This grays out the shooting information and highlights the settings shown at the bottom of the Shooting info screen. Use the Multi-selector directional buttons to highlight the setting you want to change, and then press the OK button. This takes you straight to the specific menu option. The Info Display options include Movie Quality, Auto distortion control, High ISO Noise Reduction, Long exposure Noise Reduction, Active D-Lighting, Picture Control, Color space, Assign AE-L/AF-L button, Assign Preview button, and Assign Function (Fn) button.

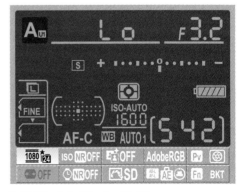

3.15 The Info Display Settings

Selecting and Using Lenses for the Nikon D7000

The choice of lenses today is much more vast than it was just as little as five years ago. With the advent of dSLRs and the DX sensor format, most camera and lens manufacturers quickly realized that the standard focal lengths being used for traditional film SLR cameras were not quite adequate. The demand for true wide-angle lenses was great and the increasing resolution of sensors led lens manufacturers to come up with new lens designs optimized for the digital era. This has benefited today's digital photographers because lenses today are truly the world's best and are affordable. With the multitude of lenses available today, selecting one can be a daunting task. This chapter gives you some background on the different types of lenses available.

The ability to use a variety of lenses is one of the main advantages of using a dSLR camera.

Intro to Lenses

A lens is one of the most important parts of a photographer's kit, arguably more important than the camera body itself because a good lens usually outlives the camera body — especially in a day and age when camera bodies are upgraded once a year or more. A lot of my lenses have been with me for more than a decade, while I've been through about a dozen camera bodies.

There are many different types of lenses, and each type allows you to portray your subjects in a different manner. One of the cool things about photography is that your lens choice enables you to show your subjects and surroundings in a way that's just not possible with the human eye. Some people will argue that photography allows you to render a scene realistically so it can be remembered as it was, but I think photography has endured because you can not only realistically render the scene, but also distort that reality with your lens choice.

Nikon Lens Compatibility

Although Nikon has been manufacturing lenses for many decades, with the D7000, you can use almost every Nikon lens made since about 1977, albeit some lenses will have limited functionality. In 1977, Nikon introduced the Auto-Indexing (AI) lens. Auto-Indexing allows the aperture diaphragm on the lens to remain wide open until the shutter is released; the diaphragm then closes down to the desired f-stop. This allows maximum light to enter the camera, which makes focusing easier. You can also use some of the earlier lenses, known now as pre-AI, but most need some modifications to work with the D7000.

Nikon's early lenses are manual focus though you can still use other modern features such as the camera's light-metering system. However, some advanced features of the metering system, such as 3D Color Matrix Metering and Balanced Fill-Flash, will not function.

In the 1980s, Nikon started releasing AF lenses. Many of these lenses are very high quality and cost less than their 1990s counterparts, the AF-D lenses. The main difference between the lenses is that the D lenses provide the camera with distance information based on the focus of the subject. These lenses focus by using a screw-type drive motor that's typically found inside the camera body (the D7000 has a screw drive motor). During this time while Nikon was refining its AF motor, many of the super-telephoto lenses remained MF (manual focus). Nikon fitted these lenses with a CPU for the lens to convey information with the camera body. These are known as AI-P lenses.

 Some lower-level Nikon cameras have had the screw-type drive motor removed. The D40, D60, and D5000 are a few examples.

More recently, Nikon has been producing its line of AF-S lenses. These lenses have a built-in Silent Wave Motor. The AF-S motor allows the lenses to focus much more quickly than the traditional screw-type lenses and also allows the focusing to be ultra-quiet. Most of these lenses are also known as G-type lenses and lack a manual aperture ring. The aperture is controlled by using the Sub-command dial on the camera body. A few years ago, only the very expensive pro lenses had the Silent Wave Motor. Nikon now offers this in even the entry-level lenses.

To date, Nikon offers about 30 AF-S lenses. These lenses range from a super-wide 10-24mm zoom lens all the way up to a 600mm super-telephoto lens. Most of the AF-S lenses are zoom lenses, but Nikon does offer a few fixed focal-length lenses. These fixed focal-length, or *prime*, lenses are mostly in the telephoto to super-tele-photo range, with the exceptions being the 35mm f/1.8, 50mm f/1.4G, and 60mm f/2.8G macro lens. Nikon's AF-S lenses range in price from around $150 for the 18-55mm f/3.5-5.6 to almost $10,000 for the 600mm f/4 with VR, so there's an AF-S lens available whatever your budget may be.

Deciphering Nikon's Lens Codes

When shopping for lenses, you may notice all sorts of letter designations in the lens name. For example, the kit lens is the AF-S DX Nikkor 18-55mm f/3.5-5.6G ED VR. So, what do all those letters mean? Here's a simple list to help you decipher them:

▶ **AI/AIS.** These are Auto-Indexing lenses that automatically adjust the aperture diaphragm down when the Shutter Release button is pressed. All lenses made after 1977 are Auto-Indexing, but when referring to AI lenses, most people generally mean the older manual focus (MF) lenses.

▶ **E.** These lenses are Nikon's budget series lenses, made to go with the lower-end film cameras, such as the EM, FG, and FG-20. Although these lenses are compact and are often constructed with plastic parts, some of them, especially the 50mm f/1.8, are of quite good quality. These lenses are also manual focus only.

▶ **D.** Lenses with this designation convey distance information to the camera body to aid in metering for exposure and flash.

▶ **G.** These are newer lenses that lack a manually adjustable aperture ring. You must set the aperture on the camera body. These lenses also convey distance information to the camera body.

▶ **AF, AF-D, AF-I, and AF-S.** All these lens codes denote that the lens is an auto-focus (AF) lens. The AF-D represents a distance encoder for distance information, the AF-I indicates an internal focusing motor type, and the AF-S indicates an internal Silent Wave Motor.

▶ **AI-P.** This designates a manual focus lens that has a CPU chip.

▶ **DX.** This lets you know the lens was optimized for use with Nikon's DX-format sensor. The DX designation is explained in depth in the next section.

▶ **VR.** This code denotes that the lens is equipped with Nikon's Vibration Reduction image stabilization system.

▶ **ED.** This indicates that some of the glass in the lens is Nikon's Extra-Low Dispersion (ED) glass, which means the lens is less prone to lens flare and chromatic aberrations. Chromatic aberrations can be seen as color fringing around the edges of a high contrast subject. They are usually more pronounced at the edges of the images.

▶ **Micro-Nikkor.** This is Nikon's designation for macro lenses that allow close-up focusing.

▶ **IF.** IF stands for *internal focus*. The focusing mechanism is inside the lens, so the front of the lens doesn't rotate or move in and out when focusing. This feature is useful when you don't want the front of the lens element to move — for example, when you use a polarizing filter. The internal focus mechanism also allows for faster focusing.

▶ **DC.** DC stands for *Defocus Control*. Nikon only offers a couple of lenses with this designation. These lenses make the out-of-focus areas in the image appear softer by using special lens elements to add spherical aberration. The parts of the image that are in focus aren't affected. Currently, the only Nikon lenses with this feature are the 135mm f/2 and the 105mm f/2. Both are considered portrait lenses.

▶ **N.** On some of Nikon's newest professional lenses, you may see a large, golden N. This means that the lens has Nikon's Nano Crystal Coating, which is designed to reduce flare and ghosting.

4.1 Nikon lenses have a veritable alphabet soup of designations on them. These lens codes designate that a Silent Wave Motor is on an 18-200mm f/3.5-5.6 lens with no aperture ring, the lens has Extra-Low Dispersion lens elements, and it is meant for use on a DX camera.

DX Crop Factor

Crop factor is a ratio that describes the size of a camera's imaging area as compared to another format; in the case of SLR cameras, the reference format is 35mm film.

SLR camera lenses were designed around the 35mm film format. Photographers use lenses of a certain focal length to provide a specific *field of view*. The field of view, also called the *angle of view*, is the amount of the scene that's captured in an image. This is usually described in degrees. For example, when you use a 16mm lens on a 35mm camera, it captures almost 180° of the scene, which is quite a bit. Conversely, when you use a 300mm focal length, the field of view is reduced to a mere 6.5°, which is a very small part of the scene. The field of view is consistent from camera to camera because all SLRs use 35mm film, which has an image area of 24mm × 36mm.

With the introduction of digital SLRs, the sensor was designed to be smaller than a frame of 35mm film to keep costs down because the sensors are more expensive to manufacture. This sensor size was called APS-C or, in Nikon terms, the DX-format. The lenses that are used with DX-format dSLRs have the same focal length they've always had, but because the sensor doesn't have the same amount of area as the film, the field of view is effectively cropped. This causes the lens to provide the field of view of a longer focal lens when compared with 35mm film images.

4.2 This image was shot with a 28mm lens on a D700 FX camera. The amount of the scene that would be captured with the same lens on a DX camera like the D7000 appears inside the red square.

Fortunately, the DX sensors are a uniform size, so you can refer to this standard to determine how much the field of view is reduced on a DX-format dSLR with any lens. The digital sensors in Nikon DX cameras have a 1.5X crop factor, which means that to determine the equivalent focal length of a 35mm or FX camera, you simply have to multiply the focal length of the lens by 1.5. Therefore, a 28mm lens provides an angle of coverage similar to a 42mm lens; a 50mm is equivalent to a 75mm; and so on.

 An easy way to figure out crop factor without a calculator is simply to halve the focal length number and then add that number to the focal length. For example, half of 50mm is 25mm, so add 25mm to 50mm and you get 75mm.

When dSLRs were first introduced, all lenses were based on 35mm film. The crop factor effectively reduced the coverage of these lenses, causing ultrawide-angle lenses to perform like wide-angle lenses, wide-angle lenses to perform like normal lenses, normal lenses to provide the same coverage as short telephotos, and so on. Nikon has created specific lenses for dSLRs with digital sensors. These lenses are known as DX-format lenses. The focal length of these lenses was shortened to fill the gap to allow true super-wide-angle lenses. These DX-format lenses were also redesigned to cast a smaller image inside the camera so that the lenses could actually be made smaller and use less glass than conventional lenses. The byproduct of designing a lens to project an image circle to a smaller sensor is that these same lenses can't be used effectively with the FX-format and can't be used at all with 35mm film cameras (without severe vignetting) because the image won't completely fill an area the size of the film or FX sensor.

There is an upside to this crop factor: Lenses with longer focal lengths now provide a bit of extra reach. A lens set at 200mm now provides the same amount of coverage as a 300mm lens, which can give you a great advantage with sports and wildlife photography or when you simply can't get close enough to your subject.

Another advantage with DX lenses is that because DX lenses are smaller, they can be manufactured for less, which in turn means DX lenses are less expensive than their full-frame counterparts.

Detachable Lenses

Although your D7000 may come with a kit lens — the 18-105mm f/3.5-5.6G VR — one advantage to owning a dSLR is the ability to use detachable lenses. This allows you to change your lens to fit the specific photographic style or scene that you want to capture. After a while, you may find that the kit lens doesn't meet your needs and you

want to upgrade. Nikon dSLR owners have quite a few lenses from which to choose, all of which benefit from Nikon's expertise in the field of lens manufacturing.

One of the great things about photography is that through your lens choice, you can show things in a way that the human eye can't perceive. The human eye is basically a fixed-focal-length lens. We can only see a certain set angular distance. This is called our field of view (or angle of view). Our eyes have about the same field of view as a 35mm lens on your D7000. Changing the focal length of your lens, whether by switching lenses or zooming, changes the field of view, enabling the camera to "see" more or less of the scene that you're photographing. Changing the focal length of the lens allows you to change the perspective of your images. In the following sections, I discuss the different types of lenses and how they can influence the subjects that you're photographing.

Kit Lenses

Some Nikon D7000 cameras come paired with Nikon's 18-105mm f/3.5-5.6G VR AF-S DX lens, which was first offered coupled with the D90. This lens covers the most commonly used focal lengths for everyday photography. The 18mm setting covers the wide-angle range, and zooming all the way out to 105mm gives you a decent tele-photo setting, allowing you to get close-up photos of subjects that may not be very close. The kit lens also has Nikon's Vibration Reduction (VR) feature. This feature allows you to hand hold the camera at slower shutter speeds without worrying about image blur that can be caused by camera shake.

The 18-105mm VR lens has received many good reviews. The optics give you sharp images with good contrast when stopped down a bit. However, when you are shooting wide open, the images can appear a little soft around the corners. It should be said here that all lenses have a "sweet spot," or a range of apertures at which they appear sharpest. With most lenses, this sweet spot is usually one or two stops from the maximum aperture. For the kit lens, the sweet spot is around f/8 to f/11. Another thing to be aware of is that as the aperture gets smaller than f/16, you also may lose some sharpness due to the diffraction of the light by the aperture blades.

 Stopping down refers to making the aperture smaller, and *opening up* refers to making the aperture larger.

Although Nikon offers many very high-quality professional lenses, the D7000 kit lenses are very good performers for their price range, and they offer some advantages when paired with the D7000 that even some of Nikon's more expensive lenses don't. These advantages include the following:

▶ **Low cost.** The 18-105mm VR lens costs less than $300, while the 55-200mm VR lens comes in at around $250. The 18-200mm VR lens retails for around $750. Buying both the 18-55mm and 55-200mm VR lenses can save you around $200.

▶ **Excellent image quality.** These lenses offer very high quality for the price. They offer aspherical lens elements, which help to eliminate distortion, and Nikon's Super Integrated Coating on the lens helps to ensure accurate color and reduce lens flare. These lenses have been praised by professional and amateur reviewers alike. They are uncommonly sharp for a lens in this price range.

▶ **Compact size.** Being that they are designed specifically for dSLR cameras, these lenses are small in size and super light. They are great lenses for everyday use or long trips where you don't want a lot of gear weighing you down.

▶ **VR.** Vibration Reduction is a very handy feature, especially when you are working in low-light situations or using a long focal length. It can allow you to hand hold your camera at slower shutter speeds than you can with standard lenses.

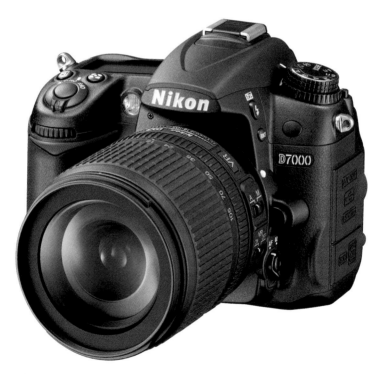

Image courtesy of Nikon, Inc.

4.3 The D7000 with the 18-105mm kit lens

Zoom Versus Prime Lenses

The debate over whether to use zoom or prime lenses has been a hot topic for many years. In the past eight years or so, lens technology has grown by leaps and bounds, and zoom lenses are just about as sharp as primes or, in the case of the Nikkor 14-24mm f/2.8, even sharper than most primes. Some photographers prefer primes, and some prefer zooms. It's largely a personal choice, and there are some things to consider.

Understanding zoom lenses

A zoom lens, such as the AF-S Nikkor 14-24mm, is a lens that has multiple optical elements that move within the lens body; this allows the lens to change focal length, and therefore field of view, which is how much of the scene you can see at any given focal length.

One of the main advantages of the zoom lens is its versatility. You can attach one lens to your camera and use it in a wide variety of situations.

There are a few things to consider when buying zoom lenses (or upgrading from one you already have), including variable aperture, depth of field, and quality.

Variable aperture

One of the major issues when buying a consumer-level lens such as the 18-105mm VR lens is that it has a variable aperture, which means that as you zoom in on something when shooting wide open or closed down to the minimum aperture, the aperture opening gets smaller, allowing less light to reach the sensor and causing the need for a slower shutter speed or higher ISO setting. Most high-end lenses have a constant aperture all the way through the zoom range. In daylight or brightly lit situations, this may not be a factor, but when shooting in low light, this can be a drawback. Although the VR feature helps when shooting relatively still subjects, moving subjects in low light are blurred.

If you do a lot of low-light shooting of moving subjects, such as concert photography, you may want to look into getting a zoom lens with a wider aperture such as f/2.8. These are fast aperture pro lenses and usually cost quite a bit more than your standard consumer zoom lens. The lens I use most when photographing action in low light is the Nikkor 17-55mm f/2.8; this lens allows me to use an ISO of about 800 (keeping the noise levels low) and has relatively fast shutter speeds to freeze the motion of the subject.

☐ : Nano Crystal Coat

☐ : Aspherical lens elements

☐ : ED glass elements

4.4 Lenses are made up of many different glass elements. This is a diagram of the inside of a Nikon 24-70mm f/2.8 lens.

Depth of field

Another consideration when buying a consumer-level zoom lens is depth of field. For example, the 18-55mm lens, because the aperture is inherently smaller and grows smaller as it zooms in, gives you more depth of field at all focal lengths than a lens with a wider aperture. If you are shooting landscapes, this may not be a problem, but if you are getting into portrait photography, you may want a shallower depth of field; therefore, a lens with a wider aperture is probably what you want.

Quality

In order to make consumer lenses like the 18-105mm VR affordable, Nikon manufactures them mostly out of a composite plastic. Although the build quality is pretty good, the higher-end lenses have metal lens mounts and some have metal alloy lens bodies. This makes them a lot more durable in the long run, especially if you are rough on your gear like I sometimes am. Conversely, the plastic bodies of the consumer lenses are much smaller and lighter than their pro-level counterparts. This is a great feature when you are traveling or if you want to pack light. If I'm going on a quick day trip, more often than not, I'll just grab my D7000 kit and go. It's more compact and much lighter than my other cameras and lenses and I appreciate the small size.

Understanding prime lenses

Before zoom lenses were available, the only option a photographer had was using a prime lens, also called a *fixed-focal-length* lens. Because each lens is fixed at a certain focal length, when the photographer wanted to change how much of the scene is in the image, he had to either physically move farther away from or closer to the subject, or swap out the lens with one that had a focal length more suited to the range.

The most important features of the prime lens are that they can offer a faster maximum aperture, are generally far lighter, and usually cost much less (ultra-fast wide-angle primes, such as the 24mm f/1.4, are the exception). Normal focal length prime lenses, such as the 35mm f/1.8, aren't very long, so the maximum aperture can be faster than it is with zoom lenses. Most standard prime lenses also require fewer lens elements and moving parts, so the weight can be kept down considerably, and because there are fewer elements, the overall cost of production is less; therefore, you pay less.

You might say, "Well, if I can buy one zoom lens that encompasses the same range as four or five prime lenses, then why bother with prime lenses?" While this may sound logical, there are a few reasons why you might choose a prime lens over a zoom lens.

▶ **Sharpness.** Prime lenses don't require as many lens elements (pieces of glass) as zoom lenses do, and this means that prime lenses are almost always sharper than consumer-level zoom lenses. Although it has to be said, with the advances in machining and lens manufacturing, high-end zoom lenses are on par with primes for sharpness.

▶ **Speed.** Some prime lenses have faster apertures than any available zooms. The fastest zoom lens you can find is f/2.8. The 35mm f/1.8 is about 1 1/3 of a stop faster than a zoom, and an f/1.4 lens is a full 2 stops faster.

Nikon now offers a pretty good selection of AF-S prime lenses. Currently, the AF-S prime lens lineup consists of the 24mm f/1.4, 35mm f/1.8, 35mm f/1.4, 50mm f/1.4, 85mm f/1.4, 60mm f/2.8 macro, 85mm f/3.5 macro, and

Image courtesy of Nikon, Inc.

4.5 The Nikkor 35mm f/1.8G AF-S fixed-focal-length prime lens is one of the best bargains in the fast prime lenses arena.

105mm f/2.8 VR macro. For telephoto primes, you have the 200mm, 300mm, 400mm, 500mm, and 600mm telephoto lenses. Unfortunately, apart from the 35mm f/1.8, which can be purchased for about $200, most of these lenses are quite expensive. For a super fast lens, the 50mm f/1.4 is a good value for about $500, and for a macro lens, consider the 85mm f/3.5, which can be found for right around $500 as well.

Wide-angle and Ultrawide-angle Lenses

Wide-angle lenses, as the name implies, provide a very wide angle of view of the scene you're photographing. Wide-angle lenses are great for photographing a variety of subjects, but they're especially excellent for subjects such as landscapes and group portraits, where you need to capture a wide area of view.

The focal-length range of wide-angle lenses starts out at about 10mm (ultrawide) and extends to about 24mm (wide angle). Most wide-angle lenses on the market today are zoom lenses, although there are quite a few prime lenses available. Wide-angle lenses are generally *rectilinear*, meaning that there are lens elements built in to the lens to correct distortion; this way, the lines near the edges of the frame appear straight. Fisheye lenses, which are also a type of wide-angle lens, are *curvilinear*; the lens elements aren't corrected, resulting in severe optical distortion. I discuss fisheye lenses later in this chapter.

In recent years, lens technology has grown rapidly, making high-quality ultrawide-angle lenses affordable. In the past, ultrawide-angle lenses were rare, prohibitively expensive, and out of reach for most amateur photographers. These days, it's very easy to find a relatively inexpensive ultrawide-angle lens; for example you can find a Sigma 10-24mm lens for under $500. Most wide-angle zoom lenses run the gamut from ultrawide to wide angle. Some of the ones that work with the D7000 include the following:

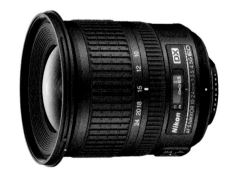

▶ **Nikkor 10-24mm f/3.5-4.5.** This is one of Nikon's newer ultra-wide DX zooms. The 10-24mm was specifically designed for DX cameras. This lens gives you a very wide field of view, and it's small and well built with little distortion. The AF-S motor allows it to focus perfectly with the D7000.

Image courtesy of Nikon, Inc.
4.6 Nikkor 10-24mm f/3.5-4.5

▶ **Sigma 10-20mm f/3.5.** When it comes to third-party lenses, I prefer Sigma lenses. They have superior build quality and their Hyper-Sonic Motor (HSM), which is similar to Nikon's Silent Wave AF-S motor, allows this lens to autofocus with the D7000. This lens is not as sharp as the Nikon mentioned previously and it has a reduced range on the long end, but it's much cheaper. You may not even miss the longer range at all, given it's most likely covered by one of your other lenses, such as the 18-55mm kit lens. This lens also has a constant aperture, which gives it a leg up on the competition. You can save about $200 by buying the variable aperture f/4-5.6 version.

▶ **Tokina AT-X 124 AF Pro DX II.** This is a 12-24mm f/4 wide-angle lens. This is Tokina's updated version of the original 12-24mm f/4, which is a very sharp and relatively inexpensive lens.

Sigma also offers a 12-24mm lens. It's built like a tank and has an HSM motor. The Sigma is also useable with Nikon FX cameras, which may be something to consider if you're planning to upgrade to FX sometime in the future.

Deciding when to use a wide-angle lens

You can use wide-angle lenses for a broad variety of subjects, and they're great for creating dynamic images with interesting results. Once you get used to seeing the world through a wide-angle lens, you may find that your images start to be more creative, and you may look at your subjects differently. There are many considerations when you use a wide-angle lens. Here are a few:

▶ **Greater depth of field.** Wide-angle lenses allow you to get more of the scene in focus than you can when you use a midrange or telephoto lens at the same aperture and distance from the subject.

▶ **Wider field of view.** Wide-angle lenses allow you to fit more of your subject into your images. The shorter the focal length, the more you can fit in. This can be especially beneficial when you shoot landscape photos where you want to fit an immense scene into your photo.

▶ **Perspective distortion.** Using wide-angle lenses causes things that are closer to the lens to look disproportionately larger than things that are farther away. You can use perspective distortion to your advantage to emphasize objects in the foreground if you want the subject to stand out in the frame.

▶ **Handholding.** At shorter focal lengths, it's possible to hold the camera steadier than you can at longer focal lengths. At 14mm, it's entirely possible to hand hold your camera at 1/15 second without worrying about camera shake.

▶ **Environmental portraits.** Although using a wide-angle lens isn't the best choice for standard close-up portraits, wide-angle lenses work great for environmental portraits, where you want to show a person in her surroundings.

Wide-angle lenses can also help pull you into a subject. With most wide-angle lenses, you can focus very close to the subject. This helps you create an intimate image while incorporating the perspective distortion that wide-angle lenses are known for. Don't be afraid to get close to your subject to make a more dynamic image. The worst wide-angle images are the ones that have a tiny subject in the middle of an empty area.

Understanding limitations

Wide-angle lenses are very distinctive when it comes to the way they portray your images, and they also have some limitations that you may not find in lenses with longer focal lengths. There are also some pitfalls that you need to be aware of when using wide-angle lenses:

▶ **Soft corners.** The most common problem that wide-angle lenses, especially zoom lenses, have is that they soften the images in the corners. This is most prevalent at wide apertures, such as f/2.8 and f/4, and the corners usually sharpen up by f/8 (depending on the lens). This problem is greatest in lower-priced lenses.

▶ **Vignetting.** This is the darkening of the corners in the image. This occurs because the light that's needed to capture such a wide angle of view must come from an oblique angle. When the light comes in at such an angle, the aperture is effectively smaller. The aperture opening no longer appears as a circle but is shaped like a cat's eye. Stopping down the aperture 1 to 2 stops

4.7 A shot taken with a wide-angle lens can add an interesting perspective to some images. Exposure: ISO 560 (Auto), f/3.5, 1/125 second using a Sigma 10-20mm f/3.5 lens at 10mm.

from the widest setting reduces this effect, and stopping down by 3 stops usually eliminates vignetting altogether.

▶ **Perspective distortion.** Perspective distortion is a double-edged sword: It can make your images look very interesting or make them look terrible. One of the reasons that a wide-angle lens isn't recommended for close-up portraits is that it distorts the face, making the nose look too big and the ears too small. This can make for a very unflattering portrait.

▶ **Barrel distortion.** Wide-angle lenses, even rectilinear lenses, are often plagued with this specific type of distortion, which causes straight lines outside the image center to appear to bend outward (similar to a barrel). This can be unwanted especially when doing architectural photography. Fortunately, you can use Adobe Photoshop and other image-editing software to fix this problem relatively easily.

Standard or Midrange Lenses

Standard, or midrange, zoom lenses fall in the middle of the focal-length scale. Zoom lenses of this type usually start at a moderately wide angle of around 16-18mm and zoom in to a short telephoto range. These lenses work great for most general photography applications and can be used successfully for everything from architectural to portrait photography. Basically, this type of lens covers the most useful focal lengths and will probably spend the most time on your camera. The 18-105mm kit lens falls into this range.

Here are some of the options for midrange lenses:

▶ **Nikkor 17-55mm f/2.8.** This is Nikon's top-of-the-line standard DX zoom lens. It's a professional lens that has a fast aperture of f/2.8 over the whole zoom range and is extremely sharp at all focal lengths and apertures. The build quality on this lens is excellent, as most of Nikon's pro lenses are. The 17-55mm has Nikon's super-quiet and fast-focusing Silent Wave Motor as well as ED glass elements to reduce chromatic aberration. This lens is top-notch all around and is worth every penny of the almost $1,400 price tag.

▶ **Sigma 17-70mm f/2.8-4 OS.** This lens is a low-cost alternative to the Nikon 17-55mm that has a variable aperture of f/2.8 on the wide end and f/4 on the long end. You can get this lens for about $450, which is almost one-quarter of the cost of the Nikon 17-55mm and it's much smaller and lighter. It's got Sigma's HSM so it autofocuses quickly and quietly. It's a great walking-around lens for standard shots. This lens also allows you to focus closely on subjects; it's not a

true macro lens, but it's close. The optical stabilization (OS) also helps to reduce camera shake blur. Currently, this is my favorite lens because it's relatively fast at all focal lengths and has a macro feature and OS. It does almost everything you need and is incredibly lightweight.

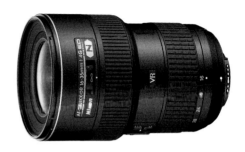

▶ **Tamron SP AF 17-50mm f/2.8 Di-II VC.** This pretty good, reasonably priced ($650) constant aperture lens includes Vibration Compensation (Tamron's version of Nikon's VR). The only drawback to this lens is that it uses Tamron's built-in motor (BIM) to focus with the D7000, and it is very slow and loud. Tamron has recently developed a silent motor, which it may integrate into this lens in the near future.

Image courtesy of Nikon, Inc.

4.8 Nikkor 16-35mm f/4

▶ **Nikon 16-35mm f/4 VR.** This is one of Nikon's newest offerings. This lens has a constant aperture but it's one step slower than the 17-55 to make it more affordable (although at $1,100 it's still quite pricey in my opinion). It also has the added benefit of VR. Another advantage of this lens is that it's designed for use on FX cameras so if you ever upgrade to a full-frame camera this lens will work perfectly as a wide-angle lens.

A few prime lenses fit into this category: the 28mm, 30mm, and 35mm. These lenses are considered normal lenses for DX cameras in that they approximate the normal field of view of the human eye. They are great all-around lenses. They come with apertures of f/2.8 or faster and can be found for less than $400. The Nikon 35mm is a great lens for under $200 and for ultra low light situations the Sigma 30mm f/1.4 HSM is a great deal for about $440.

Telephoto Lenses

Telephoto lenses have very long focal lengths and are used to get closer to distant subjects. They provide a very narrow field of view and are handy when you're trying to focus on the details of a subject. Telephoto lenses produce a much shallower depth of field than wide-angle and midrange lenses, and you can use them effectively to blur background details to isolate a subject.

Telephoto lenses are commonly used for sports and wildlife photography. The shallow depth of field also makes them one of the top choices for photographing portraits.

As with wide-angle lenses, telephoto lenses also have their quirks, such as perspective distortion. As you may have guessed, telephoto perspective distortion is the opposite of the wide-angle variety. Because everything in the photo is so far away with a telephoto lens, the lens tends to compress the image. Compression causes the background to look too close to the foreground. Of course, you can use this effect creatively. For example, compression can flatten out the features of a model, resulting in a pleasing effect. Compression is another reason why photographers often use a telephoto lens for portrait photography.

4.9 Portrait shot with a telephoto lens. Exposure: ISO 100, f/2.8, 1/640 second with a Nikon 80-200mm f/2.8D lens zoomed to 150mm.

A typical telephoto zoom lens usually has a range of about 55–200mm. If you want to zoom in close to a subject that's very far away, you may need an even longer lens. These super-telephoto lenses can act like telescopes, really bringing the subject in close. They range from about 300mm to about 800mm. Almost all super-telephoto lenses are prime lenses, and they're very heavy, bulky, and expensive.

There are several telephoto prime lenses available. Most of them are pretty expensive, although you can sometimes find some older Nikon primes that are discontinued or used at decent prices. One of these lenses is the 300mm f/4. A couple of relatively inexpensive telephoto primes in the shorter range of 50-85mm are also available. The 50mm is considered a normal lens for FX format, but the DX format makes this lens a 75mm equivalent, landing it squarely in the short telephoto range for use with the D7000. Nikon has an AF-S version of the 50mm f/1.4 and has recently released an 85mm f/1.4.

Super-Zooms

Most lens manufacturers, Nikon included, offer what's commonly termed a *super-zoom*, or sometimes called a *hyper-zoom*. Super-zooms are lenses that encompass a very wide focal length range, from wide angle to telephoto. The most popular of the super-zooms is the Nikon 18-200mm f/3.5-5.6 VRII.

These lenses allow you to have a huge focal-length range that you can use in a wide variety of shooting situations without having to switch out lenses. This can come in handy if, for example, you are photographing a landscape scene by using a wide-angle setting, and lo and behold, Bigfoot appears on the horizon. You can quickly zoom in with the super-telephoto setting and get a good close-up shot without having to fumble around in your camera bag to grab a telephoto and switch out lenses, possibly causing you to miss the shot of a lifetime.

Of course, these super-zooms come with a price (figuratively and literally). In order to achieve the great ranges in focal length, you must make some concessions with regard to image quality. These lenses are usually less sharp than lenses with a shorter zoom range and are more often plagued with optical distortions and chromatic aberration. Super-zooms often show pronounced barrel distortion (the bowing out of straight lines in the image) at the wide end and can have moderate to severe pincushion distortion (the bowing in of the straight lines in the image) at the long end of the range. Luckily, you can fix these types of distortions in Adobe Photoshop or other image-editing software.

Another caveat to using these lenses is that they generally have appreciably smaller maximum apertures than zoom lenses with shorter ranges. This can be a problem, especially because larger apertures are generally needed at the long end to keep a high enough shutter speed to avoid blurring from camera shake when handholding. Of course, some manufacturers include some sort of Vibration Reduction feature to help control this problem.

Some popular super-zooms include the Nikon 18-200mm f/3.5-5.6 VR (mentioned earlier), the Sigma 18-200mm f/3.5-6.3 with Optical Stabilization, and the Tamron 18-270mm VC f/3.5-5.6. There are also a few super-zoom super-telephoto lenses, including the Nikon 80-400mm and the Sigma 50-500mm.

Here are some of the most common telephoto lenses:

▶ **Nikkor 70-200mm f/2.8 VRII.** This is Nikon's top-of-the-line telephoto lens. The VR makes this lens useful when photographing far-off subjects handheld. This is a great lens for sports, portraits, and wildlife photography.

▶ **Nikkor 55-300mm f/4-5.6 VR.**
This is one of Nikon's newest lenses and is actually a pretty strong performer for its price range. The 55-300mm VR is quite sharp and has only mild barrel distortion issues. It's a great lens with a long reach — excellent for wildlife photography.

▶ **Nikkor 80-200mm f/2.8D AF-S.**
This is a great, affordable alternative to the 70-200mm VR lens. This lens is sharp and has a fast, constant f/2.8 aperture.

Image courtesy of Nikon, Inc.
4.10 Nikkor 55-300mm f/2.8 VR.

▶ **Sigma 70-200mm f/2.8 HSM.** This is a good alternative to the Nikon lenses. The HSM motor allows for autofocus with the D7000 and the lens costs less than half the price of the Nikon 70-200mm, although you do lose VR.

Macro Lenses

A macro lens is a special-purpose lens used in macro and close-up photography. It allows you to have a closer focusing distance than regular lenses, which in turn allows you to get greater magnification of your subject, revealing small details that would otherwise be lost. True macro lenses offer a magnification ratio of 1:1; that is, the image projected onto the sensor through the lens is the exact same size as the actual object being photographed. Some lower-priced macro lenses offer a 1:2 or even a 1:4 magnification ratio, which is one-half to one-quarter of the size of the original object. Although lens manufacturers refer to these lenses as macro, strictly speaking, they are not.

One major concern with a macro lens is the depth of field. When focusing at such a close distance, the depth of field becomes very shallow; it's often advisable to use a small aperture to maximize your depth of field and ensure everything is in focus. Of course, as with any downside, there's an upside: You can also use the shallow depth of field creatively. For example, you can use it to isolate a detail in a subject.

Macro lenses come in a variety of focal lengths, and the most common is 60mm. Some macro lenses have substantially longer focal lengths, which allows for more distance between the lens and the subject. This comes in handy when the subject

needs to be lit with an additional light source. A lens that's very close to the subject while you are focusing can get in the way of the light source, casting a shadow.

When buying a macro lens, you should consider a few things: How often are you going to use the lens? Can you use it for other purposes? Do you need AF? Because newer dedicated macro lenses can be pricey, you may want to consider some cheaper alternatives.

The first thing you should know is that it's not absolutely necessary to have an AF lens. When you shoot very close up, the depth of focus is extremely small, so all you need to do is move slightly closer or farther away to achieve focus. This makes an AF lens a bit unnecessary. You can find plenty of older Nikon manual focus (MF) macro lenses that are very inexpensive, and the lens quality and sharpness are still superb.

> **NOTE** Several manufacturers make good-quality MF macro lenses. I have a 50mm f/4 Macro-Takumar made for early Pentax screw-mount camera bodies. I bought this lens for next to nothing, and I found an inexpensive adapter that allows it to fit the Nikon F-mount. The great thing about this lens is that it's super sharp and allows me to focus close enough to get a 4:1 magnification ratio, which is 4X life size.

Nikon currently offers a few macro lenses under the Micro-Nikkor designation that work well with the D7000. Here are three:

▶ **Nikkor 60mm f/2.8.** Nikon offers two versions of this lens — one with a standard AF drive and one with an AF-S version with the Silent Wave Motor. The AF-S version also has the new Nano Crystal Coat lens coating to help eliminate ghosting and flare.

▶ **Nikkor 85mm f/3.5 VR.** This is Nikon's latest macro lens offering. This lens is comparable with the 105mm f/2.8 VR, but because it's designed solely for DX cameras, it's smaller, lighter, and less expensive. This is a great choice for serious macro photographers.

Image courtesy of Nikon, Inc.
4.11 Nikkor 85mm f/3.5G VR macro lens

▶ **Nikkor 105mm f/2.8 VR.** This is a great lens that not only allows you to focus extremely close to your subject but also enables you to back off and still get a good close-up shot. This lens is equipped with VR. This can be invaluable with macro photography because it allows you to hand hold at slower shutter speeds — a necessity when stopping down to maintain a good depth of field. This lens can also double as a very impressive portrait lens.

A couple of third-party lenses that work well with the D7000 include

▶ **Tamron 90mm f/2.8.** This lens is highly regarded for its sharpness. It also has a built-in motor, so it will autofocus with the D7000. I initially bought this lens instead of the Nikon 105mm lens, but I quickly returned it. Although it's a good-quality lens, I didn't like the fact that the front element of the lens moves in and out during focusing. This can cause the lens element to hit your subject if you're too close and not careful, possibly damaging the lens. Also, unlike the offerings from Sigma and Nikon, Tamron's built-in focus motor is very loud and very slow.

▶ **Sigma 150mm f/2.8 HSM.** This is another lens that is highly regarded for its sharpness. It has fast, quiet focusing with the HSM. It's a great lens.

Fisheye Lenses

Fisheye lenses are ultrawide-angle lenses that aren't corrected for distortion like standard rectilinear wide-angle lenses. These lenses are known as *curvilinear*, meaning that straight lines in your image, especially near the edge of the frame, are curved. Fisheye lenses have extreme barrel distortion.

Fisheye lenses cover a full 180° area, allowing you to see everything that's immediately to the left and right of you in the frame. You have to take special care to not get your feet in the frame, as is easy to do when you use a lens with a field of view this extreme.

There are two types of fisheye lenses available: regular and circular. A regular fisheye lens fills the whole image plane, resulting in a normal (albeit curved) image. A circular fisheye projects the whole 180° field of view in a circle within the frame, and the corners of the frame remain black.

Fisheye lenses aren't made for everyday shooting, but with their extreme perspective distortion, you can achieve interesting, and sometimes wacky, results. You can also "de-fish" or correct for the extreme fisheye by using image-editing software, such as

Adobe Photoshop, Nikon's Capture NX 2, and DxO Optics. The end result of correcting your image is that you get a reduced field of view. This is akin to using a rectilinear wide-angle lens.

4.12 An image taken with a Nikon 10.5mm fisheye lens. Notice how the lens distorts the horizon line.

Vibration Reduction Lenses

Nikon has an impressive list of lenses that offer Vibration Reduction (VR). This technology is used to combat image blur caused by camera shake, especially when you hand hold the camera at long focal lengths. The VR function works by detecting the motion of the lens and shifting the internal lens elements. This allows you to shoot up to 3 stops slower than you would normally.

If you're an experienced photographer, you probably know this rule of thumb: To get a reasonably sharp photo when handholding the camera, you should use a shutter speed that corresponds to the reciprocal of the lens's focal length. In simpler terms, when shooting at a 200mm zoom setting, your shutter speed should be at least 1/200

second. When shooting with a wider setting, such as 28mm, you can safely hand hold the camera at around 1/30 second. Of course, this is just a guideline; some people are naturally steadier than others and can get sharp shots at slower speeds. With the VR enabled, you should theoretically be able to get a reasonably sharp image at a 200mm setting with a shutter speed of around 1/30 second. I find that this is only possible if you have really steady hands. At wider focal lengths, you have a better chance of getting a four-stop advantage. (You won't be able to hand hold a 1-second exposure no matter how steady you are.)

Although the VR feature is good for providing some extra latitude when you're shooting with low light, it's not made to replace a fast shutter speed. To get a good, sharp photo when shooting action, you need to have a fast shutter speed to freeze the action. No matter how good the VR is, nothing can freeze a moving subject but a fast shutter speed.

Another thing to consider with the VR feature is that the lens's motion sensor may overcompensate when you're panning, causing the image to actually be blurrier. So, in situations where you need to pan with the subject, you may need to switch off the VR. The VR function also slows down the AF a bit, so when catching the action is very important, you may want to keep this in mind. However, Nikon's newest lenses have been updated with VR II, which Nikon claims can differentiate between panning motion and regular side-to-side camera movement.

While VR is a great advancement in lens technology, few things can replace a good exposure and a solid monopod or tripod for a sharp image.

Third-party Lenses

Several companies make lenses that work flawlessly with Nikon cameras. In the past, third-party lenses had a bad reputation of being, at best, cheap knock-offs of the original manufacturer's. This is not the case anymore: A lot of third-party lens manufacturers have started releasing lenses that rival some of the originals (usually at half the price).

Although you can't beat Nikon's professional lenses, there are many excellent third-party lens choices available. The three most prominent third-party lens manufacturers are Sigma, Tokina, and Tamron. Each of these companies makes lenses that cover the entire zoom range.

I have included a number of examples of third-party lenses throughout this chapter. Although I currently have a full line of Nikon pro lenses, I also have a few third-party lenses simply because they are smaller and lighter than Nikon's pro lenses, especially the constant aperture f/2.8 lenses. I highly recommend checking into some third-party lenses if you're looking for a fast constant aperture zoom lens for not a lot of money.

Understanding Exposure

For some of you, this chapter contains concepts you are familiar with. However, for others of you, dSLRs or photography in general might be new territory. And even if you're an advanced user, you may benefit from the information on evaluating your exposure using histograms and adjusting your exposure using the Nikon D7000's exposure compensation and bracketing features. This chapter covers exposure, how aperture affects depth of field, how the shutter speed is used to create different effects, and how ISO can affect both your aperture and shutter speed settings.

Understanding exposure is essential to controlling the outcome of your images.
Exposure: ISO 100, f/10, 1/60 second using a Nikon 70-200mm f/2.8 VR lens at 155mm.

Exposure Overview

Exposure is the most important aspect of photography. If you don't understand how exposure is calculated, you'll have difficulty understanding how your camera chooses the settings for semiautomatic modes such as Shutter Priority or Aperture Priority. This can hinder your ability to achieve a specific effect in your image.

By definition, exposure as it relates to digital photography is the total amount of light collected by the camera's sensor during a single *shutter cycle*. A shutter cycle occurs when the Shutter Release button is pressed, the shutter opens, closes, and resets. One shutter cycle occurs for each image (with the exception of multiple exposures, of course). An exposure is made of three elements that are all interrelated. Each depends on the others to create a proper exposure. If one of the elements changes, the others must increase or decrease proportionally or you will no longer have an equivalent exposure. Following are the elements you need to consider:

▶ **Shutter speed.** The shutter speed determines the length of time the sensor is exposed to light.

▶ **ISO sensitivity.** The ISO setting you choose influences your camera's sensitivity to light.

▶ **Aperture/f-stop.** How much light reaches the sensor of your camera is controlled by the aperture, or f-stop. Each camera has an adjustable opening on the lens. As you change the aperture (the opening), you allow more or less light to reach the sensor.

Shutter speed

Shutter speed is the amount of time light entering from the lens is allowed to expose the image sensor. Obviously, if the shutter is open longer, more light can reach the sensor. The shutter speed can also affect the sharpness of your images. When you're handholding the camera and using a longer focal-length lens, a faster shutter speed is often required to counteract against camera shake from hand movement, which can cause blur (this is the effect Vibration Reduction lenses combat). When taking photographs in low light, a slow shutter speed is often required, which causes blur from camera shake and/or fast-moving subjects.

The shutter speed can also be used to effectively show motion in photography. *Panning*, or moving the camera horizontally with a moving subject while using a slower shutter speed, can cause the background to blur while keeping the subject in focus.

This is an effective way to portray motion in a still image. On the opposite end, using a fast shutter speed can freeze action, such as the water that sprays from a wave as a surfer rides it, which can also give the illusion of motion in a still photograph.

Shutter speeds are indicated in fractions of a second. Common shutter speeds in full-stops (from slow to fast in seconds) include 1, 1/2, 1/4, 1/8, 1/15, 1/30, 1/60, 1/125, 1/500, 1/1000, and so on. Increasing or decreasing shutter speed by one setting doubles or halves the exposure, respectively. The D7000 also allows you to adjust the shutter speed in 1/3-stops. For example, if you take a picture with a 1/2-second shutter speed and it turns out too dark, logically, you'll want to keep the shutter open longer to let in more light. To do this, you need to adjust the shutter speed to 1 second, which is the next full stop, letting in twice as much light.

5.1 For this image, I used a slow shutter speed and panning to blur the background, providing an element of movement to the photo. Exposure: ISO 100, f/11, 1/80 second using a Nikon 70-200mm f/2.8G VR at 200mm.

ISO

ISO used to commonly be referred to as *film speed* in photography. Generally, these days ISO is referred to as *sensitivity*. The term *ISO* is derived from the International Organization for Standardization, which is a governing body in the international manufacturing markets. The International Organization for Standardization ensures consumers can buy similar products from different manufacturers that will perform in the

same manner. For example, the settings used on 100-speed Kodak film will be the same settings used in equivalent light with 100-speed Fuji film or any other manufacturer's film.

In addition, the ISO sensitivity number indicates how sensitive the medium is to light — in your case, the medium is the CMOS (Complementary Metal Oxide Semiconductor) sensor. The higher the ISO number, the more sensitive it is and the less light you need to take a photograph. For example, you might choose an ISO setting of 100 on a bright, sunny day when you are photographing outside because you have plenty of light. However, on a cloudy day, you may want to consider an ISO of 400 or higher to make sure your camera captures all the available light. This allows you to use a faster shutter speed should it be appropriate to the subject you are photographing.

It is helpful to know that each ISO setting is twice as sensitive to light as the previous setting. For example, at ISO 400, your camera is twice as sensitive to light as it is at ISO 200. This means it needs only half the light at ISO 400 that it needs at ISO 200 to achieve the same exposure.

As with shutter speeds, the D7000 allows you to adjust the ISO in 1/3-stop increments (100, 125, 160, 200, and so on), which enables you to fine-tune your ISO to reduce the noise inherent with higher ISO settings.

While at a glance using a higher ISO setting may seem like a panacea to correct any problems you might have when shooting in low light, there is a tradeoff — *noise*. Noise, simply put, is randomly colored dots that appear in your image. Noise is caused by extraneous electrons that are produced when your image is being recorded. When light strikes the image sensor in your D7000, electrons are produced. These electrons create an analog signal that is converted into a digital image by the analog-to-digital (A/D) converter in your camera (yes, digital cameras start with an analog signal).

There are two specific causes of noise. The first is *heat-generated*, or thermal, noise. While the shutter is open and your camera is recording an image, the sensor starts to generate a small amount of heat. This heat can free electrons from the sensor, which in turn contaminate the electrons that have been created as a result of the light striking the photocells on your sensor. This contamination shows up as noise.

The second cause of digital noise is known as *high ISO noise*. Background electrical noise exists in any type of electronic device. For the most part, it's miniscule and you never notice it. Cranking up the ISO amplifies the signals (photons of light) your sensor is receiving. Unfortunately, as these signals are amplified so is the background electrical noise. The higher your ISO, the more the background noise is amplified until it shows up as randomly colored specks.

Digital noise is composed of two elements — *chrominance* and *luminance*. Chrominance refers to the colored specks and luminance refers mainly to the size and shape of the noise.

Fortunately with every new camera released, the technology gets better and better, and the D7000 is no exception. The D7000 has one of the highest signal-to-noise ratios of any camera on the market; thus you can shoot at ISO 1600 and have almost no noticeable noise at all. In some previous cameras, shooting at ISO 1600 produced very noisy images that were not suitable for even medium-sized prints, such as an 8 × 10.

5.2 This image shows digital noise resulting from using a high ISO (6400). Notice that the noise is more prevalent in the darker areas of the image.

Although it's very low, noise does exist. Noise starts appearing in images taken with the D7000 when you shoot above ISO 1600 or use exposure times of 4 seconds or more. For this reason, most camera manufacturers have built-in noise reduction (NR) features. The D7000 has two types of NR: Long exposure NR and High ISO NR. Each one approaches the noise differently to help reduce it.

Aperture

Aperture is the size of the opening in the lens that determines the amount of light that reaches the image sensor. The aperture is controlled by a metal diaphragm that operates in a similar fashion to the iris of your eye. Aperture is expressed as f-stop numbers, such as f/2.8, f/5.6, and f/8. Here are a couple of important things to know about aperture:

▶ **Smaller f-numbers equal wider apertures.** A small f-stop such as f/2.8 opens the lens so more light reaches the sensor. If you have a wide aperture (opening), the amount of time the shutter needs to stay open to let light into the camera decreases.

▶ **Larger f-numbers equal narrower apertures.** A large f-stop such as f/11 closes the lens so less light reaches the sensor. If you have a narrow aperture (opening), the amount of time the shutter needs to stay open to let light into the camera increases.

I am often asked why the numbers of the aperture seem counterintuitive. The answer is relatively simple: The numbers are actually derived from ratios, which translate into fractions. The f-number is defined by the focal length of the lens divided by the actual diameter of the aperture opening. The simplest way to look at it is to put a 1 on top of the f-number as the numerator. For the easiest example, take a 50mm f/2 lens (okay, Nikon doesn't actually make a 50mm f/2, but pretend for a minute). Take the aperture number, f/2. If you add the 1 as the numerator, you get 1/2. This indicates that the aperture opening is half the diameter of the focal length, which equals 25mm. So at f/4, the effective diameter of the aperture is 12.5mm. It's a pretty simple concept once you break it down.

 The terms *aperture* and *f-stop* are interchangeable.

As with ISO and shutter speed, there are standard settings for aperture, each of which has a 1-stop difference from the next one. The standard f-numbers are f/1.4, f/2, f/2.8, f/4, f/5.6, f/8, f/11, f/16, and f/22. Initially these may appear to be a random assortment of numbers, but they aren't. Upon closer inspection you will notice that every other number is a multiple of 2. Broken down even further, you will find that each stop is a multiple of 1.4. This is where the standard f-stop numbers are derived from. If you start out with f/1 and multiply by 1.4, you get f/1.4; multiply this by 1.4 again and you get 2 (rounded up from 1.96), multiply 2 by 1.4 you get 2.8, and so on.

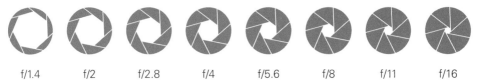

f/1.4　　f/2　　f/2.8　　f/4　　f/5.6　　f/8　　f/11　　f/16

5.3 This figure illustrates the relative difference in aperture sizes.

As it does with the ISO and shutter speed settings, the Nikon D7000 allows you to set the aperture in 1/3-stop increments.

In photographic vernacular, *opening up* refers to going from a smaller to a larger aperture and *stopping down* refers to going from a larger to smaller aperture.

Now that you know a little more about apertures, you can begin to look at why differ-
ent aperture settings are used and the effect that they have on your images. The most
common reason why a certain aperture is selected is to control the depth of field or
how much of the image is in focus. Quite simply, using a wider aperture (f/1.4–4)
gives you a shallow depth of field that allows you to exercise *selective focus*, focusing
on a certain subject in the image while allowing the rest to fall out of focus. Conversely,
using a small aperture (f/11–32) maximizes your depth of field, allowing you to get
more of the scene in focus. Using a wider aperture is generally preferable when shoot-
ing portraits because it blurs out the background and draws attention to the subject; a
smaller aperture is generally used when photographing landscapes to ensure that a
larger range of the scene is in focus.

**5.4 This shot of Maddie, my Boston terrier, was made with a wide aperture of f/2.8 to
achieve a shallow depth of field. Exposure: ISO 640 (Auto), f/2.8, 1/250 second using an
80-200mm f/2.8 lens at 200mm.**

Another way that the aperture setting is used, oddly enough, is to control the shutter
speed. You can use a wide aperture to allow a lot of light in so that you can use a
faster shutter speed to freeze action. On the opposite end of the spectrum, you can
use a smaller aperture if you want to be sure that your shutter speed is slower.

Fine-tuning Your Exposure

Your camera's meter may not always be completely accurate. There are a lot of variables in most scenes, and large bright or dark areas can trick the meter into thinking a scene is brighter or darker than it really is, causing the image to be over- or underexposed. One example of this is in a really bright situation such as the beach on a sunny day or a similar, albeit opposite weatherwise, snowy scene. The camera's meter generally sees all the brightness in the scene and underexposes to try to preserve detail in the highlights, which makes the main subject and most of the image dark and lacking in contrast. In snowy scenes, this is a special problem because it causes the snow to appear gray and dingy. The general rule of thumb in this situation is to add 1 to 2 stops of exposure compensation.

Exposure compensation

Exposure compensation is a D7000 feature that allows you to fine-tune the amount of exposure to a setting other than what the camera's exposure meter sets automatically. Although you can usually adjust the exposure of the image in your image-editing software (especially if you shoot RAW), it's best to get the exposure right in the camera to be sure that you have the highest image quality. If, after taking the photograph, you review it and it's too dark or too light, you can adjust the exposure compensation and retake the picture to get a better exposure. Exposure compensation is adjusted in EV (Exposure Value); 1 EV is equal to 1 stop of light. You adjust exposure compensation by pressing the Exposure Compensation button, next to the Shutter Release button, and rotating the Main Command dial to the left for more exposure (+EV) or to the right for less exposure (–EV). Depending on your settings, the exposure compensation is adjusted in 1/3, or 1/2, stops of light. You can change this setting in the Custom Settings menus (CSM b2).

You can adjust the exposure compensation up to +5 EV and down to –5 EV, which is a pretty large range of 10 stops. To remind you that exposure compensation has been set, the Exposure Compensation indicator is displayed on the top LCD control panel and the viewfinder display. It also appears on the rear LCD screen when the Shooting info is being displayed.

Be sure to reset the exposure compensation to 0 after you finish to avoid unwanted over- or underexposure.

There are a few ways to get the exact exposure that you want. You can use the histogram to determine whether you need to add or subtract from your exposure. You can also use bracketing to take a number of exposures and choose the one that you think is best, or you can combine the bracketed images with different exposures to create one high dynamic range (HDR) image using post-processing software.

Histograms

The easiest way to determine if you need to adjust the exposure compensation is to preview your image. If it looks too dark, add some exposure compensation; if it's too bright, adjust the exposure compensation down. This, however, is not the most accurate method of determining how much exposure compensation to use. To accurately determine how much exposure compensation to add or subtract, look at the *histogram*. A histogram is a visual representation of the tonal values in your image. Think of it as a bar graph that charts the lights, darks, and midtones in your picture.

The histogram charts a tonal range of about 5 stops, which is about the limit of what the D7000's sensor can record. This range is broken down into 256 brightness levels from 0 (absolute black) to 255 (absolute white), with 128 coming in at middle, or 18 percent, gray. The more pixels at any given brightness value, the higher the bar. If there are no bars, then the image has no pixels in that brightness range.

The histogram displayed on the LCD is based on an 8-bit image. When you're working with 12- or 14-bit files using editing software, the histogram may be displayed with 4096 brightness levels for 12-bit or 16384 brightness levels for 14-bit.

5.5 A representation of the tonal range of a histogram

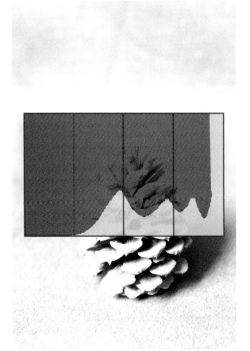 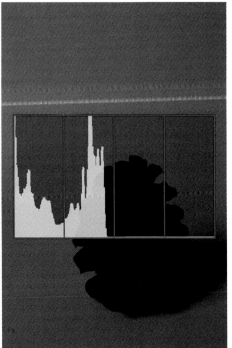

5.6 An example of a histogram from an overexposed image (no highlight detail). Notice that the histogram information is spiking and completely touching the far right of the graph.

5.7 An example of a histogram from an underexposed image (no shadow detail). Notice the spikes at the far left of the graph.

The D7000 offers four histogram views: the luminance histogram, which shows the brightness levels of the entire image, and separate histograms for each color channel (Red, Green, and Blue).

The most useful histogram for determining if your exposure needs adjusting is the luminance histogram. To display the luminance histogram without the color channel histograms, simply press the Multi-selector up while viewing the image on the LCD. This displays a thumbnail of the current image, the shooting information, and a small luminance histogram.

Theoretically, you want to expose your subject so that it falls right about in the middle of the tonal range, which is why your camera's meter exposes for 18 percent gray. If your histogram graph has most of the information on the left side, then your image is

probably underexposed; if it's mostly on the right side, then your image is probably overexposed. Ideally, with most average subjects that aren't bright white or extremely dark, you want to try to get your histogram to resemble a bell curve, with most of the tones in the middle range, tapering off as they get to the dark and light ends of the graph. But this is only for most average types of images that would be not too light and not too dark with little contrast. As with almost everything in photography, there are exceptions to the rule. If you take a photo of a dark subject on a dark background (a *low-key* image), then naturally your histogram will have most of the tones on the left side of the graph. Conversely, when you take a photograph of a light subject on a light background (a *high-key* image), the histogram will have most of the tones leading to the right.

The most important thing to remember is that there is no such thing as a perfect histogram. A histogram is just a factual representation of the tones in the image. The other important thing to remember is that although it's okay for the graph to be near one side or the other, you usually don't want your histogram to have spikes bumping up against the edge of the graph; this indicates your image has blown-out highlights (completely white, with no detail) or blocked-up shadow areas (completely black, with no detail).

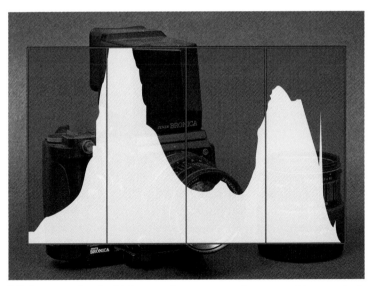

5.8 An example of a histogram from a properly exposed image shot on a neutral gray background. Notice that the graph does not spike against the left or right edge, but tapers off.

Now that you know a little bit about histograms, you can use them to adjust exposure compensation. Here is a good set of steps to follow when using the histogram as a tool to evaluate your photos:

1. **After taking your picture, review its histogram on the LCD.** To view the histogram in the image preview, press the Playback button to view the image Press the Multi-selector up, and the histogram appears directly to the right of the image preview.

2. **Look at the histogram.** An example of an ideal histogram can be seen in Figure 5.8.

3. **Adjust the exposure compensation.** To move the tones to the right to capture more highlight detail, add a little exposure compensation by pressing the Exposure Compensation button and rotating the Main Command dial to the left. To move the tones to the left, press the Exposure Compensation button and rotate the Main Command dial to the left.

4. **Retake the photograph if necessary.** After taking another picture, review the histogram again. If needed, adjust the exposure compensation more until you achieve the desired exposure.

When you're photographing brightly colored subjects, it may sometimes be necessary to refer to the RGB histograms. Sometimes it's possible to overexpose an image only in one color channel, even though the rest of the image looks like it is properly exposed. To view the separate RGB histograms, you need to set the display mode in the Playback menu.

To view RGB histograms, follow these steps:

1. **Press the Menu button.**

2. **Use the Multi-selector to select the Playback menu.**

3. **Use the Multi-selector to highlight Display mode.** Press OK or press the Multi-selector to the right to view the menu options.

4. **Use the Multi-selector to scroll down to the menu option Detailed photo info RGB histogram.** Pressing the Multi-selector right sets the option to On. This is confirmed by a small check mark in a box next to the option.

5. **When the option is set, use the Multi-selector to scroll up to the Done option.** If you fail to select Done, the setting will not be saved.

It's possible for any one of the color channels to become overexposed, or *blown out*, as some photographers call it, although the most commonly blown-out channel is the Red channel. Digital camera sensors seem to be more prone to overexposing the Red channel because these sensors are generally more sensitive to red colors. When one of these color channels is overexposed, the histogram looks similar to the luminance histogram of a typical overexposed image.

Typically, the best way to deal with an image that has an overexposed color channel is to reduce exposure by using exposure compensation. Although this a quick fix, reducing the exposure can also introduce blocked-up shadows; you can deal with this by shooting RAW or, to a lesser extent, by using Active D-Lighting. Ideally, adding a bit of fill light to the shadow areas with a reflector or flash is the way to go.

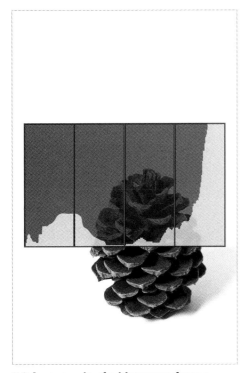

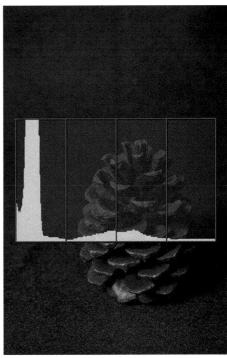

5.9 An example of a histogram from a high-key image. Although most of the tones are to the right the histogram tapers off down to the shadow side, indicating that there is detail in the shadow area.

5.10 An example of a histogram from a low-key image. Notice that although most of the tones are to the left the histogram tapers off down to the highlight side, indicating that there is detail in the highlight area.

Exposure bracketing

Another way to ensure that you get the proper exposure is to *bracket* your expo-
sures. Bracketing is a photographic technique in which you vary the exposure of
your subject over three or more frames. By doing this, you are able to get the proper
exposure in difficult lighting situations where your camera's meter can be fooled.
Bracketing is usually done with at least 1 exposure under and 1 exposure over the
metered exposure.

Technically, bracketing is done with 3 or more frames. The +2 and -2 options in
the D7000 auto-bracketing feature aren't a true bracket, but simply one
metered and one under- or overexposure.

You can bracket your images manually or you can choose to use the D7000 Auto-
bracketing function. The D7000 has a button that allows you to activate the bracketing
function quickly by pressing the BKT button and rotating the Command dial. To set up
the D7000 for exposure bracketing

1. **Press the Menu button.**

2. **Use the Multi-selector to enter the CSM.** Scroll down to CSM e Bracketing/
 flash. Press the Multi-selector right.

3. **Scroll down to CSM e5, Auto bracketing set.** Press the Multi-selector right to
 choose the options.

4. **Use the Multi-selector button to choose AE only.** Press the Multi-selector
 right.

5. **Press the OK button.** The BKT button is now assigned to be used for auto-
 exposure bracketing.

The D7000 also offers a few other different types of bracketing:

▶ **Auto-exposure and flash.** This bracketing option varies both the exposure
 compensation and the flash output.

▶ **Auto-exposure only.** This bracketing option varies the exposure compensation.

▶ **Flash only.** This bracketing option adjusts the flash output.

▶ **White Balance bracketing.** White Balance bracketing takes an image and saves
 multiple copies of the same image with small adjustments to the white balance
 (WB). This ensures that you get the proper WB. This option cannot be used
 when shooting RAW files.

▶ **ADL.** This allows you to bracket shots with one shot taken as is and the subsequent shot(s) with Active D-Lighting applied. You can choose from two or three frames. Selecting three frames gives you three shots: one with AD-L off, one with AD-L Normal, and one with AD-L set to High. When selecting two frames, you get one shot with AD-L off and one with AD-L on. The amount of AD-L is set in the AD-L menu (you can set this on the Info display). If the AD L is set to off then Auto AD-L is applied to the image.

For auto-exposure bracketing you can choose the number of frames and the exposure increments between frames.

▶ **Choose 3, +2, or −2.** This option allows you to get one overexposure, one metered exposure, and one underexposure; one metered exposure and one overexposure; or one metered exposure and one underexposure.

▶ **Vary the exposure increments from 0.3, 0.7, and 1.0 stops.** Choosing a higher exposure increment gives you a wider variation than choosing a lower increment. For example, choosing a 3-frame bracket at 0.3 EV gives you a series of exposures where your images range only ±1/3 stop over and under the original exposure. The series of exposure compensation will range as follows: −0.3, 0, +0.3. Choosing a 3-frame bracket at 1.0 EV provides a much wider series of exposures. This gives you a full 3-stop range: 1 stop over, 1 stop under, plus the original exposure.

Now that you understand all your options, the steps for activating auto-bracketing are as follows:

1. **Press and hold the BKT button.** Look at the LCD control panel on the top of the camera. If Auto-bracketing is off, the LCD displays 0F, meaning you are not bracketing any frames.

2. **While still holding the BKT button, rotate the Main Command dial to the right to choose the number of frames to bracket.** Choose from 3, +2, or −2. If you're using ADL bracketing, you choose from 2F or 3F.

3. **With the BKT button still pressed, rotate the Sub-command dial to choose the exposure compensation increments.** Choose from 0.3, 0.7, or 1.0 EV.

Once you have selected your settings, release the BKT button and shoot the photos. Shoot the specified number of images for your bracket set. You can choose to shoot them one at a time using Single shooting mode, or you can press and hold the shutter until the bracket set is completed using Continuous shooting mode.

 You must go back into the Auto-bracketing menu and change the setting to 0F to disable Auto-bracketing; otherwise the camera will continue to bracket all your images.

In CSM e6 you can change the order in which the bracketed images are taken. At the default setting, the camera first takes the metered exposure, then follows with the underexposed image, and then finishes up with the overexposed image. You can also choose to have the camera begin with the underexposure, then take the metered exposure, and finish up with the overexposure. This gives you a series of images that run from darkest to lightest. This is how I prefer to shoot my bracketed images.

 Of course, you don't have to use the Auto-bracketing function to bracket your exposures. You can just as easily bracket manually. Set the exposure mode to Manual, use the analog exposure meter to set the exposure, and then adjust the exposure up and/or down manually.

Bracketing has additional uses aside from helping ensure that you get the correct exposure. You can also use different elements from the bracketed exposures and combine them using image-editing software to get a final image that has a wider tonal range than is possible for your image sensor to capture. This technique is known as *HDR*, or High Dynamic Range. You can use a few different programs to create an HDR image. Adobe Photoshop version CS2 and later have a tool called Merge to HDR. Select two or more images (using three to five images is recommended) and this tool automatically merges the separate images for you. Using Photoshop, you can also layer the bracketed images and use layer masks to reveal or hide different areas of the images. Although HDR is a very good tool for getting more tonal range in your images, be careful not to overuse it. In recent years, quite a few photographers have had the tendency to take this technology too far, creating unrealistic, overly processed-looking images.

Figures 5.11 through 5.13 are a sequence of bracketed images. The auto-bracketing was set to AE only, 3 frames; and the EV increment was set to 1EV to show the broad range of exposures you can get with bracketing. Figure 5.14 is an HDR image that is a composite of all three images.

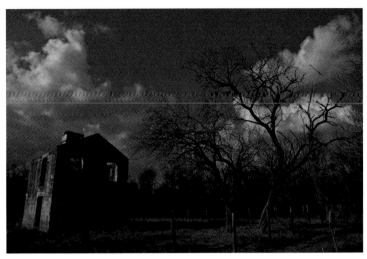

5.11 Bracketed image underexposed by 1 stop. Exposure: ISO 200, f/11, 1/800 second using a Tamron 17-50mm f/2.8 lens at 17mm.

5.12 Bracketed image shot as metered. Exposure: ISO 200, f/11 for 1/400 using a Tamron 17-50mm f/2.8 lens at 17mm.

5.13 Bracketed image overexposed by 1 stop. Exposure: ISO 200, f/11, 1/200 second using a Tamron 17-50mm f/2.8 at 17mm.

5.14 Three bracketed images merged to HDR

Working with Light

The most important factor in photography is light; without it, your camera is rendered useless. You need light to make the exposure that results in an image. Whether the light is recorded to silver halide emulsion on a piece of film or to the CMOS sensor on your Nikon D7000, you can't make a photograph without it.

Not only is light necessary to make an exposure, but also it has different qualities that can impact the outcome of your image. Light can be soft and diffuse or hard and directional, and it can also affect the color of your images. The ability to control light is crucial. When there is not enough light to capture the image you're after, you can employ alternative sources of light, such as flash, to achieve the effect you're after.

Controlling the light allows you to set the tone of the image.

Natural Light

Though it is by far the easiest type of light to find, natural light is sometimes the most difficult to work with because it comes from the sun, is often unpredictable, and can change from minute to minute. A lot of times I hear people say, "Wow, it's such a nice, sunny day; what a perfect day to take pictures." But unfortunately this is not often the case. A bright day when the sun is high in the sky presents many obstacles.

First, you have serious contrast issues on a sun-drenched day. Oftentimes, the digital sensor doesn't have the latitude to capture the whole scene effectively. For example, it is nearly impossible to capture detail in the shadows while keeping the highlights from blowing out or going completely white.

Fortunately, if you want to use natural light, it isn't necessary to stand in direct sunlight at noon. You can get desirable lighting effects when working with natural light in many ways, as shown in Figure 6.1. Here are a few examples:

▶ **Use fill flash.** You can use the flash as a secondary light source (not as your main light) to fill in the shadows and reduce contrast.

▶ **Try window lighting.** Believe it or not, one of the best ways to use natural light is to go indoors. Seating your model next to a window provides a beautiful soft light that is very flattering. A lot of professional food photographers use window light. It can be used to light almost any subject softly and evenly.

6.1 A portrait shot using natural light from a window

▶ **Find some shade.** The shade of a tree or the overhang of an awning or porch can block the bright sunlight while still giving you plenty of diffuse light with which to light your subject.

▶ **Take advantage of the clouds.** A cloudy day softens the light, allowing you to take portraits outside without worrying about harsh shadows and too much contrast. Even if it's only partly cloudy, you can wait for a cloud to pass over the sun before taking your shot.

▶ **Use a modifier.** Use a reflector to reduce the shadows or a diffusion panel to block the direct sun from your subject.

Continuous Light

Continuous lighting is just what it sounds like: a light source that is constant. It is by far the easiest type of lighting to work with. Unlike natural light, continuous light is consistent and predictable. Even when using a strobe with modeling lights, you sometimes have to estimate what the final lighting will look like. With continuous lighting, you can see the actual effects the lighting has on your subjects, and can modify and change the lighting before you even press the Shutter Release button.

Continuous lights are an affordable alternative to studio strobes. Because the light is constant and consistent, the learning curve is also not as steep. With strobes, you need to experiment with the exposure or use a flash meter. With continuous lights, you can use the Matrix meter on the D7000 to yield excellent results.

Here are a few of the more common continuous light options:

▶ **Incandescent.** Incandescent, or tungsten, lights are the most common type of lights. Thomas Edison invented this type of light. Your typical light bulb is a tungsten lamp. With tungsten lamps, an electrical current runs through a tungsten filament, heating it and causing it to emit light. This type of continuous lighting is the source of the name *hot lights*.

▶ **Halogen.** Halogen lights, which are much brighter than typical tungsten lights, are actually very similar. They are considered a type of incandescent light. Halogen lights also employ a tungsten filament, but include a halogen vapor in the gas inside the lamp. The color temperature of halogen lamps is higher than the color temperature of standard tungsten lamps.

▶ **Fluorescent.** Fluorescent lighting, which most of you are familiar with, is every-where these days. It is in the majority of office buildings, stores, and even in your own house. In a fluorescent lamp, electrical energy changes a small amount of mercury into a gas. The electrons collide with the mercury gas atoms, causing them to release photons, which in turn cause the phosphor coating inside the lamp to glow. Because this reaction doesn't create much heat, fluorescent lamps are much cooler and more energy efficient than tungsten and halogen lamps. These lights are commonly used in lighting for television production.

▶ **HMI.** HMI, or Hydrargyrum Medium-Arc Iodide, lamps are probably the most expensive type of continuous lighting. The motion picture industry uses this type because of its consistent color temperature and the fact that it runs cooler than a tungsten lamp with the same power rating. These lamps operate by releasing an arc of electricity in an atmosphere of mercury vapor and halogenides.

Incandescent and halogen

Although incandescent and halogen lights make it easier to see what you're photo-graphing and cost less, there are quite a few drawbacks to using these lights for seri-ous photography work. First, they are hot. When a model has to sit under lamps for any length of time, she may get hot and uncomfortable. This is also a problem with food photography. It can cause your food to change consistency or even sweat; for example, this happens to cheese that has been refrigerated. On the other hand, it can help keep hot food looking fresh and hot.

Second, although incandescent lights appear to be very bright to you and your subject, they actually produce less light than a standard flash unit. For example, a 200-watt tungsten light and a 200-watt-second strobe use the same amount of electricity per second, so they should be equally bright, right? Wrong. Because the flash discharges all 200 watts of energy in a fraction of a second, the flash is actually much, much brighter. Why does this matter? Because when you need a fast shutter speed or a small aperture, the strobe can give you more light in a shorter time. An SB-600 gives you about 30 watt-seconds of light at full power. To get an equivalent amount of light at the maximum sync speed of 1/250 second from a tungsten light, you would need a 7500-watt lamp. Of course, if your subject is static, you don't need to use a fast shut-ter speed; in this case, you can use one 30-watt light bulb for a 1-second exposure or a 60-watt lamp for a 1/2-second exposure.

Other disadvantages of using incandescent lights include

▶ **Color temperature inconsistency.** The color temperature of the lamps changes as your household current varies and as the lamps get more and more use. The color temperature may be inconsistent from manufacturer to manufacturer and may even vary within the same types of bulbs.

▶ **Light modifiers are more expensive.** Because most continuous lights are hot, modifiers such as softboxes need to be made to withstand the heat; this makes them more expensive than the standard equipment intended to be used for strobes.

▶ **Short lamp life.** Incandescent lights tend to have a shorter life than flash tubes, so you'll have to replace them more often.

Although incandescent lights have quite a few disadvantages, they are by far the most affordable type of lights you can buy. Many photographers who are starting out use inexpensive work lights they can buy at any hardware store for less than $10. These lights use a standard light bulb and often have a reflector to direct the light; they also come with a clamp you can use to attach them to a stand or anything else you have handy that might be stable.

Halogen work lamps, also readily available at any hardware store, offer a higher light output than a standard light, generally speaking. The downside is they are very hot, and the larger lights can be a bit unwieldy. You also may have to come up with some creative ways to get the lights in the position you want. Some halogen work lamps come complete with a tripod stand. If you can afford it, I recommend buying these; they're easier to set up and less of an aggravation in the long run. The single halogen work lamps that are usually designed to sit on a table or some other support are readily available for less than $20; the double halogen work lamps with two 500-watt lights and a 6-foot tripod stand usually cost less than $40.

If you're really serious about lighting with hot lights, you may want to invest in a photographic hot-light kit. These kits are widely available from any photography or video store. They usually come with lights, light stands, and sometimes light modifiers such as umbrellas or softboxes for diffusing the light for a softer look. The kits can be relatively inexpensive, with two lights, two stands, and two umbrellas for around $100. Or you can buy much more elaborate setups ranging in price up to $2,000. I've searched the Internet for these kits and have found the best deals are on eBay.

Fluorescent

Fluorescent lights have a lot of advantages over incandescent lights: They run at much lower temperatures and use much less electricity than standard incandescent lights. Fluorescent lights are also a much softer light source than incandescent lights.

In the past, fluorescent lights weren't considered viable for photographic applications because they cast a sickly green light on the subject. Today, most fluorescent lamps for use in photography are color corrected to match both daylight and incandescent lights. Also, given white balance is adjustable in the camera or in Photoshop with RAW files, using fluorescents has become much easier because you don't have to worry about color-correcting filters and special films.

These days, because more people are using fluorescent lights, light modifiers are more readily available. They allow you to control the light to make it softer or harder and directional or diffused.

Fluorescent light kits are readily available through most photography stores and online. These kits are a little more expensive than the incandescent light kits — an average two-light kit with light stands, reflectors, and bulbs costs about $160. Fluorescent kits aren't usually equipped with umbrellas or softboxes because the light is already fairly soft. You can buy these kinds of accessories and there are kits available that come with softboxes and umbrellas, although they cost significantly more.

Unfortunately, there aren't many low-cost alternatives to buying a fluorescent light kit. The only real option is to use the clamp light I mentioned in the section about incandescent light and fit it with a fluorescent bulb that has a standard bulb base on it. These types of fluorescent bulbs are readily available at any store that sells light bulbs.

HMI

HMI (Hydrargyrum Medium-Arc Iodide), a type of continuous light, is primarily used in the motion picture industry. HMI lamps burn extremely bright and are much more efficient than standard incandescent, halogen, or fluorescent lights. The light emitted is equal in color temperature to that of daylight.

Although I include them here for general information, these kits are usually too cost-prohibitive for use in average still-photography applications. A one-light kit with a 24-watt light can start at more than $1,000. An 18,000-watt kit can cost more than $30,000.

D7000 Flash Basics

A major advantage of the Nikon D7000 is the fact that it has a built-in flash for quick use in low-light situations. Even better is the fact that Nikon has additional flashes called *Speedlights* that are much more powerful and versatile than the smaller built-in flash.

Nikon Speedlights are dedicated flash units, meaning they are built specifically for use with the Nikon camera system and offer much more functionality than a nondedicated flash. A nondedicated flash is a flash made by a third-party manufacturer; the flashes usually don't offer fully automated flash features. There are, however, some non-Nikon flashes that use Nikon's i-TTL flash-metering system. The i-TTL system allows the flash to operate automatically, usually resulting in a perfect exposure, without you having to do any calculations.

Achieving proper exposures

If you are new to using an external Speedlight flash, exposure can seem confusing when you first attempt to use it. There are a lot of settings you need to know, and there are different formulas you can use to get the right exposure. Once you understand the numbers and where to plug them in, using the Speedlight becomes quite easy.

If you are using your Speedlight in i-TTL mode, the calculations you would otherwise do manually are done for you, but it's always good to know how to achieve the same results if you don't have the technology to rely on, and to understand how to work with the numbers. When you know these calculations, you can use any flash and get excellent results.

Three main components go into making a properly exposed flash photograph: Guide Number (GN), aperture, and distance. If one of these elements is changed, another one must be changed proportionally to keep the exposure consistent. The following sections cover each element and how to put them together.

Guide Number

The first component in the equation for determining proper flash exposure is the Guide Number (GN), which is a numeric value that represents the amount of light emitted by the flash. You can find the GN for your specific Speedlight in the owner's manual. The GN changes with the ISO sensitivity to which your camera is set. For example, the GN for a Speedlight at ISO 400 is greater than the GN for the same Speedlight at ISO 100 (because of the increased sensitivity of the sensor). The GN

also differs depending on the Speedlight's zoom setting. The owner's manual has a table that breaks down the GNs according to the flash output setting and the zoom range selected on the Speedlight.

 If you plan to do a lot of manual flash exposures, I suggest making a copy of the GN table from the owner's manual and keeping it in your camera bag with the flash.

Aperture

The second component in the flash exposure equation is the aperture setting. As you already know, the wider the aperture, the more light that falls on the sensor. Using a wider aperture allows you to use a lower power setting (such as 1/4 when in Manual mode) on your flash; or if you're using the automatic i-TTL mode, the camera fires the flash using less power.

Distance

The third component in the flash exposure equation is the distance from the light source to the subject. The closer the light is to your subject, the more light falls on it. Conversely, the farther away the light source is, the less illumination your subject receives. This is important because if you set your Speedlight to a certain output, you can still achieve a proper exposure by moving the Speedlight closer or farther away as needed.

GN / Distance = Aperture

Here's where the GN, aperture, and distance all come together. The basic formula allows you to take the GN and divide it by the distance to determine the aperture at which you need to shoot. You can change this equation to find out what you want to know specifically:

▶ **GN / D = A.** If you know the GN of the flash and the distance of the flash from the subject, you can determine the aperture to use to achieve the proper exposure.

▶ **A / GN = D.** If you know the aperture you want to use and the GN of the flash, you can determine the distance to place your flash from the subject.

▶ **A × D = GN.** If you already have the right exposure, you can take your aperture setting and multiply it by the distance of the flash from the subject to determine the approximate GN of the flash.

Flash Exposure Compensation (FEC)

When you're photographing subjects using flash, whether you're using an external Speedlight or the built-in flash on your D7000, there may be times when the flash causes your principal subject to appear too light or too dark. This usually occurs in difficult lighting situations, especially when you use TTL metering. Your camera's meter can bo fooled into thinking the subject needs more or less light than it actually does. This can happen when the background is very bright or very dark, or when the subject is off in the distance or very small in the frame.

Flash Exposure Compensation (FEC) allows you to manually adjust the flash output while still retaining TTL readings so your flash exposure is at least in the ballpark. With the D7000, you can vary the output of your built-in flash's TTL setting (or your own manual setting) from –3 Exposure Value (EV) to +1 EV. This means if your flash exposure is too bright, you can adjust it down 3 full stops under the original setting. Or if the image seems underexposed or too dark, you can adjust it to be brighter by 1 full stop. Additionally, the D7000 allows you to fine-tune how much exposure compensation is applied by letting you set the FEC incrementally in either 1/3, 1/2, or 1 stop of light.

To adjust the FEC when using the built-in flash, press and hold the flash pop-up/FEC button and rotate the Sub-command dial. The amount of FEC being applied is displayed on the LCD control panel and the viewfinder.

 FEC is not reset when the camera is turned off, so be sure to dial the FEC back to 0 when you are finished.

Fill flash

Fill flash is a handy flash technique that allows you to use your Speedlight as a secondary light source to fill in the shadows rather than as the main light source; hence the term *fill flash*. Fill flash is used mainly in outdoor photography when the sun is very bright, creating deep shadows and bright highlights that result in an image with very high contrast and a wide tonal range. Using fill flash enables you to reduce the contrast of the image by filling in the dark shadows, thus allowing you to see more detail in the image. Figure 6.2 shows two portraits, one taken without flash and one taken with fill flash.

6.2 A picture taken without flash on the left and a picture with fill flash on the right

You also may want to use fill flash when your subject is backlit (lit from behind). When the subject is backlit, the camera's meter automatically tries to expose for the bright part of the image that is behind your subject. This results in a properly exposed background while your subject is underexposed and dark. However, if you use the spot meter to obtain the proper exposure on your subject, the background will be overexposed and blown out. Ideally, fill flash provides an amount of light on your subject that is equal to the ambient light of the background. This brings sufficient detail to both the subject and the background, resulting in a properly and evenly exposed image.

All of Nikon's dSLR cameras offer i-TTL BL (Nikon calls this Balanced Fill-Flash) or, in layman's terms, automatic fill flash, with both the built-in flash and the detachable Speedlights: the SB-900, SB-800, SB-700, SB-600, and SB-400. When you use a Speedlight, the camera automatically sets the flash to fill flash (as long as you're not in Spot metering mode). This is a very handy feature because it allows you to concentrate on composition and not worry about your flash settings. If you decide that you don't want to use the i-TTL BL option, you can set the camera's metering mode to Spot metering, or if you are using an SB-900, SB-800, SB-700 or SB-600, you simply press the Speedlight's Mode button.

Diffusers

One of the easiest ways to improve your flash photography is to use a flash diffuser. These are simple devices that fit over or are placed in front of the flash head. As the name implies, a diffuser diffuses, or softens, the light. This helps to avoid that annoying dark black shadow that often appears next to your subject when you take photos using direct flash. There are a lot of different types of diffusers that range in price from $10 to $60. The type of diffuser I use depends on which flash I'm using. When using the built-in flash, I use a LumiQuest Soft Screen that I picked up at my local camera store for about $12. When using the SB-900 or SB-800, I use the diffusers that were included with them, and for the SB-600, I use a Sto-Fen Omni-Bounce. I've tried other diffusers, particularly the Gary Fong Lightsphere, and found it too bulky. It's no better than the smaller diffusers that are easier to store in your camera bag.

I almost never use a flash or Speedlight without a diffuser unless I am specifically aiming for a scene that has very hard and directional light. If you use the built-in flash a lot, I recommend *always* using a diffuser. I cannot stress this point enough. It makes a huge difference in image quality.

Of course, if you don't own an additional i-TTL-dedicated Speedlight or you'd rather control your flash manually, you can still use fill flash. It's actually a pretty simple process that can vastly improve your images when you use it in the right situations.

To execute a manual fill flash, follow these steps:

1. **Use the camera's light meter to determine the proper exposure for the background or ambient light.** A typical exposure for a sunny day is 1/125 second at f/16 with an ISO of 100. Be sure not to set the shutter speed higher than the rated sync speed of 1/250 second.

2. **Determine the flash exposure.** Using the GN / D = A formula, find the setting that you need to properly expose the subject with the flash.

3. **Set the flash output.** Setting the output of the Speedlight 1/3 to 2/3 stops under what your calculations are is the key to proper fill flash and allows the flash exposure to be less noticeable while filling in the shadows or lighting your backlit subject. This makes your images look more natural, as if a flash didn't light them, which is the ultimate goal of fill flash.

Bounce flash

One of the easiest ways to improve your flash pictures is to use bounce flash. Bounce flash is a technique in which the light from the flash unit is bounced off of the ceiling or off of a wall onto the subject to diffuse the light, resulting in a more evenly lit image. To do this, your flash must have a head that swivels and tilts. Most flashes made within the last 10 years have this feature, but some may not. Figure 6.3 shows a picture taken with straight flash and a picture taken with bounced flash.

When you attempt bounce flash, you want to get as much light from the flash onto your subject as you can. To do this, you need to first look at the placement of the subject and then adjust the angle of the flash head appropriately. Consider the height of the ceiling or distance from the surface you intend to bounce the light from to the subject.

Unfortunately, not all ceilings are useful for bouncing flash. For example, the ceiling in my studio is corrugated metal with iron crossbeams. If I attempt to bounce flash from it, it makes little or no difference to the image because the light doesn't reflect evenly and scatters in different directions. In a situation where the ceiling is not usable, you can position the subject next to a wall and swivel the flash head in the direction of the wall and bounce it from there. To bounce the flash at the correct angle, remember the *angle of incidence* equals the *angle of reflection*, or the angle at which the light hits a flat surface is the same angle that it's reflected.

You want to aim the flash head at such an angle that the flash isn't going to bounce in behind the subject so it is poorly lit. You want to be sure that the light is bounced so that it falls onto your subject. When the subject is very close to you, you need to have your flash head positioned at a more obtuse angle than when the subject is farther away. I recommend positioning the subject at least 10 feet away and setting the angle of the flash head at 45° for a typical height ceiling of about 8 to 10 feet.

An important pitfall to be aware of when bouncing flash is that the reflected light picks up and transmits the color of the surface from which it is bounced. This means if you bounce light off a red surface, your subject will have a reddish tint to it. The best approach is to avoid bouncing light off of surfaces that are brightly colored, and stick with bouncing light from a neutral-colored surface. White surfaces tend to work the best because they reflect more light and don't add any color. Neutral gray surfaces also work well, although you can lose a little light given there is less reflectivity.

Unfortunately, you can't do bounce flash with the built-in flash on the D7000; you need an external Speedlight such as an SB-900, SB-800, SB-700, SB-600, or SB-400.

6.3 A picture taken with straight flash on the left and bounced flash on the right

Flash Exposure Modes

Flashes have different modes that determine how they receive the information on setting the exposure. However, be aware that, depending on the Speedlight or flash you are using, some flash modes may not be available.

i-TTL and i-TTL BL

The D7000 determines the proper flash exposure automatically by using Nikon's proprietary i-TTL (intelligent Through-the-Lens) system. The camera gets most of the metering information from monitor preflashes emitted from the Speedlight. These preflashes are emitted almost simultaneously with the main flash so it looks as if the flash has only fired once. The camera also uses data from the lens, such as distance information and f-stop values, to help determine the proper flash exposure.

Additionally, two types of i-TTL flash metering are available for the D7000: Standard i-TTL flash and i-TTL Balanced Fill-Flash (BL). With Standard i-TTL flash, the camera determines the exposure for the subject only and doesn't take the background lighting into account. With i-TTL BL mode, the camera attempts to balance the light from the flash with the ambient light to produce a more natural-looking image.

When you use the built-in flash on the D7000, the default mode is i-TTL BL. To switch the flash to Standard i-TTL, the camera must be switched to Spot metering.

The Standard i-TTL and i-TTL BL flash modes are available with Nikon's current Speedlight lineup, including the SB-900, SB-700, SB-600, SB-400, and the R1C1 macro flash kit, as well as the recently discontinued SB-800.

Manual

When you set your Speedlight (either the built-in or accessory flash) to full Manual mode, you must adjust the settings yourself. The best way to figure out the settings is by using a handheld flash meter or by using the GN / D = A formula I discussed previously.

Auto

With Speedlights that offer the Auto mode (sometimes referred to as Non-TTL Auto Flash), such as the SB-900 and SB-800, you decide the exposure setting. These flashes usually have a sensor on the front of them that detects the light reflected back from the subject. When the flash determines enough light has been produced to make the exposure, it automatically stops the flash tube from emitting any more light.

When using this mode, you need to be aware of the limitations of the flash you are using. If the flash doesn't have a high GN or the subject is too far away, you may need to open the aperture. Conversely, if the flash is too powerful or the subject is very close, you may need to stop the aperture down a bit.

 When you use Auto mode with a non-Nikon flash, be sure not to set the shutter speed on the D7000 higher than the rated sync speed, which is 1/250 second. If you do, the image will not be completely exposed.

Auto Aperture

Some flashes, such as the SB-900 and SB-800, also offer Auto Aperture Flash mode. In this mode, you decide which aperture is best suited for the subject you are photographing, and the flash determines how much light to add to the exposure.

Guide Number distance priority

In the Guide Number distance priority mode available with the SB-800 and SB-900, the flash controls the output according to aperture and subject distance. You manually enter the distance and f-stop value into the flash unit and then select the f-stop with the camera. The flash output remains the same if you change the aperture. You can use this mode when you know the distance from the camera to the subject.

 Changing the aperture or the distance to the subject after entering the setting on the flash can cause improper exposures.

Repeating flash

When in Repeating flash mode, the flash fires repeatedly like a strobe light during a single exposure, as shown in Figure 6.4. You must manually determine the proper flash output you need to light your subject using the formula to get the correct aperture (GN / D = A), and then you decide the frequency (Hz) and the number of times you want the flash to fire. The slower the shutter speed, the more flashes you can capture. For this reason, I recommend only using this mode in low-light situations because the ambient light tends to overexpose the image. Use this mode to create a multiple exposure-type image.

6.4 An image shot using Repeating flash

To determine the correct shutter speed, use this simple formula: Shutter speed = number of flashes per frame / Hz. For example, if you want the flash to fire 10 times with a frequency of 40 Hz (40 times per second), divide 10 by 40, which gives you .25 or 1/4 second.

Flash Sync Modes

Flash sync modes control how the flash operates in conjunction with your D7000. These modes work with both the built-in Speedlight and accessory Speedlights, such as the SB-900, SB-800, SB-600, and so on. These modes allow you to choose when the flash fires, either at the beginning of the exposure or at the end, and they also allow you to keep the shutter open for longer periods, enabling you to capture more ambient light in low-light situations.

Sync speed

Before getting into the different sync modes, you need to understand sync speed. The sync speed is the fastest shutter speed that can be used while achieving a full flash exposure. This means if you set your shutter speed at a speed faster than the rated sync speed of the camera, you don't get a full exposure and end up with a partially underexposed image. With the D7000, you can't actually set the shutter speed above the rated sync speed of 1/250 second when using a dedicated flash because the camera won't let you (unless you're using Auto FP High-Speed Sync; more on that later). This means you don't need to worry about having partially black images when using a Speedlight. But if you're using a studio strobe or a third-party flash, this may be of concern.

Limited sync speeds exist because of the way shutters in modern cameras work. As you already know, the shutter controls the amount of time the light is allowed to reach the imaging sensor. All dSLR cameras have a *focal plane* shutter. This shutter is located directly in front of the focal plane, which is essentially on the sensor. The focal plane shutter has two shutter curtains that travel vertically in front of the sensor to control the time the light can enter through the lens. At slower shutter speeds, the front curtain covering the sensor moves away, exposing the sensor to light for a set amount of time. When the exposure has been made, the second curtain then moves in to block the light, thus ending the exposure.

Auto FP High-Speed Sync

Although the D7000 has a top-rated sync speed of 1/250 second, Nikon has built in a convenient option in Custom Settings menu e1 (CSM e1) that allows you to use flash at shutter speeds faster than the rated sync speed. This is called Auto FP High-Speed Sync (the FP stands for focal plane, as in the shutter). Setting CSM e1 to Auto FP allows you to shoot the built-in flash at 1/320 second and other compatible Speedlights (SB-900, SB-800, SB-700, and SB-600) to a maximum of 1/8000 second. Earlier, I said that the sensor must be fully exposed to receive the full flash exposure and that's limited to 1/250 second, so how on earth does Auto FP flash work?

It's pretty simple actually: Instead of firing one single pop, the flash fires multiple times as the shutter curtain travels across the focal plane of the sensor (hence the Auto FP). The only drawback is that your flash power, or GN, is diminished, so you may need to take this into consideration when doing manual flash calculations.

Auto FP is a useful feature. It's mainly used when shooting in brightly lit scenes using fill flash. An example is shooting a portrait outdoors at high noon; of course, the light is very high in contrast and you want to use fill flash, but you also require a wide aperture to blur out the background. At the sync speed 1/250 second, ISO 200, your aperture needs to be at f/16. If you open your aperture to f/4, you then need a shutter speed of 1/8000 second. This is possible using Auto FP.

At shutter speeds faster than 1/250, the second curtain of the shutter starts closing before the first curtain has exposed the sensor completely. This means the sensor is actually exposed by a slit that travels the length of the sensor. This allows your camera to have extremely fast shutter speeds, but limits the flash sync speed because the entire sensor must be exposed to the flash at once to achieve a full exposure.

 The built-in flash on the D7000 only uses Auto FP up to 1/320 second.

Front-Curtain Sync

Front-Curtain Sync is the default sync mode for your camera whether you are using the built-in flash, one of Nikon's dedicated Speedlights, or a third-party accessory flash. With Front-Curtain Sync, the flash is fired as soon as the shutter's front curtain fully opens. This mode works well with most general flash applications.

One thing worth mentioning about Front-Curtain Sync is that although it works well when you're using relatively fast shutter speeds, when the shutter is slowed down (also known as *dragging the shutter* in flash photography), especially when you're photographing moving subjects, your images have an unnatural-looking blur in front of them. Ambient light reflecting off of the moving subject creates this.

When doing flash photography at slow speeds, your camera is actually recording two exposures: the flash exposure and the ambient light. When you're using a fast shutter speed, the ambient light usually isn't bright enough to have an effect on the image. When you slow down the shutter speed substantially, it allows the ambient light to be recorded to the sensor, causing *ghosting*. Ghosting is a partial exposure that is usually fairly transparent looking on the image.

In Figure 6.5, ghosting causes a trail to appear in front of the subject because the flash freezes the initial movement of the subject. Because the subject is still moving, the ambient light records it as a blur that appears in front of the subject, creating the illusion that it's moving backward. To counteract this problem, you can use a Rear-Curtain Sync mode, which I explain later.

6.5 A shot using Front-Curtain Sync with a shutter speed of 1 second. Notice that the flash freezes the hand during the beginning of the exposure and the trail caused by the ambient exposure appears in the front, causing the hand to look like it's moving backward.

Red-Eye Reduction

We've all seen red-eye in a picture at one time or another — that unholy red glare emanating from the subject's eyes that is caused by light reflecting off the retina. Fortunately, the D7000 offers a Red-Eye Reduction mode. When this mode is activated, the camera either fires some preflashes (when using an accessory Speedlight) or turns on the AF-assist illuminator (when using the built-in flash), which cause the pupils of the subject's eyes to contract. This stops the light from the flash from reflecting off of the retina and reduces or eliminates the red-eye effect. This mode is useful when you're taking portraits or snapshots of people or pets with little light available.

Slow Sync

Sometimes when you're using a flash at night, especially when the background is very dark, the subject is lit but appears to be in a black hole, as shown on the left in Figure 6.6. Slow Sync mode helps take care of this problem. In Slow Sync mode, the camera allows you to set a longer shutter speed (up to 30 seconds) to capture the ambient light of the background, as shown on the right in Figure 6.6. Your subject and the background are lit, so you can achieve a more natural-looking photograph.

6.6 These two images show the difference between straight flash at night (left) and slow sync (right).

 Slow Sync can be used in conjunction with Red-Eye Reduction for night portraits.

 When you use Slow Sync, be sure the subject stays still for the whole exposure to avoid ghosting. Of course, you can use ghosting creatively.

Rear-Curtain Sync

When using Rear-Curtain Sync, the camera fires the flash just before the rear curtain of the shutter starts moving. This mode is useful when you're taking flash photographs of moving subjects. Rear-curtain sync allows you to more accurately portray the motion of the subject by causing a motion blur trail behind the subject rather in front of it, as is the case with Front-Curtain Sync. Rear-Curtain Sync is used in conjunction with Slow Sync.

 Rear-Curtain Sync is available in all exposure modes (P, S, A, and M), Rear-Curtain Slow Sync is only available when in P or A mode.

6.7 A picture taken using Rear-Curtain Sync

Understanding the Creative Lighting System

Nikon introduced the Creative Lighting System (CLS) in 2004. In simple terms, it is a system designed to enable you to use Nikon Speedlights off-camera. This allows you to position the Speedlights wherever you want and control the direction of light to make the subject appear exactly how you want. The Nikon CLS enables you to achieve creative lighting scenarios similar to what you would achieve with expensive and much larger studio strobes. You can do it wirelessly with the benefit of full i-TTL metering. To take advantage of the Nikon CLS, you need the D7000 (or a CLS-compatible Nikon camera) and at least one SB-900, SB-800, SB-700, SB-R200, or SB-600 Speedlight. With the CLS, there is no more mucking about with huge power packs and heavy strobe heads on heavy-duty stands, with cables and wires running all over the place.

The Nikon CLS is not a lighting system in and of itself, but is comprised of many different pieces you can add to your system as you see fit (or your budget allows). The first and foremost piece of the equation is your camera.

The Nikon CLS is basically a communication system that allows the camera, the commander, and the remote units to share information regarding exposure.

A commander, which is also called a *master*, is the flash that controls external Speedlights. Remote units, which are sometimes referred to as *slaves*, are the external flash units the commander controls remotely. Communications between the commander and the remote units are accomplished by using pulse modulation. *Pulse modulation* is a term that means the commanding Speedlight fires rapid bursts of light in a specific order. The pulses of light are used to convey information to the remote group, which interprets the bursts of light as coded information.

Firing the commander tells the other Speedlights in the system when and at what power to fire. The built-in flash on the DX can act as a commander. Using an SB-700, SB-800, or SB-900 Speedlight or an SU-800 Commander as a master allows you to control three separate groups of remote flashes and gives you an extended range.

Using the built-in Speedlight as a commander, you can only control two groups of external Speedlights and have a limited range on how far the camera can be from the remote flashes.

This is how CLS works in a nutshell:

1. **The commander unit sends out instructions to the remote groups to fire a series of monitor preflashes to determine the exposure level.** The camera's i-TTL metering sensor reads the preflashes from all the remote groups and takes a reading of the ambient light.

2. **The camera tells the commander unit the proper exposure readings for each group of remote Speedlights.** When the shutter is released, the commander, via pulse modulation, relays the information to each group of remote Speedlights.

3. **The remote units fire at the output specified by the camera's i-TTL meter, and the shutter closes.**

All these calculations happen in a fraction of a second as soon as you press the Shutter Release button. It appears to the naked eye as if the flash just fires once. There is no waiting for the camera and the Speedlights to do the calculations.

Given the ease of use and the portability of the Nikon CLS, I highly recommend purchasing at least one (if not two) SB-900, SB-800, SB-700, or SB-600 Speedlights to add to your setup. With this system, you can produce almost any type of lighting pattern you want, and it can definitely get you on the road to creating more professional-looking images.

For a definitive and in-depth look into the Nikon CLS, read the *Nikon Creative Lighting System Digital Field Guide,* 2nd Edition (Wiley, 2009).

Using the Built-In Flash

The built-in Speedlight on the D7000 is a handy little flash that's great for taking casual snapshots. Although it lacks the versatility of the bigger external flashes, the built-in flash is always there when you need it and requires no extra batteries because the camera's battery powers it. Activate it by pressing the flash pop-up button on the top left of the camera (as you would hold it for shooting) near the built-in flash.

The built-in flash is set to i-TTL mode by default in the menu (i-TTL appears as TTL in the menu), although you can choose to set it to Manual mode (you set the output). You can also set it to Repeating flash (RPT) or Commander mode, which allows you to use it to control up to two separate groups of remote Speedlights.

And you can use it with all the sync modes your camera offers: Front-Curtain Sync, Rear-Curtain Sync, Slow Sync, and Red-Eye Reduction. To change the sync mode, press the Flash mode button located just below the Flash pop-up button. Rotating the Main Command dial while pressing the Flash mode button changes the mode. The selected mode appears in the LCD control panel.

You can also apply exposure compensation by pressing the Flash mode button and rotating the Sub-command dial.

One of the best features of the built-in flash is that you can use it to wirelessly control remote units using the CLS. To take advantage of this feature, you need at least one SB-600, SB-700, SB-800, SB-900, or SB-R200. Follow these steps to use the built-in flash in Commander mode:

1. **Press the Menu button and use the Multi-selector to navigate to the Custom Settings menu.**

2. **Use the Multi-selector to highlight CSM e Bracketing/flash, and then press the Multi-selector right to enter the CSM e menu.**

3. **Use the Multi-selector to highlight CSM e3 Flash cntrl for built-in flash, and then press the Multi-selector right to view flash control options.**

4. **Press the Multi-selector up or down to choose Commander mode, and then press the Multi-selector right to view settings.**

5. **Press the Multi-selector up or down to choose a flash mode for the built-in flash.** You can choose M, TTL, or --. The last option (--) allows the flash to control the remotes without adding additional exposure.

6. **Press the Multi-selector right to highlight the exposure compensation setting.** Press the Multi-selector up or down to apply exposure compensation if desired. If the built-in flash is set to --, this option is not available.

7. **Use the Multi-selector to set the mode for Group A.** You can choose TTL, AA, M, or --. Press the Multi-selector right to highlight exposure compensation. Press the Multi-selector up or down to apply exposure compensation if desired. Repeat this process for Group B.

8. **Use the Multi-selector to highlight the Channel setting.** You can choose from channels 1 to 4. These channels can be changed if you are shooting in the same area as another photographer using CLS. If you are both on the same channel, you will trigger each other's Speedlights. If you use CLS alone, it makes no difference which channel you choose.

9. **Press the OK button.** If this button is not pressed, no changes are applied.

When you use wireless CLS, be sure that your remote Speedlights are set to the proper groups and channel. If the remotes aren't properly set, they will not fire.

Light Modifiers

When you set up a photographic shot, in essence, you are building a scene using light. For some images, you may want a hard light that is very directional; for others, a soft, diffused light works better. Light modifiers allow you to control the light so you can direct it where you need it, give it the quality the image calls for, and even add color or texture to the image. There are many different kinds of diffusers. Here's a list of the most common ones:

▶ **Umbrella.** The photographic umbrella is used to soften the light of a flash. You can either shoot through the umbrella or bounce the light from the inside of the umbrella depending on the type of umbrella you have. Umbrellas are very portable and make a great addition to any Speedlight setup.

▶ **Softbox.** These also soften the light and come in a myriad of sizes, from huge 8-foot softboxes to small 6-inch versions that fit right over your Speedlight mounted on the camera.

▶ **Reflector.** This is probably the handiest modifier you can have. You can use it to reflect natural light onto your subject or you can use it to bounce light from your Speedlight onto the subject, making it softer. Some can act as diffusion material to soften direct sunlight. They come in a variety of sizes from 2 to 6 feet and fold up into a small portable size. I recommend that every photographer have at least a small reflector in his alternate camera bag.

▶ **Parabolic reflectors.** Most light sources come equipped with a parabolic reflector. They usually range from 6 to 10 inches in circumference, although you can buy larger ones. Without a reflector, the light from the bare bulb, whether it's a flash tube or an incandescent, scatters and lacks direction, resulting in the loss of usable light. The reflector focuses the light into a more specific area, actually

increasing the amount of usable light by 1 or 2 stops. Parabolic reflectors are commonly used in conjunction with other light modifiers, including umbrellas, barn doors, and grids. When you use an umbrella, you should always use a reflector to direct the light into the umbrella, which diffuses the light. Using only a reflector gives the light a very hard quality that results in a lot of contrast.

▶ **Barn doors.** Barn doors are used to control the direction of light and to block stray light from entering the lens, which can result in lens flare. Blocking the light is also known as *flagging*. Barn doors are normally attached to the reflector and come in two types — 4-leaf and 2-leaf. Barn doors consist of panels that are attached to hinges, which allow you to open and close the doors to let light out or keep it in. Typically, barn doors are used when you want a hard light source to shine on a specific area of the subject but you don't want any stray light striking other parts of the subject or the camera lens.

▶ **Grids.** Grids, also known as *grid spots* or *honeycombs*, are used to create a light similar to a spotlight. A grid is a round disc with a honeycomb-shaped screen inside of it. When the light shines through it, it is focused to a particular degree, giving you a tight circle of light with a distinct falloff at the edges. There are different types of grids that control the spread of light. They run from a 5° grid to a 60° grid. The 5° grid has very small holes and is deep, so the light is focused down to a small bright spot. The higher the degree of the grid spot, the more spread out the spot becomes. Grids fit inside of the reflector, just in front of the lamp or flash tube. They are great to use as hair lights and to add a spot of light on the background to help the subject stand out.

▶ **Snoots.** A snoot creates a spotlightlike effect similar to the grid. A snoot is shaped like a funnel and it kind of works that way, too, funneling light into a specific area of the scene. The snoot usually has a brighter spot effect than a grid does, and fits directly over the flash head.

▶ **Gobos.** A gobo can be anything that *goes between* the light source and the subject or background, often to create a pattern or simulate a specific light source, such as a window. It is usually attached to a stand and placed a few feet in front of the light source. A common technique in film noir-type photography is to place venetian blinds between a light and the background to simulate sunlight shining through the blinds of the office window of a private eye. You can make gobos or purchase them from a photographic supply house.

Working with Live View and Video

Nikon has been improving its Live View/Video feature with every camera it releases, and with the introduction of the D3100 and D7000 it made some pretty radical changes. Live View is now standard on every camera in Nikon's current lineup, adding convenience to the picture-taking process and also easing the transition for those stepping up from compact cameras.

A main change is that Nikon added full-resolution 1080p HD video while the early cameras recorded at 720p. Probably the biggest feature is the addition of full-time autofocus, the first of its kind in HD dSLRs (with the exception of the D3100).

Many filmmakers are turning to dSLR cameras because of their portability and wide selection of lenses.

Live View

Using Live View allows you to view a live feed of what is being projected onto the sensor from the lens. As you may already know, the image from the lens is projected to the viewfinder via a mirror that is in front of the sensor. A semitransparent area in the mirror acts as a beam splitter, and is used by the camera for its normal phase-detection AF (autofocus). For Live View to work, the mirror must be flipped up, making phase-detection AF unusable; the camera uses contrast detection directly from the sensor to determine focus instead. This makes focusing with Live View a bit slower than focusing normally. In addition, when you're shooting still photographs, the mirror must flip down and back up, which takes extra time. For this reason, Live View is not the best option to use when shooting moving subjects or things like sports events, where timing is the key element in capturing an image successfully.

That being said, Live View can come in handy when you are shooting in a studio setting, especially when using a tripod. You can move the focus area anywhere in the frame because Live View isn't limited to the standard the 39 AF points. Live View can also be handy when grabbing snapshots of everyday scenes.

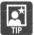 Keep in mind that when using Live View handheld, you are holding the camera at arm's length and this increases the risk of blurry images due to camera shake. Keep your elbows close to your sides for added stability.

Focus modes

The D7000 has a few different focus modes in Live View or Video mode. They operate similarly to the focus modes you use when shooting stills using the viewfinder.

Single-servo AF (AF-S)

Single-servo AF (AF-S) is equivalent to Single AF (AF-S) when you're shooting stills. Use the Multi-selector to move to focus point to your subject, and half-press the Shutter Release button to focus. The shutter won't release until the camera detects that the scene is in focus. Pressing the Record button starts the recording, but the focus will be locked on the initial subject.

This setting is best for stationary subjects like portraits, still lifes, products, and landscapes.

For video you need to be sure that your subject isn't moving at all, especially if you're using a wide aperture for a shallow depth of field. Even the slightest change in distance can cause the subject to go out of focus.

Full-time-servo AF (AF-F)

Full-time-servo AF (AF-F) was introduced with the D3100 and D7000 cameras. This focus mode allows the camera to focus continuously while in Live View or when shooting video (similar to AF-C, or Continuous AF). Even though the camera is focusing continuously to shoot a still frame, the AF is engaged and refocuses before releasing the shutter. I find that this mode works best when shooting video.

Full-time-servo AF operates in conjunction with the AF-area modes, which are covered in the next section.

AF-area modes

To make the Live View focusing quicker and easier, Nikon has given you a few different options for AF-area modes. These modes noticeably speed up the process of focusing when compared with previous cameras. You can change the settings in the Shooting menu by choosing AF-area mode ➜ Live View.

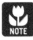

The AF-area mode cannot be changed while recording video.

▶ **Face-priority AF.** Use this mode for shooting portraits or snapshots of the family. You can choose the focus point, but the camera uses face recognition to focus on the face rather than on something in the foreground or background. This can really be an asset when you're shooting in a busy environment, such as when there's a lot of distracting elements in the background. When the camera detects a face in the frame, a double yellow border is displayed around the AF area. If more than one face is detected (the camera can read up to 35 faces), the camera chooses the closest face as the focus point.

▶ **Wide-area AF.** This makes the area where the camera determines focus from about 4X the size of the Normal-area AF mode. This is good when you don't need to be very critical about the point of focus in your image. For example, when shooting a far-off landscape, you really only need to focus on the horizon line. This is a good general mode for everyday use. You can move the AF area anywhere within the image frame.

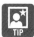 When using Face-priority, Normal-area, or Wide-area AF, press the OK button to move the AF area to the center of the frame.

▶ **Normal-area AF.** This mode has a smaller AF point and is used when you need to achieve focus on a very specific area within the frame. This is the preferred mode to use when shooting with a tripod. It's the mode I use when shooting macros, still lifes, and similar subjects. I also use this mode when shooting portraits, instead of Face-priority, so I can control the AF area.

▶ **Subject-tracking AF.** This is a pretty cool feature, especially when used in conjunction with video. Use the Multi-selector to position the AF area over the top of the main subject of the image. Press the OK button to start the tracking. The AF area follows the subject as it moves around within the frame. Be aware, however, that this feature works best with slow to moderately fast-paced subjects that stand out from the background. When using this mode with a very fast-moving subject, the camera tends to lose the subject and lock on something of similar color and brightness within the frame. This mode also decreases in effectiveness in lower light. To disable subject tracking, simply press the OK button. This resets the AF area to the center. To reactivate subject tracking, press the OK button again.

 When you half-press the Shutter Release button to focus for taking a still shot, subject tracking is disabled. Releasing the button reactivates tracking.

Video

About two years ago, Nikon introduced the world's first dSLR with HD video capability, the D90. Since then Nikon has been adding features to the Video mode with every new camera. The D7000 is currently one of only two Nikon cameras that offers true 1080p HD video and full-time AF when you're actually *recording* video.

Before going any further, one thing must be made clear: The D7000 is not a video camera. It's a still camera that just happens to record video by using the feed from the Live View feature. The D7000 is one of Nikon's newest dSLR *cameras*, and it's an excellent example of that. It has a 16-megapixel sensor, low noise at high ISO settings, and a fast continuous shutter speed — everything you could want from a dSLR. Why am I bringing this up? Because some people aren't happy with the current video performance in dSLR cameras. These evaluations are being based on comparisons to

dedicated video cameras. This is an unfair comparison. You wouldn't compare a still image taken from a video camera to a high-res still image from the D7000. It's like comparing apples to oranges.

HD dSLR videography has been taking off, not just for still photographers, but for serious filmmakers as well. Many TV shows and feature films have been made using HD dSLR cameras because dSLR cameras like the D7000 have advantages that far outweigh any perceived drawbacks when compared with a dedicated video camera. A few of the major advantages that dSLR cameras have over HD video cameras include

▶ **Price.** dSLR cameras are much cheaper than a mid- to pro-level HD video camera.

▶ **Image quality.** The D7000's APS-C-sized sensor also allows the camera to record video with less noise at high sensitivities than most video cameras can.

▶ **Interchangeable lenses.** You can use almost every Nikon lens ever made on the D7000. While some HD video cameras take Nikon lenses, you need an expensive adapter, and you lose some resolution and the ability to get a very shallow depth of field.

▶ **Depth of field.** You can get a much more shallow depth of field than video when using a lens with a fast aperture, such as a 50mm f/1.4. Most video cameras have sensors that are much smaller than the sensor of the D7000, which gives them a much deeper depth of field. A shallow depth of field gives videos a much more professional cinematic look.

About video

Before getting into the basics of the D7000's Video mode, it's best to do a little exploration into the realm of video. Video capture functions much differently from still-photo capture. Of course, all photography is capturing light by using a sensor (or film), a lens, and a lightproof box (your camera). Video is just digitally capturing still images at a high frame rate and playing them back sequentially.

The D7000 can shoot video in three resolutions that can be set in the Shooting menu under the Movie settings option or in the Info display. You can choose a small video size of 640 × 424 pixels, which is shot using a 3:2 aspect ratio. This is the same ratio at which still images are recorded. This resolution is very small and best suited for filming small clips that will be sent through e-mail or posted on the Internet without using too much bandwidth. Note that this setting is not HD. The best setting to use is the 1080p/24fps HD setting, which is a 16:9, or *cinematic*, ratio. This setting gives you

the most resolution and can easily be watched on large HDTVs with exceptional image quality. For smaller HD videos, you can record at 720p, which offers more than enough resolution for all practical purposes.

Progressive versus interlaced

If you're familiar with HD, you've probably heard the terms *progressive* and *interlaced*. Your D7000 has an HDMI (High-Definition Multimedia Interface) output setting (found in the Setup menu) that lets you choose between progressive and interlaced resolutions. So, what's the difference? Interlaced video scans every other line that makes up the picture, though the picture appears as if it is being displayed all at once. Progressive scanning progressively displays single lines of the image. As with interlaced technology, all of this happens too fast for the human eye to detect the separate changes, and so everything appears to happen all at once.

Frame rate

You may have noticed another number in subscript (24, 25, 30) at the end of the resolution number (1080 or 720). This subscript number is the *frame rate*, or the number of frames recorded every second, and is expressed using the term *frames per second* (fps).

Most video cameras capture video at 30 or 60 fps. A rate of 30 fps is generally considered the best for smooth-looking video that doesn't appear jerky. Shooting at 24 fps is the minimum rate to fool the human eye into seeing seamless motion. This also gives videos a quality that's similar to cinema.

The Nikon D7000 shoots full 1080p HD video at 24 fps, giving you a cinematic feel from the start. You can select different frame rates when shooting at 720p. You can choose to record at 24, 25, or 30 fps. This can be set in the Shooting menu under the Movie settings option or in the Info display menu. Select 24 fps for the cinematic look, or 30 fps for a smoother look. The 25-fps option is for videos that will be played back on PAL devices (the analog TV encoding system used in Europe).

Shutter

When you shoot video with your D7000, the camera isn't using the mechanical shutter that it uses when making still exposures. The Video mode uses what's known as an *electronic shutter*. This electronic shutter isn't an actual physical shutter but is a feature of the sensor that tells the sensor when to activate to become sensitive to the light striking it. The D7000 has a CMOS sensor that uses a *rolling shutter*.

A rolling shutter operates by exposing each row of pixels progressively (similar to HDTV reception discussed earlier) from top to bottom. In effect, it rolls the exposure down the sensor row by row. Unfortunately, this rolling shutter has a few unwanted artifacts that are inherent in its operation. These artifacts are usually most noticeable when the camera is making quick panning movements or the subject is moving from one side of the frame to the other. There are three types of artifacts common to the rolling shutter:

▶ **Skew.** This is the most common artifact. Skew causes objects in the video to appear as if they're leaning (or skewed). This artifact only appears when the camera is quickly panned or the subject is moving extremely fast. It is caused by the image being progressively scanned. As just discussed, the rolling shutter exposes each single frame from the top down. When the camera is moved sideways while the frame is being exposed, the top of the subject is exposed on one side of the frame, and the bottom of the subject is on the other side of the frame. This can also be seen when a subject moves very quickly across the frame.

▶ **Jello.** This video problem is closely related to skew and occurs when the camera is panned quickly back and forth. First, the video skews to one side and then the other, causing it to look like it's made of Jell-O, as if the subject is wobbly. This is the most common problem you will encounter when shooting video with the D7000. It's a symptom of the rolling shutter. The sidebar in this section provides some ideas to help minimize the effect.

▶ **Partial exposure.** This is caused by a brief flash of light, typically from a camera flash. As the shutter rolls down the frame, it's exposing for the ambient light. The brief flash duration causes part of the frame to be overexposed. You can expect to experience it at weddings or events where people are taking pictures with flash. If it's a major problem, steer clear of people doing flash photography.

Dealing with the Jello Effect

There's a very easy way to deal with the jello effect: *Don't do fast pans or whip pans.* It's that simple. If you know something is going to look bad, avoid it. Think like a filmmaker; use slow, preplanned camera movements. This small tip will make your videos look more professional. Another easy way to minimize the effect is to use something like a steadicam to stabilize the camera.

> ⚠ **CAUTION** Older fluorescent lights with low-frequency ballasts can cause video with a rolling shutter to flicker. Try changing the settings in the Flicker reduction option in the Setup menu if you run into this problem.

7.1 This still photo taken from video shows the effect of skew on an image.

Setting up for video

Using the video feature is quite simple. Simply pull the Live View switch on the back of the camera to activate Live View, and then press the Record button to start recording. However, there are some important things to consider before you start recording:

▶ **Quality.** The Quality setting determines what size your videos are. Sizes and their uses are covered earlier in this chapter. You set the Quality by going to the Shooting menu, selecting the Movie settings option, selecting Quality, and then pressing OK. You have five choices: 1920 × 1080; 24fps (16:9), 1280 × 720; 24fps (16:9), 1280 × 720; 25fps (16:9), 1280 × 720; 30fps (16:9), or 640 × 424 (3:2).

▶ **Sound.** This option is also found under the Movie settings option under Microphone. You can either record sound using the D7000's built-in microphone or an external microphone. You can adjust the microphone sensitivity to suit the environment. You can turn the sound recording off.

▶ **Picture Control.** Just like with your still images, the D7000 applies Picture Control settings to your movie. You can also create and use Custom Picture Controls that fit your specific application. For example, I created a Custom Picture Control called Raging Bull that uses the Monochrome Picture Control with added contrast and the yellow filter option. This gives me a black-and-white scene that's reminiscent of the Martin Scorsese film of the same name. Before you start recording your video, decide which Picture Control you want to use for your movie.

Adding too much sharpening to a Picture Control can cause haloing in your movies.

▶ **Shooting mode.** Selecting a Shooting mode is one of the most important parts of shooting video. This is how you select your lens aperture. The mode you select determines the aperture that you shoot with for the entire clip. This is important for controlling depth of field. The scene modes apply the same settings that they use for still photography, but they can be unpredictable.

If you use Programmed Auto (P), you are taking a major risk with your aperture setting. Shutter Priority (S) is only used for shooting stills so this mode operates in much the same fashion as P when shooting video. That leaves you with the two most useful Shooting modes: Aperture Priority (A) and Manual (M). When shooting A the shutter speed is completely controlled by the camera. The shutter speed that's displayed on the screen is for shooting stills in Live View and has no impact upon the movie. Manual operates in much the same fashion as A unless Manual Movie settings is turned on in the Shooting menu under Movie settings.

Recording

After you figure out all your settings and before you press the Record button, you want to get your shot in focus. You can do this by pressing the Shutter Release button halfway, as you normally would. When the AF point on the LCD is green, you're focused and ready to go. If you're using the AF-F full-time autofocus be sure that the image is in focus before pressing the Record button.

Be aware that video clips are limited to 10 minutes in length to avoid overheating and damaging the sensor. You may notice that your videos may appear noisier near the end of clips due to thermally generated noise.

Manual Movie Settings

One of the biggest improvements that Nikon has made to the video in dSLR cameras other than the upping the resolution to 1080p is the addition of the Manual movie settings (in the Shooting menu under Movie settings). Instead of being completely automatic like the previous cameras (D90, D300s, D5000, D3100) the D7000 allows you to select shutter speed and ISO manually. This allows you greater control over the outcome of your videos.

To start, turn on the Manual movie settings option and set the camera to Manual exposure mode (any other mode reverts the camera back to the fully auto settings).

When selecting the shutter speed for video you can only choose a shutter speed from 1/30 second up to 1/8000 second. The rule for shutter speeds is that you should double the frame rate (this is called the 180-degree shutter rule), so when shooting at 1080p 24fps you should be using a shutter speed of 1/48. Of course this speed isn't an option, so use the closest one, which is 1/50. The speed gives video a cinematic look; the shutter speed blurs moving subjects just enough to look natural. If you use a shutter speed slower than that, your video will look "smeary" due to the extreme motion blur in each still frame (remember that video is just still frames linked together).

Choosing a fast shutter speed is also an option, but faster shutter speeds are generally chosen only for the effect that they create. Fast shutter speeds can cause the video to appear slightly jerky because, just as when shooting a still, the action is frozen and as the subject moves through the frame there is no motion blur to make it look more natural to the eyes. Movies such as *Saving Private Ryan* and *Gladiator* use this effect in the action scenes.

When you shoot in extremely bright light outdoors, it's generally wise to use a Neutral Density (ND) filter. ND filters cut out the amount of light that reaches your camera without adding any colors or effects. This will help you stick to the 180-degree shutter rule and avoid the strange-looking fast shutter speed effect. If you're serious about making great video I highly recommend using the Manual movie settings.

Sound

One thing to be aware of when recording video is that you're not only recording images — you are also recording sound. The microphone is on the camera and noises, including those the camera makes when adjustments are made, will be picked up.

It may not sound loud at the time, but it will be extremely loud in your footage. The best bet is to get your settings right before you begin filming to avoid this, or to turn the sound setting to off.

Although the full-time AF seems like a great feature, there is one huge caveat: Nikon's Silent Wave Motor is not silent. The focusing mechanism of the lens is clearly picked up by the on-camera mic and is very evident during playback. If you plan on using the on-camera mic, I recommend using AF-F sparingly. As I mentioned before, think like a filmmaker. Plan out your shots and know where the focus will be and set it before you start recording.

 Buying an accessory microphone is highly recommended if you plan on getting serious with your videos and recording a lot of sound. The difference between the on-camera mic and a good accessory mic is like night and day.

If you're really computer savvy and you have the proper video editing software, you can record sound using a separate sound recorder and sync the sound and video later using software such as Final Cut Pro or Adobe Premiere.

Playback

Playing back your videos is super easy. Press the Play button on the back of the camera and scroll through the videos and stills as normal. When the video is displayed on the LCD screen, simply press the OK button to start playback. Press the Multi-selector up to stop, down to pause, and left or right to rewind or fast-forward. Use the Zoom-in and Zoom-out buttons to raise or lower the volume.

Connecting your camera to an HD or standard TV displays what is on the LCD on the TV and the options are the same.

Action and Sports Photography

Action photography allows you to freeze a moment in time, which affords the viewer the chance to see the action in a way that's just not possible with the naked eye. This is probably why action and sports photography is so popular.

Generally action photography is associated with some kind of sport, although that doesn't have to always be the case. This type of photography can be done with any type of moving subject, from a pet running up the beach to a child running around at the playground to a professional basketball player slam-dunking the ball.

Catching an athlete at the peak of the trick is the key to a successful action shot.

Preparing Your Shot

Timing is the key to getting a great action shot. You need to capture the peak of the action, and it helps to be familiar with the sport. For example, when photographing a track event such as the 100-yard dash, you know that as the runners come off the starting blocks, there will be strength and energy in their form. Of course, catching the winner crossing the finish line is also a great time for a shot.

The best way to get a feel for the sport you're photographing is quite simply to stand back and watch before you start shooting. Taking a few minutes to be a spectator can allow you to see the rhythm of the action.

Another big part of capturing a great action shot is being in the right place at the right time. While this sounds like luck, it's not. With basketball, for example, you know exactly where the action is going to be 95 percent of the time: right at the basket. With other sports it's not always quite as easy, but as I mentioned previously, watching for a while can give you an idea of where most of the action will be.

Shutter speed is perhaps the most important camera setting for photographing action. The shutter speed determines how the movement is shown in your photograph. For the most part, a fast shutter speed is used when photographing action because it allows you to freeze the motion of the subject. Freezing the motion lets you get a sharp image of an athlete. Take Figure 8.1, for example. I was photographing an extreme cage-fighting event in San Antonio, Texas. The action at this type of event happens very fast. The goal is to freeze the action and to capture the moment of impact, which requires a shutter speed of at least 1/500 second. As you can see from the photo, I was just a tad late in getting the contact, capturing instead the moment just as the fighter pulled his head away, so you can still see the effect of the impact on his face.

The lighting at indoor sports events can be very dim and flash is prohibited, so to get a shutter speed that fast, I had to open up my aperture to f/2.8 and crank my ISO up to 1800. Because this was a cage fight, I also needed to open the aperture wide to provide a shallow depth of field so that the wires from the cage were almost invisible. My other settings were Center-weighted metering, Continuous AF, and a single focus point set to center. The reason I chose Center-weighted metering was that Matrix and Spot metering were giving me unreliable results because the fighters were moving all around the ring and the lighting was constantly changing. Center-weighted metering allowed me to get a good average exposure. I selected a single focus point because there were so many colored elements in the scene; both Dynamic and 3D-tracking were having problems tracking the subject. Of course, because I knew I needed a fast shutter speed, I used Shutter Priority mode.

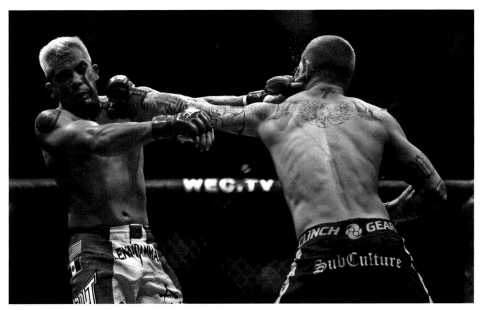

8.1 Using a fast shutter speed of 1/500 second was absolutely necessary to freeze the motion in this shot. Exposure: ISO 1800 (Auto), f/2.8, 1/500 second using a Nikon 80-200mm f/2.8D lens at 86mm.

Using a fast shutter speed isn't the only way to capture great action shots. Using a slow shutter speed can sometimes be exactly what you need to bring out the movement in an action shot. For example, when shooting any type of motorsports, photographers often use a slow shutter speed to introduce some blurring into the image to illustrate movement.

Panning

In Figure 8.2, I was photographing a Formula car race. As you probably know, race cars are pretty fast, and in order to capture the action, I had to employ a couple of different techniques. I used a relatively slow shutter speed (considering the speed of the subject) and *panning*. If you're not familiar with panning, it is a technique in which you follow your subject along the same plane that it is traveling. Typically, you pan horizontally. You can also pan vertically, but this can be more difficult and generally isn't done because most action takes place on a horizontal plane.

Panning reduces the relative speed of the subject in relation to the camera, thereby allowing you to freeze the motion of the subject more easily than if you held the camera still and snapped the shot while the subject moved through the frame.

When you are photographing racing cars that are moving at more than 100 mph, using a fast shutter speed sounds like an obvious choice, right? Wrong. Using a fast shutter speed freezes all the movement of the car, including the tires, which are the fastest-moving part of the car. Freezing the motion of the tires causes the car to look like it's sitting parked on the track.

Panning is most effective when used in conjunction with a relatively slow shutter speed. Because the speed of the subject is effectively reduced by the camera movement, you can use a slower shutter speed to freeze the action. In addition to this, because the background effectively moves faster, the slow shutter speed causes the background to have motion blur. The background blur gives your image the illusion of movement and also helps to isolate the subject from the background. In Figure 8.2, I employed a relatively slow shutter speed of 1/125 second using Shutter Priority mode. I say *relatively* because for most sports, a fast shutter speed is generally 1/250 second or faster. In auto racing, 1/250 second is relatively slow.

Panning can be used with almost any type of moving subjects, from racing horses to runners or even your pet running across the yard.

8.2 I employed a relatively slow shutter speed of 1/125 second using Shutter Priority mode. I panned along with the car to freeze the motion, but the wheels and background are rendered as blurs giving a feeling of motion. Exposure: ISO 200, f/13, 1/125 second using a Nikon 70-200mm f/2.8G VR lens at 185mm.

Using Speedlights

Although in general flash isn't used when shooting sports, sometimes it can add a special effect and help to freeze the action if there isn't a lot of light. In Figure 8.3, I used a completely different technique to freeze action: Speedlights. I used flash to light this skateboarder, but I also kept the background in mind when choosing my settings.

It was late afternoon during the shoot and I was looking to get a very dynamic image; I underexposed the background to make the sky more dramatic and make the image darker for more contrast and saturation.

When I set up for the shot, I knew I wanted an extreme perspective distortion to give the image more impact. I used a Nikon 10.5mm Fisheye lens because its extreme wide angle gives it a really deep depth of field; this makes achieving focus with this lens simple.

8.3 Using uncommon techniques and lenses can give your images more impact. Exposure: ISO 400, f/5.6, 1/60 second using a Nikon 10.5mm f/2.8 fisheye lens.

To get the extreme perspective distortion I was looking for, I had to get pretty close. I got right up to the lip of the ramp and just prayed he wouldn't crash into me! Although he looks like he's a couple of feet away, the skateboard was only about 10 inches from my lens.

 Be careful when using wide-angle lenses when photographing moving subjects. Wide-angle lenses make things look farther away than they really are when looking through the viewfinder. What looks like feet to you may actually be inches.

I first set my camera to Spot metering mode. I then aimed the lens at the brightest spot in the sky, which was just over the horizon. I took the reading, and then I subtracted two stops from it; this was the exposure I was looking for — 1/60 second at f/5.6, which I set in Manual exposure. This is a relatively slow shutter speed for action shots, but I wasn't worried because I was using a Speedlight. The short duration of the flash is often enough to freeze your subject in motion.

I used an SU-800 Speedlight as a commander and an SB-800 Speedlight as a remote to achieve this shot. I set the SB-800 to function as a remote on Group A and used the AS-19 Speedlight stand to attach it to a light stand. I positioned the SB-800 and stand to the right of the camera, just out of sight. I used the built-in wide-angle diffuser to soften the light just a bit and to give the flash a little more coverage.

 Before using flash on action shots, be sure to get permission from the athlete. Using a flash may blind him, which can lead to disastrous results.

The first couple of shots I took with straight Through-the-Lens (TTL) weren't quite bright enough to make the rider really stand out, so I adjusted the Flash Exposure Compensation (FEC) on the SU-800 to +2 exposure value (EV). This gave me the amount of light that I was looking for, exposing my subject perfectly while the background was underexposed, which made for a dramatic effect.

Event Photography

E vent photography has become a popular way for some advanced amateur photographers to make a little extra cash. There are many different types of events, and photographers must handle each type in a specific way. For example, photographing a wedding involves much more than just showing up and snapping some photos of the ceremony, whereas photographing a concert doesn't involve much preparation at all.

The one caveat about taking on an event gig for pay is that it comes with serious responsibility to get all the coverage that's needed in a timely manner. Be sure that if you take on this sort of job, you're completely comfortable doing it. The best way to get the hang of any type of photography is to practice. Assisting an event photographer is a great way to get familiar with the process.

Concert lighting can be the most difficult lighting to deal with, but it also can give you some very cool effects.

Wedding

Many photographers assume wedding photography is the key to making a living as a working photographer. While this may be the case in many instances, jumping into the wedding photography business should not be taken lightly. Photographing a wedding is a very serious responsibility and should be treated as such. I recommend spending some time assisting a wedding photographer for a few weddings to get the hang of it before actually diving in and attempting to cover a wedding all on your own.

Wedding photography is one of the most challenging and nerve-racking types of photography. There are a lot of things going on and you only get one chance to get it right. Wedding photography can be very complicated, and while there isn't enough room in this book to cover all the facets, I will touch on some of the most basic ones to get you started. Many great books are dedicated solely to wedding pho-

9.1 Capturing spontaneous moments is very important in wedding photography. Exposure: ISO 320, f/5.6, 1/30 second using a Nikon 16-35mm f/4 VR lens at 18mm.

tography, and if you plan on doing much of this type of photography I suggest you read some.

Despite all the caveats, wedding photography can be a really fun and rewarding endeavor. Using your creative eye and your skill at composition to give the couple images they will cherish for many years is a great honor and is very rewarding. After the event is done, the food is gone, and the wedding dress has been put into storage, what remains are the memories and photographs. The memories will likely fade, but the photographs will be there for generations to come.

Getting started

Wedding photography isn't just all about showing up on the wedding day and taking pictures. As with any major event, there's a lot of planning involved and that includes some preplanning on the photographer's part. The first thing you want to do is sit down with the bride and groom (at the very least the bride) and talk about their expectations. Make sure that they know your style and are happy with that. Find out what kind of shots they are expecting. Establish a time frame for delivery of the images, and last but not least, discuss the payment (if any).

Shot list

One of the most important things to discuss with the couple is creating a must-have shot list. This might sound silly, but during all the hectic action going on during a wedding it's very easy to forget some key shots. Here's a short list of some of the most common shots.

▶ **Bride getting ready.** This can include shots such as the bride applying makeup, the bridesmaids helping her into the dress, and her mom adjusting the veil, among other things.

▶ **Groom getting ready.** Some shots include the groom putting on the tie and boutonniére, groomsmen hanging around, and so on.

 Don't forget to get these portraits of the bride: headshots of her, and ¾- and full-length pictures.

▶ **Leaving for the venue.** These are optional, but it's nice to get some candid photojournalistic-type shots of the bride and groom getting into the limo or whatever transportation.

▶ **The ceremony.** This is where it starts getting hectic, but you should get pictures of the mothers of the bride and groom being escorted down the aisle as well as each bridesmaid and the maid of honor, and, of course, the bride being led down the aisle and given away. Of course, the exchange of the rings and the kiss should be photographed as well. Also, don't forget to photograph the recessional or the bride and groom leaving.

▶ **Formal portraits.** This can be one of the most frustrating aspects of the whole wedding. Everyone will be running around trying to get ready for the reception and congratulating the bride and groom. You will need to be assertive to get everyone together who you need for the shots. Here's a short list of some of the shots you might need:

- Entire bridal party

- Bride alone

- Bride and bridesmaids

- Bride and maid of honor

- Bride and groom

- Groom and groomsmen

- Groom and best man

- Groom alone

- Groom with parents

- Bride and groom with groom's parents

- Bride and groom with bride's parents

▶ **The reception.** The reception is where you can relax and start having a little more fun, loosening up and being a little more

9.2 When shooting a group shot, try to vary head placement to avoid making the shot appear static. Exposure: ISO 900, f/5, 1/60 second using a Nikon 16-35mm f/4 VR lens at 16mm.

creative. Some of the shots should include the first dance, the toasts, the cake-cutting, the bouquet and garter toss, and, of course, candid shots of the guests dancing and having fun.

Even with a shot list, don't overlook small details. You should photograph such things as the rings, the bride's shoes, minute details of the dress, the table settings, the bouquet, and the cake (before it's cut).

Other preparations

Here are some other very important things to think about:

▶ **Scout the location.** Going to check out the location ahead of time can help you figure out what equipment you may need or what settings you might have to use. If you know that the ceremony is going to be in a dark church, you may want to bring a faster lens such as a 50mm f/1.4. If you can, attend the rehearsal to get an idea of some of the angles you may want to shoot from. This can also help as a dry run to get an idea of the lighting and some of the settings you may want to use or some pitfalls to avoid.

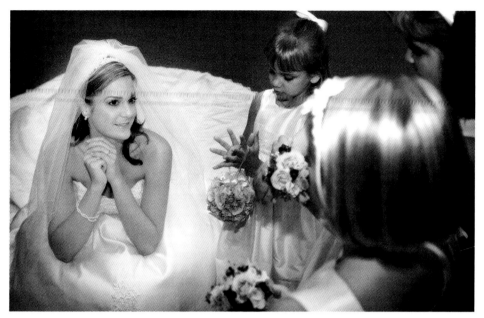

9.3 Don't forget to capture intimate details. These are the types of shots that make your wedding photos special. Exposure: ISO 200, f/2.8, 1/60 +0.7EV using a Nikon 17-55mm f/2.8G lens at 22mm.

▶ **Be prepared.** Just like the Boy Scout motto. Although this may seem like a no-brainer, you need to be sure that you have spare formatted memory cards, extra batteries, and a lens cloth.

▶ **Have a backup.** One of the most important things to have is a backup camera. Whether you buy, borrow, or rent one, you should have one. Cameras, as with any electronic equipment, can fail at any time. You could drop it, the shutter could fail, or any number of things could happen. You only get one try at a wedding and if your camera is inoperable, you're sunk.

> **TIP** Turn off the sound on your camera. You don't want your camera beeping during the ceremony. You're there to record the event as unobtrusively as possible. The sound can be turned off using CSM d1.

Using flash

During the ceremony, it's important not to interrupt the bride and groom's biggest moment, so most often you are not allowed to shoot flash. Before and after the ceremony, you can usually use your Speedlight as much as you like. Generally when

photographing weddings, I like to shoot both with and without flash so that my images don't all look the same. I actually have the Function button on my cameras programmed to be a flash cancel button so I can cancel the flash in a split second if I see a shot that would look best in natural light. One of the tricks of being a good wedding photographer is knowing when and when not to use your Speedlight. You can program the Function button on the D7000 using CSM f3 and set the function to Flash off.

First and foremost — and I cannot stress this point enough — *use a diffuser*. The SB-800 and SB-900 come with a diffusion dome, so use it. I can honestly say that I almost never shoot without the diffusion dome on my Speedlight. If you're using the Speedlight mounted to the hot shoe of your camera, put on the diffusion

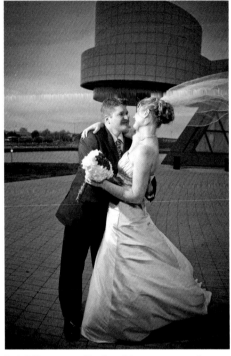

9.4 Off-camera flash adds some creative spark to wedding photography. Exposure: ISO 200, f/8, 1/250 second using a Nikon 17-55mm f/2.8G lens at 17mm.

dome and aim the flash head up to the 60° position for the best results. This softens the light and allows some of it to bounce from a ceiling when you're shooting indoors. When you're shooting outdoors, it's okay to point the flash head straight ahead as long as there is nothing close to the subject in the background, such as a wall. If there is something directly behind your subject, you will get the nasty black shadow that I'm sure you've seen in many shots.

There are many types of diffusers on the market today, from simple ones like the Sto-Fen Omni-Bounce to miniature softboxes made by LumiQuest. One of the most popular ones is the Gary Fong Lightsphere. I admit that I was taken in by the great marketing technique and I bought one, but I can honestly say that I didn't find it to work any better than the diffuser that came with the Speedlights (I use a Sto-Fen Omni-Bounce for my SB-600). As a matter of fact, the Lightsphere is so big and bulky that it causes the flash head to drop down all the time. Save your money and pass on this product.

Suggested Settings and Lenses for Weddings

Given weddings are generally pretty fast paced, I try to automate my camera as much as possible while still maintaining a good degree of control over the settings. My general settings include

▶ **Auto ISO.** This is a great mode that I think is underutilized. The current crop of Nikon cameras works so well at high ISO settings that I don't need to worry too much about it. I set the Max ISO to 1600 and let the camera do the rest of the work.

▶ **Programmed Auto.** This mode allows me to concentrate more on composition and worry less about the settings. The camera generally tries to keep the aperture at f/5.6–f/8 to get a depth of field that isn't too deep or too shallow. If I need to open the aperture for a shallow depth of field shot, I simply rotate the Main Command dial and use the flexible program feature.

▶ **Matrix metering.** This metering system is pretty accurate for the most part; a quick review of the histogram will tell you if you need to add some exposure compensation.

A good range of lenses is a necessity when shooting weddings. I find that fast zooms are the best option. A zoom lens allows you to quickly compose so that you can grab the shot. I prefer high-quality, pro-level lenses to ensure sharp images with a good degree of contrast.

▶ **Nikkor 17-55mm f/2.8G.** This is my go-to lens and it's the one that spends the most time on my main camera. It's a great standard focal length lens.

▶ **Nikkor 70-200mm f/2.8G VR.** This lens is great for getting close-ups without intruding on the action. Remember you want to record the wedding, not be a part of it.

▶ **Nikkor 50mm f/1.4G.** I use this lens mostly for the bridal portraits. It's a great portrait lens and gives a nice, smooth background.

▶ **Sigma 10-20 f/3.5 EX HSM.** This ultrawide lens gets only occasional use for special effect shots. I prefer this lens over the Nikon 10-24mm f/3.5-4.5 for its faster constant aperture.

A couple of other flash tips:

▶ **Use FEC.** Don't be afraid to dial in some Flash Exposure Compensation (FEC). When photographing the bride, it is usually necessary to up the FEC by +1 to +2 EV (exposure value) to ensure that her dress looks white. The camera meter is thrown off by all the white and tends to underexpose. The opposite is true of the groom, the black tends to cause overexposures, so dialing the FEC down to −1 to −1.7 EV is usually advisable. When photographing them both together, be sure to check your histogram and adjust it appropriately.

▶ **Bounce your flash.** This is probably the easiest and one of the most important flash techniques you can use. Bounce off of ceilings, bounce off of walls, bounce off of whatever you can. Bouncing softens the light and makes the images appear more natural.

▶ **Use Slow Sync.** One great technique is dragging the shutter by using Slow Sync. As discussed previously, Slow Sync allows more ambient light in the exposure. As with other types of photography, you can use this technique to show motion and to keep the ambience of the scene. Shooting straight flash often gives you the black hole effect, where the background is completely dark and the subject is too bright. This technique works best when shooting candid shots, and I don't recommend using Slow Sync for the more important shots because you can sometimes have ghosting and blurring.

▶ **Use off-camera flash.** Utilizing the Creative Lighting System (CLS) and using the built-in flash to trigger off-camera Speedlights gives your images a more interesting and professional look.

After the wedding

After the wedding comes the real work: post-processing. You'll probably have at least a thousand images to sort through and this can be a very time-consuming process. As a matter of fact, I would venture to say that most of the cost of shooting a wedding is tied up in post-processing.

Establishing a good workflow is the first step to quickly sorting images. This also applies to other types of photography as well. The first step should be to import your images to some sort of software that allows you to organize and sort your images. Quite a few programs work great for this, including Adobe Lightroom and Apple Aperture. Both programs also allow you to do your most basic post-processing, including color management and tonal corrections. The latest versions of Adobe Photoshop are packaged with Adobe Bridge, which is a great browser and allows you to sort images. However, you must open Photoshop to do any corrections.

Concert

Concert photography is quickly becoming one of the most popular types of photography. Almost everyone loves music and capturing an iconic image of your favorite performer is an exciting prospect. Of course, don't expect that you're going to be able to head right out and shoot photos of the Rolling Stones or Aerosmith. One of the most frustrating aspects about concert photography is how hard it can be to obtain permission to photograph your favorite band. This leads me to the first part of concert photography: gaining access.

Gaining access

As I just mentioned, major performers are off limits for the most part. In the past, almost anyone with a camera could take it to a concert and snap off as many rolls of film as desired. These days, with dSLRs offering superb image quality and public relations firms and record labels concerned about image — not to mention the monetary aspect involved — access is severely limited. Therefore, to photograph a top musician, you need to be affiliated with some sort of publication or agency. In order to get this press affiliation, you need to start at the bottom and work your way up until you have built a good-enough portfolio to shop around.

The best way to start out is to get involved in your local music scene and scope out smaller venues and clubs. More often than not these small venues have no restrictions on shooting and the bands are generally happy to get the exposure. Just make sure you offer them some copies of your images. These will likely be posted to the band's Web site, which gives both of you exposure. It's a win/win situation. And you never know; if the band or performer likes your images, it could mean paid gigs later on.

Although most major venues and national bands don't allow you to use flash, local bands and small clubs typically have no restrictions. I only use flash as a last resort, such as in Figure 9.5. I was photographing local Austin, Texas, punk rockers the Lower Class Brats and there wasn't a single light in the venue. I used the pop-up flash to add some light to the scene and a dragged the shutter to capture whatever ambient light I could while letting the flash freeze the action.

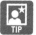 It's often a good idea to call the venue in advance to check on the camera policy just to be sure.

9.5 Photographing smaller venues can give you greater access to the performers, but you may have to jump into the fray to get a shot, as I did here with local Austin, Texas, punk rockers the Lower Class Brats. Exposure: ISO 200, f/5.6, 1/4 second using a Nikon 10.5mm f/2.8 fisheye lens.

Once you gain access to the local music scene, making friends with the staff can be of great benefit to you. The one thing that you want to remember is that being a pest could get you banned from taking photos at the venue. Try not to disrupt the band members or performers and give the crowd some deference as well. Most major artists limit photography to the first three songs, and following this rule when you're starting out is a good idea. Trust me; you can get plenty of images during only three songs. Of course, if there are no actual restrictions, you can always get some grab shots if anything exciting is going on; but the point is to act professionally — the band is playing first and foremost for the fans.

When building your portfolio, try for variety. There are many types of music and a diverse portfolio is more interesting and broadens your marketability. I'm lucky enough to live in the "Live Music Capital of the World." This allows me to shoot almost any type of music seven days a week, from country and blues to rock and beyond. My diverse portfolio has led to jobs shooting all types of gigs.

After you pay your dues in the clubs and build a portfolio, you can start to shop it around. Start out with your local papers. The local alternative paper is usually a better candidate than the daily paper, which usually has a staff photographer on hand. Another option is to work for an online publication or blog (if you're really ambitious, you can start one of your own). Another even more ambitious option is to try to sign a contract with an agency. An agency provides photos for all types of publications, from print to online, including advertising. An agency provides a greater market with more high-profile clients than you will likely be able to get for yourself, but keep in mind it takes a substantial cut of the profit and sets the prices. You need a top-notch portfolio to get agency representation. I shot small events for many years before I signed with the Corbis agency, which grants me access to the top performers and events.

Techniques and settings

In this section, I show a few photographs of typical event situations and explain which settings I used as well as any special techniques I used to work around potential problems.

One of my favorite camera settings to use when shooting concerts is Auto ISO. This feature is perfect for concert photography where the lighting changes constantly from second to second and the performers move in and out of shadows. The easiest way to shoot a concert is to set the ISO and leave it. This can result in all your images having quite a bit of noise. I like to get at least a few shots at lower ISO settings, but I don't like to waste a lot of time constantly changing ISO settings. For this reason, I set the ISO sensitivity auto control to On, the maximum sensitivity to 1600, and the minimum shutter speed to 1/250 second. You can set the Auto ISO in the Shooting menu under the ISO sensitivity settings option.

9.6 Spot metering allows you to expose for the performers and ignore the flashing lights of the background. Exposure: ISO 360, f/2.8, 1/200 using a Nikon 17-55mm f/2.8G lens at 17mm.

Suggested Settings and Lenses for Concerts

When shooting concerts, I have typical settings that I generally stick with and modify if need be. Here's a list of the general settings that I start out with:

▶ **Auto ISO.** This is described in the preceding section. It's a great setting for making sure your images have as little noise as possible.

▶ **Continuous AF (AF-C).** I almost always set my AF to continuous because the performers are generally moving quite a bit. In rare circumstances, such as when I shot Bo Diddley and Etta James who were sitting in a chair, I switch focus to Single-servo.

▶ **Single-point AF.** Using the Multi-selector, I place the focus point exactly where I want the focus to be. In the past, I tried to use 3D-tracking but found that the flashing lights and colors confused the AF system, causing it to focus at the wrong spot. For the most part, I focus on the performer's face.

▶ **Spot meter.** As discussed later, spot metering ensures your subject is exposed properly.

There are many opinions on which lenses to use, but one thing is sure — you need a fast lens. Some people prefer to use very fast prime lenses. I prefer to use zooms mostly because you're generally in a small space where you won't be able to move much. The zoom lens is invaluable for helping with composition. Here's a list of the lenses I prefer for shooting concerts with a DX camera such as the D7000.

▶ **Nikkor 17-55mm f/2.8G.** This is the lens I get most of my shots with. It's a good wide to short telephoto, which works for most stages and venues.

▶ **Sigma 10-20mm f/3.5.** This is an ultrawide lens and it allows me to get some cool effects using perspective distortion. I use ultrawide lenses sparingly at concerts.

▶ **Micro-Nikkor 105mm f/2.8 VR.** This is the only prime I carry to concerts. I use the lens for close-ups and to get the drummer. I find that this focal length is perfect for these types of shots and this lens is much smaller than my alternative lens, the 80-200mm f/2.8.

▶ **Nikkor 80-200mm f/2.8.** I usually only bring this lens to exceptionally large concerts with very high stages. Sometimes I use it to shoot from outside of the photo pit to get a different perspective.

With most concert photography, the lighting comes from the stage lights. If you're shooting at a larger venue or concert, typically the stage lighting is all you need, and you can get amazing images using relatively low ISO settings. The stage lighting engineers are paid to make the performers look good; you essentially piggyback off their expertise and focus on the composition and settings.

In Figure 9.6, rockabilly guitar hero Reverend Horton Heat was performing at a local amphitheater and most of the lighting was coming from behind. One of the main problems with this shot as well as with most concert photography is *backlighting*, which is, of course, light coming from behind your subject.

Because stage lights are often flashing on and off in front of and behind the

9.7 Backlighting adds some cool effects. Exposure: ISO 220, f/2.8, 1/100 using a Nikon 17-55mm f/2.8G lens at 70mm.

performers, the best thing you can do is spot meter. Because the spot meter is tied to the focus point (providing you're using a CPU lens), you meter on the most important aspect of the shot: the subject. This can cause the bright areas of light to blow out and dark shadow areas to be blocked up, but this isn't generally a problem in this type of photography as it can add to the atmosphere of the shot.

Although backlighting can be troublesome, it also provides cool effects, such as lens flare and rim lighting. The shot of John Mayer in Figure 9.7 has dramatic rim light highlighting his profile while still retaining detail in the facial area; some lens flare adds interest to the shot.

At all-day concerts, you often find that you can shoot performers in the daylight. Although this isn't the most dramatic type of lighting it's very simple. Even though it's light out, lighting techs usually add light that fills in some shadow and adds some splashes of colors. Figure 9.8 is a perfect example of this situation. I was shooting

psychedelic rockers the Flaming Lips at an outdoor venue. Because it was daylight, I switched to Matrix metering. The only time I shoot Matrix is for concerts during mid-day. The stage was exceptionally tall, so I used my long 80-200mm telephoto lens zoomed out to about 155mm. Even though it was early evening and there was plenty of light, I opened up my aperture to get a shallow depth of field to try to isolate singer Wayne Coyne from the busy background.

9.8 Daylight concerts afford you the best opportunity to get great exposures. Exposure: ISO100, f/2.8, 1/1000 second, −0.3EV using a Nikon 80-200mm f/2.8D AF-S lens at 155m

Landscape and Nature Photography

Landscape and nature photography is done outdoors and is simple and accessible. Any local park or nature preserve is filled with birds, plants, flowers, rock formations — almost any type of flora and fauna you can imagine. To take landscape and nature shots, you don't necessarily need a lot of specialized lenses or lighting equipment; almost any lens will do and the sun provides the light.

You can use photography to capture images of places you've visited. Exposure: ISO 200, f/5.6, 1/125 second using a Nikon 10.5mm f/2.8 fisheye lens.

Landscape

Landscape photography simply shows a specific scene as it exists within nature. Generally people and animals are excluded from the pictures so the emphasis is on the properties of the land.

You can take a landscape photograph in any type of environment — deserts, mountains, lakes, forests, skylines, or just about any terrain. One very interesting aspect of landscapes is that if you return to the same spot even as soon as a couple of hours after the first time, the scene will look different according to the position of the sun and the quality of the light. You can also return to the same scene months later and find it completely different due to the change in seasons.

There are three distinct styles of landscape photography:

▶ **Representational.** This is a straight approach — "what you see is what you get." This is not to say that a representational landscape photo is a simple snapshot; it requires great attention to details such as composition, lighting, and weather.

▶ **Impressionistic.** With this type of landscape photo, the image is not realistic due to filters or special photographic techniques such as long exposures. These techniques can give the image a mysterious or otherworldly quality.

▶ **Abstract.** With this type of landscape photo, the image may or may not resemble the actual subject. The compositional elements of shape and form are more important than an actual representation of the scene.

One of the most important parts of capturing a good landscape image is *quality of light.* Quality of light is the way the light interacts with the subject. Many different terms are used to define the various qualities of light, such as soft light, diffused light, or hard light, but for the purposes of landscape photography, the most important part is knowing how the light interacts with the landscape at certain times of day.

Most photographers agree that the best times to photograph a landscape are just after the sun rises and right before the sun sets. The sunlight at those times of day is refracted by the atmosphere and bounces off low-lying clouds, resulting in a sunlight color that is warmer, which is more pleasing to the eye than it is at high noon. Photographers often refer to both times of day as the *golden hour,* given the color and quality of the light that appears.

Wildlife

One type of nature photography is wild-life photography. You will find wildlife in many different places — zoos, wildlife preserves, and animal sanctuaries as well as out in the wild. One of the easiest ways to capture wildlife photos is to be where you know the animals are.

Opportunities to take wildlife pictures can occur when you're hiking in the wilderness, or even when you're sitting out on your back porch enjoying the sunset. With a little perseverance and luck, you can get great wildlife images that rival the ones you see in *National Geographic.*

Using a telephoto lens is essential; for the most part the animals will be some distance away and a long lens enables

you to get up close and personal. The most important thing to remember about wildlife photography is to be careful. Wild animals can be unpredictable, and even aggressive, when confronted by humans.

Although sunrise and sunset are usually considered the best times to shoot, you often will be constrained by time, especially if you're on vacation and running on a tight schedule. It is possible to shoot a great landscape image at high noon on a bright, sunny day. The bottom line is that it's best to grab your shot when you can rather than not taking the shot altogether.

Figure 10.1 is a representational landscape image that I shot at twilight. I used spot metering and metered the brightest part of the scene to underexpose the shot to give the sky a rich, deep color and to allow the palm trees and buildings to silhouette. Traditionally landscape images are framed horizontally, hence the term *landscape orientation,* but I composed this image vertically (portrait orientation) to play up the striking tallness of the central palm tree. Bending the rules sometimes adds interest to your composition.

In Figure 10.2, I used an ultrawide fisheye lens to add impact to the image. When you use a wide-angle lens, take great care when considering composition. You need to pay

close attention to your foreground. Using a wide-angle lens enables you to fit a lot of the scene into the frame; this can often lead to having copious amounts of blank space, which doesn't make for a particularly compelling photo. Make sure your foreground is interesting; look for patterns, leading lines, or bold colors. In Figure 10.2 the leading lines of the trees add a dynamic tension to the image. Using the reflection allowed me to make a very surreal image. I actually flipped the image upside down to further the effect

Experiment with your image orientation; try shooting in portrait orientation to make a landscape more interesting.

While wide-angle lenses are generally your best bet for landscapes, you can use telo photos with great success as well. In the abstract landscape image in Figure 10.3, I used a 50-500mm telephoto lens zoomed to 500mm to get close up on the setting sun. Using the telephoto to achieve compression perspective distortion flattens the image, giving it a subtle abstract effect.

10.1 I shot this landscape just at twilight at a park in Encinitas, California. You don't necessarily need to leave the city to get a good landscape shot. Exposure: ISO 640 (Auto ISO), f/2.8, 1/250 second using a Tamron 17-50mm f/2.8 lens at 50mm.

10.2 This landscape shot is more of an impressionistic shot due to the wide-angle lens distortion. Exposure: ISO 400, f/5.6, 1/125 second using a Nikon 10.5mm f/2.8 fisheye lens.

10.3 I shot this landscape with a telephoto lens. Exposure: ISO 200, f/11, 1/500 second using a Sigma 50-500mm f/4-6.3 lens at 500mm.

A few other landscape tips:

▶ **Maximize your depth of field.** Using a small aperture enables you to get everything in focus, which is generally the goal in landscape photography.

▶ **Use a tripod.** When using smaller apertures, your shutter speed will be slower by necessity. Using a tripod helps ensure that your images are sharp.

▶ **Keep an eye on the horizon.** Be sure your horizons are straight. There's nothing that screams out "snapshot" more than a crooked horizon.

Nature

There are many interpretations of nature photography but generally, it's agreed that nature photography is done outdoors. You will want to look carefully for plants, animals, and insects.

The techniques of nature photography are as varied as the subjects. You can use almost any type of lens to get different effects; the options are unlimited.

When going out to take general nature shots, I usually like to bring two lenses: a wide to normal zoom, such as a 17-55mm, and a longer lens, which is invariably the 105mm macro lens. If I know there is a chance that I will run into some wildlife, I bring a long telephoto zoom lens.

Flowers and plants are probably the easiest subjects for nature shots. They have inspired artists throughout the centuries. Many artists choose flowers and plants not only for their beauty but also because they don't have to pay them to model! Plants and flowers also offer an almost unlimited variety of colors and textures. From reds and blues to purples and yellows, the color combinations are practically limitless.

I was taking a walk through Austin's Zilker Park when I saw the flower in Figure 10.4. Because it was nearing twilight, the background was a distinct blue and the yellow/orange of the flower allows it to pop right out of the image. If you walk around and look at the interesting colors of the local flora, you may notice interesting features. Pay close attention to the way the light interacts with different plants. Though many times it is undesirable to have a backlit subject, sometimes the light coming through a transparent flower petal can add a different quality of beauty to an already beautiful flower.

Using complementary colors can also give your images an added boost. Pay attention to the color scheme of the background and subject. Try to avoid having a subject and a background that are similar colors.

10.4 Flowers are easy subjects for nature shots. Exposure: ISO 800, f/1.8, 1/125 second using a 35mm f/1.8G lens.

Macro Photography

M acro photography, also referred to as *close-up photography* (although technically speaking, you don't necessarily need to be close up to get a macro shot) is one of the most popular types of photography.

Macro photography can encompass many different types of subjects, from small products and plants to insects and beyond. I think the reason why macro photography is so interesting is that it allows you to see the small details of things that you overlook at first glance. Getting closer to the subject makes these details stand out.

Insects such as this caterpillar make very interesting macro subjects. Exposure: ISO 800, f/45, 1/250 second using a Nikon 105mm f/2.8G VR macro lens.

Preparing Your Shot

To do macro photography, you need to be able to focus close enough to your subject that the image your lens projects on the sensor of your camera is the exact same size as the subject. The relative size of the actual subject to the projected image is defined in terms of a *reproduction ratio*. So if your image size is the same as the subject size, you have a ratio of 1:1.

Strictly speaking, the true definition of a macro image is one that has a ratio of 1:1 or better. These days, however, the marketing gurus at the camera and lens manufacturing companies have broadened the definition of macro lens to encompass any lens that allows you get a ratio of 1:2, or half the size of your subject.

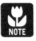 Nikon's macro lenses are termed *Micro-Nikkor.*

Generally speaking, the most difficult aspect of macro photography is getting your entire subject in focus. The depth of field is reduced the closer you focus on the subject and it can be difficult to maintain focus. When you're handholding your lens an inch or so from the subject, breathing in and out is sometimes enough to lose focus on the area that you want to capture. For this reason, you usually want to use the smallest aperture you can to increase the depth of field. Of course, you may not always want to have the entire subject in focus, so using a shallow depth of field and selective focus is a great way to draw attention to a specific aspect or feature of the subject.

Tools of the Trade

As you've probably already figured out, each discipline of photography, from landscape to portraiture, has many different tools to get the job done. Macro photography is no different. There are lenses and accessories that you can use to get close up or to magnify the subject, ranging from expensive lenses to relatively inexpensive reversing rings.

Lenses

The preferred and probably easiest method of taking macro shots is to purchase a lens specifically designed for this purpose. Macro lenses allow you to focus very close to the subject, which is how you get a reproduction ratio of 1:1 or better.

Using a good, dedicated macro lens is going to get you the best results by far, although it can be a bit expensive.

For more detailed information on macro lenses, see Chapter 4.

Close-up filters

An inexpensive alternative to a macro lens is a close-up filter. A close-up filter is like a magnifying glass for your lens. It screws onto the end of your lens and allows you to get closer to your subject. It has a variety of different magnifications, and they can be *stacked*, or screwed together, to increase the magnification even more.

As with any filter, there are cheap ones and more expensive ones. Using cheap close-up filters can reduce the sharpness of your images because the quality of the glass of the filter isn't quite as good as the glass of the lens elements. This reduction in sharpness becomes most obvious when you stack filters. Buying the more expensive filters is still cheaper than buying a macro lens, and the quality of your images will definitely be better.

Extension tubes

An extension tube is exactly what it sounds like: It's a tube that extends your lens. An extension tube attaches between the lens and the camera body and gives your lens a closer focusing distance, allowing you to reduce the distance between the lens and your subject. Extension tubes are widely available and easy to use. Manufacturers make both autofocus tubes and those that require you to focus manually.

A drawback to using extension tubes is that they reduce the aperture of the lens they're attached to, causing you to lose a bit of light. Extension tubes come in various lengths, and some of them can be stacked or used in conjunction with each other.

Reversing rings

Reversing rings are adapters that have a lens mount on one side and filter threads on the other. The filter threads are screwed into the front of a normal lens like a filter, and you attach the lens mount to the camera body. The lens is then mounted to the camera backward. This allows you to closely focus on your subject. One thing to be careful of when using reversing rings is damaging the rear element of your lens; special care should be taken when using one of these.

Not all lenses work well with reversing rings. The best lenses to use are fixed focal-length lenses that have aperture rings for adjusting the f-stop. Zoom lenses simply don't work well, nor do lenses that don't have aperture control (such as the kit lens). If you're thinking about going this route, the best option for a lens is an inexpensive MF (manual focus) lens like a 50mm f/1.8. Another thing to remember is that when you are using a reversing ring, your camera will have no CPU contact with the lens; therefore, you will have to shoot in Manual exposure.

Manual Focus with Macro

Although autofocus (AF) is a great help in most photography, there are times when it's beneficial to focus manually. Quite a few photographers swear that manual focus is the only way to do macro photography. Personally, I find that AF is a great benefit with macro photography, especially when you are trying to catch small, fleeting critters, though there are many instances where only manual focus will do.

As I discussed previously, the closer you focus on a subject, the less depth of field you have at any aperture. For this reason, the point of focus is extremely important. For example, when you're photographing an insect's face, if the point of focus is just a little bit off, the eyes of the insect will be out of focus, while just behind the insect, it will be sharp. As with any portrait, even those of nonhumans, the eyes should be sharp.

When you're photographing up close, it's best to pick the spot that you feel is most important to the image and focus on that (eyes, for example). When using AF, the best way to do this is to use a single point, but even then, you are relying on the AF module, which may not always be exact. Simply switching to Manual and using your own eyes to determine that your point of focus is exact can be the best method to ensure that your image comes out exactly as you want it.

That being said, another option for inexpensive macro photography is a manual focus lens. Nikon has a few older MF macro lenses that are very sharp and much less expensive than the newer AF-S versions. You can also look into other options. I have an excellent Pentax M-42 screw-mount macro lens (Macro-Takumar 50mm f/4) that I found for next to nothing. With an inexpensive M-42 to Nikon F-mount adapter that I got on eBay, I have a great macro setup that gives me a 4:1 ratio. So don't overlook the benefits of taking control and focusing manually. After all, the camera is your tool; make it work for you, not against you.

Tripod

Arguably one of the most important tools in the macro photographer's toolkit is the tripod. As I mentioned before, sometimes even the small motion of breathing in and out is enough to shift focus away from your subject when the lens is very close. To remedy this, simply stick your camera on a tripod. This ensures that the focus is maintained exactly where you want it. Of course, a tripod only works if the subject is stationary; it can be quite difficult to chase down small insects and try to get them to stand still in front of your tripod-mounted camera.

A tripod is also great to counteract camera shake. As you magnify the subject, any camera movement is also magnified. Even the smallest amount of shaking from your hands or any vibration is enough to cause blur in your images. VR lenses can also help with this, but as you get closer to your subject, the VR function has less of an effect.

Flash

To get enough depth of field, you often need to stop down the aperture to the point that you don't have enough light to make the shot without having a very long exposure, high ISO settings, or in the worst case, both. If you have a moving subject or are handholding your camera, using a slow shutter speed isn't an option. The only other option is to add some light.

Nikon and a few other manufacturers make macro flash kits that attach to the end of your lens to evenly illuminate your subject; this allows you to get maximum depth of field by providing enough light so that you can use a small aperture. Nikon's R1-C1 kit is expensive, costing almost half as much as the D7000 camera body itself, but it is an excellent kit. I have also found a very inexpensive unit, the Phoenix Smart Flash RF46N ring flash. It costs about $100 and functions with i-TTL, albeit with pretty limited features. For the price, the Phoenix works exceptionally well, and I don't have any problems recommending this simple macro flash unit.

Indoor Macro

One of the cool things about macro photography is that it can basically be done anywhere with almost any subject. For the simple shot in Figure 11.1, I used the Phoenix ring flash I mentioned previously. Ring flashes are circular and are attached to the end of the lens with an adapter. Putting the flash around the lens allows the light to surround the optical axis of the lens. This type of light enables you to see the fine detail in a macro shot.

While this can be great for technical photography (think circuit boards) and simple product photography (think eBay), for artistic purposes, this type of lighting can lack depth and drama. One way you can add interest and depth to an image when using a ring flash is to use a contrasting background or one with complementary colors.

The settings I used for the flash were very simple. I used Matrix metering and set the flash to TTL. After a couple of test shots, I decided to dial down the flash exposure –1EV. You will often find that when photographing up close with a ring flash, you will need to reduce the output a bit to avoid overexposure.

11.1 The on-axis lighting really highlights the fine details of the twenty pence coin. Exposure: ISO 3200, f/5.6, 1/30 second using a Nikon 105mm f/2.8G VR lens.

For Figure 11.1, I set the exposure manually (as I often do when using flash), and set the aperture to f/5.6. For a shot like this one, using a small aperture isn't absolutely necessary. The camera was on a tripod pointed at a 90° angle to the coin. Because coins are thin, a deep depth of field isn't required. When shooting something with a lot of depth at an angle, you want to maximize your depth of field.

If you don't have (or don't want to buy) a ring flash and you have an additional Speedlight such as the SB-400, SB-600, SB-700, SB-800, or SB-900, you can get your light on axis with the lens by using an inexpensive, off-camera TTL flash cord such as the Nikon SC-28 or 29 (the SC-29 adds an AF-assist feature). This cord allows you to hold the Speedlight next to the lens for softer lighting (remember, the closer the light source is to the subject, the softer the light). I often use this technique because the one-sided light adds a nice depth to some images, allowing textures to be highlighted.

For Figure 11.2, I simply used the available light in my living room, which came from a standard, old end-table lamp, to photograph this small box of kitchen matches. This shot wasn't planned, but rather I just noticed it out of the corner of my eye. I really liked how the warm yellow light of the tungsten lamp offset the brown of the box and table. For this shot I wanted an extremely shallow depth of field to limit the sharp focus to the match heads only, so I chose a wide aperture of f/2.8. The light was rather low and adding any type of flash would have completely ruined the effect I was

after with the tungsten lighting, so I pulled out the tripod to be sure that the shot was nice and sharp. Because the D7000 is so great in low light, I didn't mind cranking up the ISO to 1600 to keep the shutter speed faster than the 1-second mark.

Figure 11.2 shows that you don't really need elaborate setups to get really cool indoor macro shots. A simple lamp and an everyday object such as a box of matches can make a great shot with just a small amount of effort.

11.2 An indoor macro shot of a box of matches. Exposure: ISO 1600, f/2.8, 1/25 second using a Nikon 105mm f/2.8G VR lens.

Outdoor Macro

Unfortunately, when you're photographing outdoors, the lighting is far from perfect most of the time. During the brightest part of the day, the sun is often too bright, giving your images a lot of contrast, which can result in blown-out highlights and/or blocked-up shadows. When the lighting is the best for outdoor photography (early morning or evening and overcast days), there often isn't enough light to allow you either a small aperture setting to ensure a deep depth of field or a fast shutter speed to combat camera shake.

There are a few ways you can get around these problems. In bright light, you can use Spot metering to ensure that the highlight detail is retained while letting the shadows go completely black. Active D-Lighting can also help in this situation. You or a friend can hold a small diffuser in front of the subject (although this could possibly frighten your subject off). You can also use a bit of fill flash to reduce contrast.

For Figure 11.3, I was photographing whatever insects I could run across at the local botanical gardens. This is a pretty simple way to come across interesting subjects and can be a great way to kill a few hours.

As previously mentioned, when you focus very close to a subject, the depth of field is greatly reduced. For this shot of a honeybee collecting pollen from a flower, I wanted to be sure that the whole bee was in focus and I wanted to catch all the details of the flower. I set the camera to Aperture Priority and stopped down to f/22. As you can see, even at that extremely small aperture the depth of field is so narrow that the background is out of focus, which really serves to bring attention to the subject.

11.3 An outdoor macro shot of a honeybee on a flower. Exposure: ISO 800, f/22, 1/125 second using a Nikon 105mm f/2.8G VR lens.

When you're shooting close-up not only is the subject magnified, but also so is any movement your hand makes while holding the camera. This makes using a relatively fast shutter speed a necessity, even when you are using a lens with Vibration Reduction (VR). When shooting Figure 11.3, I chose a relatively fast shutter speed of 1/125.

Because I was photographing a moving subject, I couldn't really use a tripod and I had switched the camera to AF-C, or Continuous AF, to ensure that when the honeybee moved, the camera would continue to focus on the subject.

When you're handholding your camera to get a macro shot, I recommend using AF-C because even the slightest movement can throw your focus off, and allowing the AF to adjust for your movements will result in sharper images. If you're using a tripod and photographing a nonmoving subject, using AF-S (Single AF) or Manual focusing is advised.

Night and Low-Light Photography

O nce the sun goes down and the light becomes low, a whole new world of pho-
tography opens up. This allows you to capture the world in an entirely different
light, so to speak. Taking photographs at night or in low light brings a set of challenges
that are not present when you take pictures during the day. The exposures become
significantly longer, making it difficult for you to hand hold your camera and get sharp
images. Your first instinct may be to use the flash to add light to the scene, but when
you do this, the image may lose its nighttime charm.

Almost any type of photography can be accomplished in low light, from landscapes
to portraits. Each type requires slightly different techniques and accessories, but the
goal is the same: to get enough light to make a good exposure and capture the deli-
cate interplay between light and dark.

**Taking photos at night often gives you the most colorful photographs. Exposure: ISO
100, f/22, 30 seconds taken with a Sigma 10-20mm f/3.5 lens at 10mm.**

How to Photograph at Night and in Low Light `

One of the easiest ways to do night photography is simply to grab a tripod and venture out into the night. Set up the camera on the tripod and shoot! The tripod stabilizes your camera so that you don't have to worry about camera shake with long exposures.

You can use the long exposures to create special effects like streaks of light from moving vehicles. One of my favorite things to do when I visit any city is to photograph the skyline at night. The multitudes of different-colored lights make these pictures vibrant and interesting. Even though they are shot in the dark, there is actually plenty of light to be found. Cities take on a different, and more intriguing, character when photographed at night.

12.1 A shot of the Austin, Texas, skyline. Exposure: ISO 200, f/8, 20 seconds using a Sigma 17-70mm f/2.8-4 OS lens at 17mm.

It's best to get a sturdy tripod for this type of work. Having a ball head on the tripod helps you quickly compose your images.

Generally, when shooting night landscapes or architecture, I use manual exposure and I bracket my exposures. Bracketing allows me to be sure that I get the exact exposure

that I'm looking for, and if necessary, I can combine elements of different exposures. For my base exposure, I set the metering mode to Matrix and look at the light meter in the viewfinder.

I generally start my exposure settings where the meter says that the shot will be 1 stop underexposed. I find that this is typically pretty close to the right exposure. I bracket five frames at 1/2-stop intervals from my base exposure. You can use smaller or larger increments and bracket more frames if you want more or less latitude in your exposures.

When doing night photography such as this, I generally use small apertures and long shutter speeds.

Long shutter speeds

When you're photographing a city street scene using a shutter speed of 30 seconds, a person walking through the scene will not register as long as he keeps moving. This also allows you to capture streaks from any moving light sources such as a car or truck headlights.

I also like to use long shutter speeds from 4 to 30 seconds when shooting city skylines because most metropolitan cities are located near a river or lake and the reflection of the city in the water has a glass-like appearance with the longer exposure.

Small apertures

I use small apertures for two specific reasons. First, smaller apertures require longer shutter speeds to make an exposure. Second, when you use a small aperture, any points of light that are in the scene are rendered as starbursts. This occurs because the light diffracts from the aperture blades, and the smaller the aperture, the more pronounced the points are. Unfortunately, diffraction also causes the image to lose a little sharpness. Be aware of this when stopping down past f/16.

What to Watch For

One thing to watch for when doing night photography with long exposures is lens flare. This is especially prevalent if you are using an ultrawide-angle lens. Lens flare occurs when the various bright points of light are reflected off the glass lens elements

and is usually exacerbated by long exposure times, making it more visible. Using a faster shutter speed makes lens flare of this type less noticeable.

If you find yourself without a tripod, don't fret. The D7000 is excellent in low light when you use high ISO sensitivity settings. Couple that with the Vibration Reduction (VR) on the kit lens, and shooting most still subjects in the darkness is easy.

You can also use wide-angle settings when shooting handheld in low light. Wide-angle settings are easier to hand hold at longer shutter speeds without camera shake.

Zooming

One cool technique you can try when shooting at night is using a long shutter speed and zooming your lens out to create light trails. This is a really simple trick that can be done handheld or with a tripod. For this shot of the Austin, Texas, skyline with the Stevie Ray Vaughan statue in the foreground, I simply mounted the camera on a tripod, set a long shutter speed of 20 seconds, and zoomed the lens out during the exposure.

Shooting Architecture

Architecture often lends itself well to night photography especially when the structure is lit up with bright colors as in Figure 12.2.

Setting up this shot was relatively easy. I set the camera on a tripod, composed the image, and checked the camera's analog light meter in the viewfinder. The camera was set to Manual mode, and I adjusted the settings so that the meter was reading about 1 stop underexposed so I could get a nice black sky and avoid getting blown-out highlights in the rest of the scene. I opted for a small aperture and a low ISO setting of 100 so I could get a long shutter speed that allowed the cars driving by to become invisible, leaving only the streaks of their headlights and taillights. The people in the scene were moving around, and have a ghost-like appearance that's pretty interesting.

12.2 A shot of the Ritz Theater in Austin, Texas. Exposure: ISO 100, f/16, 25 seconds using a Sigma 17-70mm f/2.8-4 OS lens at 29mm.

Because there are many different light sources in this shot, I recorded the image in RAW so I could adjust the white balance manually in post-processing until I got the effect that I liked the most. The camera's white balance was set to Auto, and I composed the image using Live View.

The shot in Figure 12.3 shows a situation you might come across pretty often when photographing brightly lit buildings at night. The problem is that the difference between the bright sections and the dark sections in the scene is too far apart for the camera's sensor to capture accurately. The difference between the lightest and darkest areas of the scene is called *dynamic range*.

For this shot I bracketed three exposures, exposing one shot for the highlights, one shot for the mid-tones, and one for the shadow areas. I took these three images and combined them in Adobe Photoshop, creating an image with High Dynamic Range, more commonly referred to as *HDR*.

12.3 The Long Center for Performing Arts in Austin, Texas. Exposure: ISO 100, f/11, 30 seconds, 15 seconds, and 5 seconds using a Tamron 17-50mm f/2.8 VC lens at 20mm.

Shooting Low Light Indoors

Of course, not all of your low-light photography is going to consist of buildings or cityscapes. Sometimes you just may be indoors in a dark place and will want to take a photograph without using a flash. In this type of situation, it's best to have a fast lens. A lens with a maximum aperture of f/2.8 is suggested at the least and a faster lens such as an f/1.4 is ideal. Nikon offers a few fast primes that are great for low-light photography. The newest ones are the AF-S prime lenses: the 24mm f/1.4, 35mm f/1.4, and the 50mm f/1.4. The 24mm and 35mm options are very expensive at more than $2,000, but the 50mm is pretty affordable at just under $500. If you're looking for a bargain, consider some the older AF-D lenses, such as the 50mm f/1.8 or f/1.4. The 50mm f/1.8 is the best deal. You can find this lens for about $100 used.

Figure 12.4 shows a simple example of using a fast lens. To get this shot, I set the camera to Aperture Priority mode, set the aperture to f/1.4, and still had to crank up the ISO to 3200 to get a shutter speed of 1/80 second so I could be sure that I could hand hold the camera without getting blur from camera shake.

12.4 A quick and easy low-light portrait. Exposure: ISO 3200, f/1.4, 1/80 second using a Nikon 50mm f/1.4G lens.

Portrait Photography

Portrait photography can be one of the easiest or most challenging types of photography. Almost anyone with a camera can do it, yet getting the perfect lighting can sometimes be difficult. Sometimes simply pointing a camera at someone and snapping a picture creates an interesting portrait; other times elaborate lighting set-ups may be needed to create a mood or to add drama to your subject.

A *portrait*, simply stated, is the likeness of a person — usually the subject's face — whether it is a drawing, a painting, or a photograph. A good portrait should go farther than that. It should go beyond showing your subject's likeness and delve a bit deeper, revealing some of your subject's character or emotion.

A good portrait should capture some personality of the subject. Exposure: ISO 200, f/4, 1/320 second using a Sigma 17-70mm f/2.8-4 OS at 70mm.

Portrait Settings

One of the most important parts of portrait photography is finding, or more likely creating, a suitable setting that captures the mood you want to project with the image. For a subdued or moody portrait, a dark background, such as black, dark gray, and brown, works best. If you're going for a more high-fashion look, keeping the background bright and uncluttered is the norm. White backgrounds work exceptionally well for fashion, though brightly colored backgrounds can work as well.

You can also shoot on location using the outdoor scenery as your setting or shoot indoors at a location of your choosing, be it bright and modern, cozy and warm, or dark and foreboding.

Lighting and background are the principal ways to create a certain mood or ambience in a portrait image, but there are other ways. Shooting the image in black and white can give your portrait an evocative feel. You can shoot your image so that the colors are more vivid, giving it a live, vibrant feeling, or you can tone the colors down for a more ethereal look.

13.1 For this shot I used a rock wall in the background to create a gritty setting. Exposure: ISO 100, f/1.8, 1/60 second using a Nikon 35mm f/1.8G lens.

Indoor Portraits

Shooting portraits indoors can be quite easy once you know what pitfalls to avoid and learn a few tricks on how to overcome some of the main problems that you're likely to encounter. One of the most obvious problems that you find when attempting an indoor

portrait is that there's often not enough light to make a correct exposure while still having a fast-enough shutter speed to avoid blur from camera shake; you may find that you need an additional light source. The most obvious additional light source is the built-in flash. Although the built-in flash on the D7000 sometimes works very well, especially outdoors as fill, you probably already know that the light from on-camera flash projects straight forward, making the subject look harsh, flat, and overall unflattering.

The best way to add additional light is to use an external Speedlight such as the Nikon SB-900. As with the built-in flash, you don't want to have your Speedlight pointed directly at the subject, so bouncing the flash off of the ceiling or a wall is your best option.

For more information on using Speedlights, see Chapter 6.

Probably one of the easiest ways to achieve a more natural-looking portrait indoors is to move your subject close to a window. Window lighting gives you more light to work with and the window acts as a diffuser, softening the light and giving your subject a nice glow. In Figure 13.2, I positioned Toni next to the window to take advantage of the soft light.

I shot this portrait with a Nikkor 50mm lens with the aperture set to f/1.4 to blur the background. I chose Spot metering to make sure that the camera was exposing for her face, and I used a Single AF point and Single-servo AF mode.

One thing to watch for when you use window lighting is *mixed light*, which occurs when you have two or more

13.2 An indoor portrait shot using window light. Exposure: ISO 200, f/1.4, 1/500 second using a Nikon 50mm f/1.4G lens.

light sources in one setting. For example, if the ambient light from indoors is coming from a tungsten light bulb and you have your model sit in front of the window, the light coming from the window is going to have a bluish cast while the light from the light bulb will appear very orange.

There are a number of different ways you can deal with mixed lighting. I recommend using a Speedlight (bounced) to add some fill to overpower the tungsten lighting in the room. The light from the Speedlight is going to be close to the same color temperature of the window light. You will probably need to dial down the Flash Exposure Compensation (FEC) by about −1EV to ensure that the window light is overpowered. Another simple way to deal with mixed lighting is to convert the image to black and white.

13.3 Here you can see the effect of mixed lighting on a window light portrait. Exposure: ISO 1600, f/1.4, 1/20 second using a Nikon 50mm f/1.4 lens.

Studio Portraits

Studio portraits are essentially indoor portraits except the lighting and background is controlled to a much greater extent. Although most professional portrait photographers use studio strobes to light their subjects, you can basically get the same results using a few Speedlights.

The most important part of a studio setting is the lighting setup. You have quite a few considerations to keep in mind when setting up for a studio portrait:

Quality of Light

The *quality of light* is a photographic term that basically describes how the light reacts with your subject. Simply put, for portraits there are two different types of lighting: hard light and soft light. You can use either type of lighting depending on the effect you are going after. For the most part, portrait photographers prefer soft light. This type of light "wraps" around the subject, creating a smooth transition from shadow to highlight. It's the most flattering type of light for most portraits. To get this effect, photographers often use softboxes, umbrellas, diffusion panels, or bounce flash. Soft light is created by a large light source (in relation to the subject), so moving the light source closer to the subject gives you a softer light.

Conversely, hard light comes from a small bright light source (again in relation to the subject). Moving your light farther away from the subject makes the light harder, giving the image more contrast, darker shadows, and specular highlights. The shadow edge transfer is more abrupt, giving the image a stark contrast. Hard light is often used to make portraits more dramatic. The figure on the left illustrates soft light and the one on the right shows hard light.

13.4 Planning out the lighting, background, and poses is important in studio photography. Adding the fan as a prop added some interest to the photo. Exposure: ISO 100, f/11, 1/60 second using a Nikon 50mm f/1.4G lens.

▶ **What kind of tone are you looking for?** Do you want the portrait to be bright and playful or somber and moody? Consider these elements, and set up the appropriate lighting and background.

▶ **Do you want to use props?** Sometimes having a prop in the shot can add interest to an otherwise bland portrait.

▶ **What kind of background is best for your shot?** The background is crucial to the mood and/or setting of the shot. For example, when shooting a high-key portrait, you must have a bright (usually white) background. You can also use props in the background to evoke a feeling or specific place.

▶ **What type of lighting will achieve your mood?** Decide which lighting pattern you are going to use, and light the background if needed.

Studio portraits require more thought and planning than other types of portraits. They also require the most equipment — lights, stands, reflectors, backgrounds, and props are just a few of the things you may need.

Portrait Lighting Patterns

Professional photographers use different types of lighting patterns, generally to control where the shadow falls on the face of the subject. If you don't control the shadows while lighting your subject, your portrait can seem odd because strange shadows appear in unwanted places. In addition to the lighting patterns, there are two main

types of lighting — broad lighting and short lighting. Broad lighting occurs when your main light is illuminating the side of the subject that is facing you. Short lighting occurs when your main light is illuminating the side of the subject that is facing away from you. In portrait lighting, there are five main types of lighting patterns.

▶ **Shadowless.** This lighting pattern is when your main light and your fill light are at equal ratios. Generally, you will set up a light at 45° on both sides of your model. This type of light can be very flattering, although it can lack moodiness and drama. This can also be referred to as *front lighting*.

▶ **Butterfly or Hollywood glamour.** This type of lighting is mostly used in glamour photography. The name is derived from the butterfly shape of the shadow that the nose casts on the upper lip. You achieve this type of lighting by positioning the main light directly above and in front of your model.

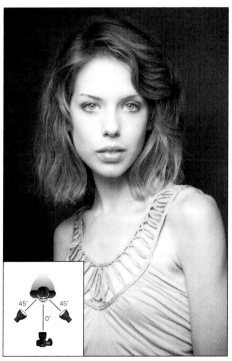 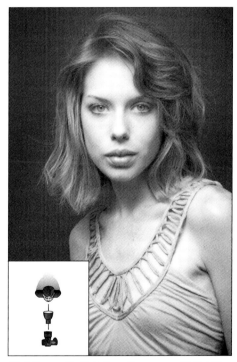

13.5 Shadowless lighting. Exposure: ISO 100, f/5.6, 1/200 second using a Nikon 50mm f/1.4G.

13.6 Butterfly lighting. Exposure: ISO 100, f/5.6, 1/200 second using a Nikon 50mm f/1.4G.

▶ **Loop or Paramount.** This is the most commonly used lighting technique for portraits. Paramount Studios used this pattern so extensively in Hollywood's golden age that this lighting pattern became synonymous with the studio's name. This lighting pattern is achieved by placing the main light at a 10° to 15° angle to the face, making sure to keep the light high enough that the shadow cast by the nose is at a downward angle and not horizontal.

▶ **Rembrandt.** The famous painter Rembrandt van Rijn used this dramatic lighting pattern extensively. It's a moody pattern achieved from using less fill light. The light is placed at a 45° angle and aimed a little bit down at the subject. Again, I emphasize using little or no fill light. This pattern is epitomized by a small triangle of light under one of the subject's eyes.

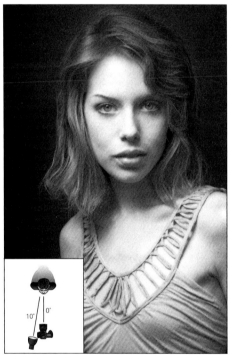 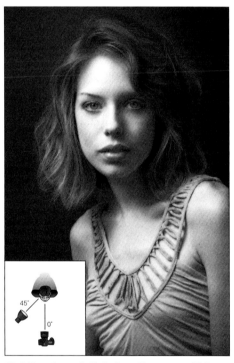

13.7 Loop, or Paramount, lighting. Exposure: ISO 100, f/5.6, 1/200 second using a Nikon 50mm f/1.4G.

13.8 Rembrandt lighting. Exposure: ISO 100, f/5.6, 1/200 second using a Nikon 50mm f/1.4G.

▶ **Split.** This is another dramatic pattern that benefits from little or no fill. You can create it by simply placing the main light at a 90° angle to the model.

Posing and Composition Considerations

Through body language, a person can convey many different emotions and expressions, so it goes without saying that how a subject is posed can make a huge impact on the general mood of the image.

Posing your model can be one of the hardest things to learn when starting out in portrait photography, and get-ting good poses can separate a good

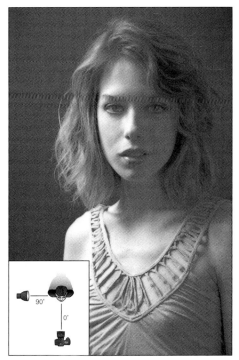

13.9 Split lighting. Exposure: ISO 100, f/5.6 second, 1/200 using a Nikon 50mm f/1.4G.

portrait from a truly great one. It's important to remember that your models or clients expect you to know what you're doing. You need to be confident and assertive. Acting timid or being afraid to ask your model to do what you need will get you nowhere in the portrait business.

You should also pay close attention to your subject's hands. Hands can subliminally reveal a lot about how a person is feeling. Make a conscious effort to tell your models or clients to relax their hands. When a model's hands are relaxed, she looks and feels more relaxed. If the model's hands are clenched up or tense, your portraits look forced or she looks uncomfortable. Hands are an extension of the arms, and arms can have an emotional impact on your image, as well. For example, having your subject cross his arms can show strength and determination, or even that he's obstinate, depending on the facial expression.

13.10 Different poses can give your portraits different feelings. Here the model appears relaxed and at ease. Exposure: ISO 100, f/1.4, 1/640 second using a Nikon 50mm f/1.4G lens.

One of the easiest ways to learn about posing is to study poses from other photographers or artists. Open a fashion magazine or browse the Internet. I keep a folder on my desktop where I copy small files of images with interesting poses. If I'm feeling particularly uninspired during a photo shoot, I open the folder to get some ideas and the creative juices flowing. Some of my favorite poses don't even come from other photographers, but from artists. Alberto Vargas and Gil Elvgren painted pinup girls in the 1940s, and their art is iconic and fun. Check out their work for some inspiration.

When posing your model, you need to keep an eye on everything from stray hairs and clothing bunching up in weird ways to awkward limb positions. Before you trip the shutter, be sure to take time to look closely at everything in the frame.

Here are a few more tips for posing subjects:

▶ **Place one foot behind the other.** One of the first things I do is have the person put one foot behind the other. This helps distribute the person's weight evenly and gives her a more relaxed appearance. Having the person lean back slightly is also helpful.

▶ **Come in at an angle.** For close-up portraits, you almost never want the subject to face straight ahead (unless you're a police photographer). Having your subject angled slightly away from the camera with one shoulder closer to the camera is a good idea.

▶ **Tilt the head.** Tilt your subject's head a bit to avoid having him look static; the tilt gives the portrait a casual feel. Of course, if you're shooting a formal portrait, you won't want to do this. For example, if you're shooting a CEO of a corporation, you want to portray strength and character, so keeping the subject's head straight is ideal.

▶ **Watch the hands.** Try to keep your subject's hands at an angle; the flat side of the back of the hand or the palm facing the camera can look odd. A three-quarter view or the side of the hand is preferable.

Outdoor Portraits

When you shoot portraits outdoors, the problems that you encounter are usually the exact opposite of those you have when you shoot indoors. The light tends to be too bright, causing the shadows on your subject to be too dark. This results in an image with too much contrast.

In order to combat this contrast problem, you can use your flash. I know that this sounds counterintuitive; you're probably thinking, "If I have too much light, why should I add more?" Using the flash in the bright sunlight fills in the dark shadows, resulting in a more evenly exposed image. This technique is known as *fill flash*.

Another way to combat images that have too much contrast when you shoot outdoors is to move your model into a shaded area, such as under a tree or a porch. This helps block the direct sunlight, providing you with a nice, soft light for your portrait. You can also have someone hold a diffusion panel in front of the sun, and it acts as a softbox.

In Figure 13.11 I was shooting at 1 o'clock in the bright midday sun, which is probably the worst time to shoot. I brought in a diffusion panel to block the stray sunlight, giving us a nice, diffuse light to work with.

An easy way to achieve a soft light when shooting outdoors is to wait for a cloudy or partly cloudy day. When the sun is behind a cloud, you get a diffused light, which is perfect for portraits.

13.11 I shot this outdoor portrait of my niece J'Ana using a diffusion panel to reduce contrast. Exposure: ISO 100, f/4, 1/160 second using a Sigma 17-70mm f/2.8-4 OS lens at 70mm.

Portrait Photography Tips

There are a number of different techniques that you can use to make your portraits stand out. Some of them include

▶ **Use a wide aperture.** Using a wide aperture gives you a shallow depth of field. This isolates the subject from the background, allowing her to stand out.

▶ **Use Single-point AF mode.** Using a single focus point allows you to control exactly where the area of focus is in the image. Relying on the camera to choose which focus point is selected can sometimes give you unpredictable results.

▶ **Focus on the eyes.** Generally the eyes are the most important part of the portrait and you want them to be sharp. Always focus on the eyes unless you are trying for some sort of artistic effect using selective focus.

▶ **Use a longer focal length.** Avoid using a lens that is shorter than 50mm. Wide-angle lenses cause perspective distortion, which can make your models look, well, kind of funny. Generally a focal length of 75mm or longer is recommended. A telephoto lens tends to flatten the model's features and increases the background blur when you're shooting with a wide aperture.

▶ **Don't sever limbs.** Try not to frame the image in the middle of a knee joint or elbow. Don't cut off the toes or fingers. If a foot or hand is in the image, be sure to get all of it in the frame.

▶ **Watch out for *mergers*.** Be aware of the background as well as the subject. Oftentimes you can get so involved with looking at the model, you can forget about the rest of the photograph. You don't want your model to look as though she has a tree sprouting out of her head or a lamp suddenly growing out of her shoulder.

▶ **Fill the frame.** Make your subject the dominant part of the image. Having too many details in the background can distract from the subject of the image.

Still-Life, Product, and Food Photography

Although still-life, product, and food photography are three different types of photography, inherently they are very similar. With each one, you take a picture of a nonmoving subject, so many of the same techniques can be applied. Unlike concert or event photography, photography with stationary subjects allows you to create a scene rather than just capture it; it's up to you to build the composition starting with the background. Often this requires changing the lighting numerous times, moving the objects around, and adjusting the camera settings to achieve the desired effect.

A still-life photograph can be as simple or complex as you make it. This is a very simple arrangement that took only a few minutes to set up and shoot. Exposure: ISO 320 (Auto ISO), f/5.6, 1/80 second using a Tamron 17-50mm f/2.8 VC lens at 35mm.

The Basics

Three basic elements go into any still-life photograph: background, composition, and lighting. These three elements must work together if the image is to be successful. Before getting started on your own images, you may want to research some famous still-life photographers to see how they worked within these elements.

Edward Weston is one of the best-known still-life photographers of the twentieth century. His images were very simple and relied heavily on the form of the subject to make the composition striking. He made his images almost exclusively in high-contrast black and white.

Another great still-life artist is Irving Penn. Although Penn is best known for the glamorous portraits he did for *Vogue* magazine, he was a very well accomplished still-life photographer (and painter as well). Penn's compositions are colorful, well planned and carefully composed. Penn had an acerbic wit and this often comes out in his compositions. See his photograph "Cholesterol's Revenge" for a great example.

Background

The first thing you want to do (after choosing your subjects, of course) is to decide what the background is going to look like. Often the best background is a simple one. This allows your subject to stand out.

Some different options for background material include seamless paper, poster board, cloth, and black velvet (this is often used when shooting jewelry to reduce reflections). The main question when choosing a background is the color, and two very simple choices are black or white. Either of these works well with almost any subject. Of course, you can use any color in the rainbow as well. Using a dark background gives you a *low-key* image, while using a white or light colored background gives you a *high-key* image. These two terms refer to the brightness of the scene and have a major impact on the feeling of your image. High-key photographs are bright and can sometimes have limited contrast between the subject and the background. High-key images tend to evoke a lighter feeling. A low-key image is dark with a lot of shadows and contrast. These images tend to be moody and evocative.

14.1 An example of a high-key image. Exposure: ISO 400, f/16, 1/125 second using a Nikon 35mm f/1.8G lens.

14.2 An example of a low-key image. Exposure: ISO 400, f/16, 1/125 using a Nikon 35mm f/1.8G lens.

One thing to keep in mind when you use colored backgrounds is that your background should add to the image, not draw attention away from the subject. Using complementary colors to set off your subject is a great way to add interest to a still-life or product picture.

Sometimes rather than having a plain background, you may want to include some background scenery to add some interest or to help the image tell a story. In Figure 14.3 you can see where I use the existing background to give the image an urban nightlife feel. Although I wanted the background to be busy, I also didn't want it to distract from the main subject, so I used a shallow depth of field to render the background indistinct.

When incorporating background elements in the photograph, it's sometimes necessary to build a scene or to

14.3 The background in this shot gives it a sense of place. Exposure: ISO 1600, f/1.8, 1/25 second using a Nikon 35mm f/1.8G lens.

use props. For example, if your subject is a fruit, a cutting board and knife could be the background. If your subject is a cup of coffee, the background could be a burlap sack with coffee beans. The key to building a background is to be sure your background props match your subject, and that there aren't so many props that they compete with the subject.

Composition

Composition is a very important factor in creating a successful still-life shot. If the subject or subjects aren't set up right, the composition isn't going to flow and thus the image may be unappealing to the viewer. Your job as a still-life photographer is to arrange the subject so that the viewer's eye flows through the image, taking it all in.

Figure 14.4 is a very simple still-life photograph. The berries are arranged in a fashion that leads your eye through the picture, starting at the focus point leading back to the second berry, over to the third berry, and then out of the frame. I took care not to place any of the berries facing the same direction to avoid repetition.

Another factor in composing still-life images is color. One way to give your images more impact is to use a single bright color as I did with these raspberries. When using objects that are more than one color, you want to be sure that the colors match or are complementary. Of course, if you are going for an odd effect you can use clashing colors.

One of the prevailing rules in composition, especially when shooting still-life subjects, is the *Rule of Odds*. This is a rule that's not often mentioned, but it states that an odd number of subjects in a composition is aesthetically more pleasing than an even number. Loosely related to that is the fact that triangles make very strong and interesting compositions whereas squares and rectangles make for relatively static and uninteresting images. As you can see in Figure 14.4, the arrangement of the berries loosely forms a triangle.

14.4 The arrangement of the berries in this shot leads your eye through the image and the strong colors provide visual impact. Exposure: ISO 320, f/8, 1/60 second using a Nikon 105mm f/2.8G VR macro lens.

Lighting

Lighting is the crux of the still-life image. Controlling the quality of light is how you give your images the look you are going for. The light can be hard and directional or soft and diffuse depending on the subject. Still-life and product photography can be done using almost any type of light source. You can use natural light, flash, or continuous lighting, all with great results. In my experience I generally find that natural lighting works best for artistic still-life or food photography while the controlled lighting of flashes or continuous lighting works best for product shots.

The easiest and simplest way to light a still-life is to use window lighting. This is the preferred method of many food photographers. As I explain in earlier chapters, light coming through a window is naturally diffused and works very well. If the shadows are too dark, you can use a reflector to bounce a little more light into the scene. Figure 14.5 shows a very simple food shot. The lighting is 100 percent natural light from the window. For food shots I generally like to use a shallow depth of field to draw attention to the main subject, which in this case was the burger with bacon and Gruyere cheese (yes, it was delicious).

14.5 Window lighting is perfect for food photography. Exposure: ISO 320, f/2.8, 1/320 second using a Tamron 17-50mm f/2.8 VC lens at 28mm.

Figure 14.6 shows a more complicated lighting setup than the one in Figure 14.5. For this shot of my 1959 Gretsch G6119 Chet Atkins, I used a Smith-Victor 300ws mono-light strobe with a large softbox for diffusion and a reflector to fill in the dark shadows on the left side of the amplifier. I placed the strobe directly in front of the subject for even lighting. Another factor in a shot like this is the placement of the subject. To avoid lighting the background, it was necessary to place the guitar and amp as far from the background as possible. The allowed the background to go completely black with little shadow detail, which in turn makes the subject pop.

You can also use the Nikon Creative Lighting System to effectively light product images. Figure 14.7 is an uncomplicated product shot that is similar to something you might put up for an online auction. This shot was lit very simply with one SB-600 con-trolled by the D7000 built-in flash. I used a piece of white poster board to make a seamless background for the old Polaroid camera.

Using the AS-19 Speedlight stand, I placed the SB-600 on a chair next to the setup. I bounced the flash from a piece of white foam core to get an even, almost shadowless light. The built-in flash was set to Commander mode and the exposure was set to "−" so that the flash didn't add any expo-sure to the scene. The SB-600 was set to Group 1 and the exposure mode was set to Through-the-Lens (TTL). I added +1.7 EV of FEC to capture the shadow detail and to be sure that the background was a bright white.

14.6 Using a dark background can allow your subject to really stand out. Exposure: ISO 200, f/8, 1/320 second using a Tamron 17-50mm f/2.8 VC lens at 50mm.

For simple nonartistic product shots, I usually like to stop down the lens to a small aperture to ensure the whole subject is sharp.

14.7 Using a small aperture allows you to get the entire subject is sharp focus. Exposure: ISO 800, f/16, 1/60 second using a Nikon 80-200mm f/2.8D lens at 180mm.

Stock Photography

A lmost everyone who puts a substantial amount of money into cameras and lenses would like to recoup their investment. Becoming a full-time professional may not be in your plans, but there are ways to make a little money in photography. One of these ways is by selling stock photography. Making and selling stock photography can be as easy as taking photos on your family vacation or as ambitious as hiring models, finding sets, and creating your own photographic scenarios.

Nearly any type of image can be used for stock photography. Exposure: ISO 1200, f/2.8, 1/200 second using a Nikon 35mm f/1.8G lens.

Stock Photography Overview

What exactly is stock photography? Stock photography can encompass every type of photography that's out there, but the short answer is that stock photography is a collection of images that is available to art directors, editors, and advertising agencies for use in books, magazines, ad campaigns, brochures, or thousands of other mediums ranging from print to Web. A buyer can purchase these images outright for a one-time fee and use them however she wants for however long she sees fit (royalty-free), or they can be leased for a usage fee (rights-managed). This section explains the different types and uses of stock photography.

Basically there are two different types of uses for stock photography: creative and editorial. Creative stock photography is generally used for advertising campaigns and almost anything that has to do with business, from mailers and pamphlets to billboards. Editorial stock photography generally includes current event, entertainment, documentary, and even archival photographs. Editorial stock is used for mostly magazines, books, and sometimes television or film documentaries.

Creative stock

Creative stock photography is usually conceptual. The photographer conceives of an image and specifically sets out to photograph it. This can be anything from a still-life setup to a lifestyle or animal shot. Lifestyle photography is probably the most lucrative form of stock photography out there right now and lifestyle shots can be used for almost anything. The goal of creative stock is ultimately to sell a product.

Lifestyle photography

Lifestyle photography is a loosely interpreted term that can mean almost anything. The general goal of lifestyle photography is to show a brand style or attitude. It most often features people or groups of people in settings where there is some sort of staged action (typically intended to appear as if it were not staged). Think of the ads that come with the Sunday morning paper. If the merchant is selling sports clothing, you might see a group of guys hanging out, holding some sort of sporting equipment, be it a football, a hockey stick, or something sports related. Lifestyle photography can feature families, medical personnel, or even extreme sports types. Essentially this form of photography uses imagery that certain types of people can identify with and may or may not feature an actual product.

 Be sure to get model releases for any stock images with people in them.

Basically, the process for taking lifestyle photographs is as follows:

1. **Conceive of an idea.** This is basically where you come up with a concept. Think of activities or events like a trip to the beach, moving into a new house, gardening, and so on.

2. **Make a shot list.** Take the idea and think of what would be happening for the concept. For example, when new occupants move into a new house, you might see them unpacking moving boxes, painting, or putting up shelves. A shot list should consist of a number of different shots and you can list what kind of angles you want, the depth of field effect you're after, or other notes.

3. **Get the pieces into place.** Find or build a set, hire models, and piece together the wardrobe and props.

4. **Shoot.** Pose the models, position the props, set up the lighting, and shoot the photos.

5. **Edit.** Edit out the weakest images and post-process the ones that you have selected as keepers.

Lifestyle photography is an ambitious endeavor and can get very expensive if you want to make a serious go of it. Of course you can make it much simpler and do smaller shoots, but the more styles and scenes you have, the more likely you will be to sell your images.

Figure 15.1 shows a typical lifestyle shot. This shot was a simple setup consisting of a model enjoying a cup of coffee in a coffee shop. It portrays the easygoing lifestyle of a young urbanite.

15.1 This figure shows a typical lifestyle shot. Exposure: ISO 1600, f/5.6, 1/400 second using a 35mm f/1.8G lens.

Product/Still-life

Although more often than not lifestyle photography has people in it, you don't necessarily need people to portray a lifestyle. Often you can portray a life-style simply by making a still-life setup that evokes a feeling or an attitude. Figure 15.2 is a stock photography shot that evokes a feeling of nostalgia by featuring a vintage-style microphone in the forefront and a vintage guitar and amplifier implied in the background, recognizable even though they are blurred by the shallow depth of field.

For this shot I used an off-camera SB-600 triggered by the built-in flash to add highlights to the chrome microphone. The flash was set to TTL (Through-the-Lens) with –0.7 FEC.

Although it's probably less lucrative than traditional lifestyle photography, this type of photography is much more accessible for most people. All you really need is a good concept and a few props.

15.2 This figure shows a still-life stock photography shot. Exposure: ISO 400, f/3.2, 1/60 second using a Nikon 28mm f/2.8D lens.

Animals

There are also quite a few stock agencies that deal with pet and animal photography. More often than not they are looking for clean pet portrait shots done on a plain background to allow ad agencies to drop in type or another background if desired.

Figure 15.3 is a stock shot of my dog Henrietta. This shot was very easy to execute and when setting up this type of shot, you can get a variety of different shots by adding props or different poses. I've seen shots similar to this one at stock photo Web sites that feature dogs with party hats, wigs, bones, and many other types of props.

For this shot I simply used a piece of white poster board for the backdrop. I used the built-in flash to trigger an off-camera SB-800 that was diffused by using a Photoflex LiteDome XS softbox. This softbox was specifically made for use with off-camera Speedlights. It's great for a portable studio and enables you to get pro-quality lighting for a small amount of money.

A good idea for shooting pets and animals is to keep some treats on hand. It also helps to work with animals that have had a little training.

Editorial stock

Editorial stock photography is used for books, magazines, and newspapers. Editorial stock isn't used for selling a product but for illustrating a story or simply showing what has happened in a current event. This type of photography is usually conceptual and includes

15.3 This figure shows a stock shot of a Boston Terrier. The model is my dog Henrietta. Exposure: ISO 200, f/5.6, 1/200 using a Nikon 28-70mm f/2.8D lens at 40mm.

photographs by famous photographers; for example the stock photography agency Corbis Images deals with the licensing of images by famous photographers Ansel Adams and Brett Weston.

Documentary

Documentary stock photography consists of a multitude of different subjects. Food, travel, nature, wildlife, science, and technology are just some examples. These images are often used in feature stories of magazines and newspapers when the articles are not considered news or current events. Almost any image can be used as a documentary type of stock photograph because the topics can be so varied.

Current events and entertainment

Current events and entertainment photography is pretty self-explanatory. It ranges from newsworthy events such as politicians' spracuhuu, movie premieres, sports, concerts, and other similar types of events. This is the type of stock photography I do the most of for my agency, Corbis Images.

This type of photography can be hit or miss. Some events require a press pass, but some events you can just show up and shoot. Check the local paper for things like movie premiers, charity events, and political rallies. All these events are great for current events photos.

Figure 15.5 is a shot of NBA star LeBron James and rapper Jay-Z at a charity event. When images of this type are placed with a stock agency, trade magazines or sports and celebrity Web sites will pick them up.

15.4 This stock image of a great horned owl was used to illustrate a story about the plight of the owls as civilization encroaches on their habitat. Exposure: ISO 320 (Auto ISO), f/7.1, 1/350 second using a Nikon 80-200mm f/2.8D lens.

Stock Photography Licensing

As I touched on earlier, two distinctly different types of licensing are available to those purchasing stock images: royalty-free and rights-managed. The licensing largely depends on what the image is going to be used for. Typically, this part of the stock photography business is handled by the agency unless the photographer is acting as his own agent. What does licensing mean exactly? It means that you own your images and you grant the right to use them to a buyer for specific applications and lengths of time. The price is usually determined by a number of factors, which are explained in the following sections.

Royalty-free

This is probably the cheapest way to obtain an image. Royalty-free doesn't exactly mean that people are free to use the image as they see fit. The buyer must pay for the image. The payment is a one-time fee that allows the purchaser of the image to use it multiple times without paying additional royalties to the copyright owner.

One of the most attractive things about royalty-free images to buyers is that the price is generally based on file size, meaning that if the buyer wants to use it on a blog at 72 dpi (dots per inch), the image is usually very cheap, and if the buyer wants to use it on the Web for 1,000 blogs, she doesn't need to pay additional fees.

15.5 This figure shows a typical current events stock shot. Exposure: ISO 1100 (Auto ISO), f/4, 1/125 second using a Nikon 17-55mm f/2.8G lens at 17mm.

One of the downsides to royalty-free images (for the buyer at least) is that the images are usually licensed under what's known as a *nonexclusive license*, meaning that same image could be licensed to a competitor and used for the same application. This is an upside to the photographer because multiple small fees for an image can make almost as much (sometimes more) money than a one-time more-expensive fee for exclusive licensing.

Rights-managed

Rights-managed images get more "bang for the buck" for both the photographer and the buyer than royalty-free images. Licensing these types of images costs more than the royalty-free photos. The price is determined by quite a few factors, which usually include, but aren't limited to

▶ **Usage.** This is what the image is going to be used for. It could be print advertising, such as on a billboard or in a magazine ad; corporate imagery, such as in the company newsletter or Web site; or editorial content, such as in a newspaper article. Generally any type of national or international use is the most lucrative.

▶ **Size.** This is self-explanatory; obviously a billboard-sized image is worth more than a postage stamp-sized image buried in the back pages of the Sunday paper.

▶ **Print run.** This refers to how many copies of the photos are going to be printed for the specific usage. For example, a small local paper will have a print run of a few thousand papers whereas a national magazine will print a million or more magazines. Of course, the larger the print run, the larger the fee.

▶ **Duration.** This is how long the image will be displayed. For example, it might appear in a daily newspaper, a bimonthly magazine, or a recurring ad campaign.

▶ **Geographical location.** This refers to the specific country or region where the image will be used. For example, if the image will be used nationwide, it will be worth more than if it's going to be used in a small town.

▶ **Exclusivity.** Rights-managed images aren't necessarily exclusive. The buyer is usually guaranteed that the image won't be used by a competitor or in the same geographical location, though it truly depends on the contract. Exclusive images command a higher price due to the fact that they cannot be used by multiple parties, which limits the income the photographer can earn from the particular image.

A lot of other factors go into determining the price, including the amount of images, whether the buyer has purchased images previously, and the current market rate, among other things.

Breaking into the Market

If this sounds good to you, then you're probably asking, "Where do I sign up?" Well, it's not just as easy as putting your images up online, although that's one way to approach it. Of course, you can design a Web site and put up all your photographs and hope that a photo buyer stumbles across them and buys some. This is akin to the photo buyer finding a needle in a haystack. What you need is marketing.

At one time, stock photography was a thriving business with many different agencies representing the work of a select number of professional photographers. With the advent of digital photography and, subsequently, the affordability of pro-level dSLR cameras, the industry was turned on its head. In the '90s, as digital photography boomed and the Internet made it easy to browse images online, two companies began buying out the smaller companies and enveloping them in their maw to create two huge stock photography agencies: Getty Images and Corbis Images (owned by Microsoft's Bill Gates). My work is licensed through Corbis, which has helped place my images in many national and international outlets.

These agencies handle marketing as well as negotiating the sale of the image, leaving you free to create your photos. This does come at a cost. First, the agency usually sets the price of your images. Second, the agency takes a cut, usually to the tune of 50 percent. That's a pretty small price to pay for national exposure, though.

Micro-stock agencies generally keep between 60-80 percent of the royalty fees of each image sold.

The best situation would be to sign a contract with one of the super-agencies. This is where the national magazines and ad agencies shop. It's actually pretty simple to apply to them, but you need a top-notch portfolio and usually many years of experience behind you. That's not say you don't have a chance at being represented by them, but it's probably best to start small. There are a number of agencies known as *micro-stock agencies* (these agencies are often subsidiaries of the big two, so it's a good way to get your foot in the door). Micro-stock agencies are different than the big guys in that most of their images are culled from the Internet; they accept small portfolios of stock photography from many photographers, including amateurs; and they sell royalty-free images at very low prices.

Micro-stock agencies work on the premise that small businesses and people wanting to buy images for personal use don't want to pay the larger rates of the bigger agencies and don't need to worry about exclusivity. They just want good images at fair prices.

Most micro-stock agencies don't accept all photographers who submit; they do review the work, but they don't expect you to have a huge portfolio. Here's a list of a few of the most popular micro-stock sites:

▶ **iStockphoto.** This is one of the largest micro-stock agencies with more than 5 million images for sale. This company was purchased by Getty in 2006. You must provide three sample images and take a short quiz before you can submit stock images.

▶ **Shutterstock.** This is another large micro-stock agency boasting almost eight million images for sale. Shutterstock pays a flat fee of 25 cents per image with an increase of 5 cents once you reach $500 in sales. You must fill out a questionnaire before you're allowed to submit images. Images are reviewed before they are posted to the site.

▶ **Fotolia.** This micro-stock agency operates a little differently than the others. It pays 50 percent and allows the photographer to set the price. You must become a member to submit photos.

What are you waiting for? Get out there and start shooting. You can submit almost any type of photography, so when you're out shooting, whether you're on vacation or just out shooting for fun, keep stock photos in mind. You never know — after a while you may be able to quit your day job and focus solely on stock photography!

Viewing and In-camera Editing

With the D7000's bright, 3-inch, Hi-res, 930,000-dot VGA LCD monitor, you can view your images and even use the in-camera editing features that allow you to save some time in post-processing. These features give you the option to fine-tune your images for printing without ever having to download your images to a computer. You can even process RAW files right inside the D7000 and save the results directly to the memory card. Nikon has made enhancing your photos much more simple and fun.

The Retouch menu allows you to edit your images without a computer.

Viewing Your Images

The Nikon D7000 offers three ways to view your images while the memory card is still inserted in the camera. You can view the images directly on the LCD monitor on the camera or you can hook up your camera to a standard TV using the included EG-DG2 A/V cable. The D7000 also has an HDMI (High-Definition Multimedia Interface) output. With a Type C mini HDMI connector (available separately at most electronics stores) you can view your photos or even your HD video in full High Definition right on your HDTV.

When you're viewing images on an external device such as a TV, the view is the same as would normally be displayed on the LCD monitor. The camera's buttons and dials function exactly the same.

Standard TV

Before connecting the camera to a standard TV, you need to set the Video out mode. There are two video interface types: PAL and NTSC (NTSC is the camera default). These modes control how the electronic signal is processed. NTSC mode transmits 30 frames each second with each frame comprised of 525 scan lines. PAL mode transmits 25 frames per second with each frame comprised of 625 scan lines. It's unlikely you'll ever need to refer to this information but it can be nice to know how the modes work. The two different video modes are used in different parts of the world. Most of North and South America use the NTSC mode while Asia and Europe use the PAL video system. If you're unsure whether your TV accepts NTSC or PAL, you should check the owner's manual.

To set the Video mode, follow these steps:

1. **Turn the camera on.**
2. **Press the Menu button.**
3. **Use the Multi-selector to highlight the Setup menu.**
4. **Use the Multi-selector to highlight Video mode, and then press the OK button.**
5. **Use the Multi-selector to highlight NTSC (or PAL).**
6. **Press the OK button to save the settings.**

 For more information on playing back images, see Chapter 3.

To connect your camera to a standard TV

1. **Turn the camera off.** This can prevent static electricity from damaging your camera.

2. **Open the connector cover.** The connector cover is on the left side of the camera when the lens is facing away from you

3. **Plug in the EG-D2 video cable.** The cable is available separately from Nikon. Plug the cable into the Video out jack. This is the connection at the bottom.

4. **Connect the EG-D2 to the input jack of your TV or VCR.**

5. **Set your TV to the video channel.** This may differ depending on your TV. See the owner's manual if you are unsure.

6. **Turn on the camera, and press the Playback button.**

HDTV

Being able to view your images and videos straight from the camera on your HDTV is a really nice feature. You can set up a slide show to show all your friends the photos you shot that day or you can edit your photos using the Retouch menu straight from the camera while being able to view the images larger than life. If your HDTV is device control compatible (HDMI-CEC), you can also use the remote control to browse the images and camera menus. Isn't technology great?

 If your HDTV is HDMI-CEC compatible, the camera displays CEC in place of the number of remaining frames.

Attaching the camera to your HDTV is a pretty simple affair:

1. **Turn the camera off.** This can prevent static electricity from damaging your camera.

2. **Open the connector cover.** The connector cover is on the left side of the camera when the lens is facing away from you.

3. **Plug in the type C mini-pin HDMI cable.** The cable is available separately from almost any electronics or camera store. Plug the cable into the HDMI out jack. This is the connection just below the USB port. It's clearly labeled.

4. **Connect the HDMI cable to the input jack of your HDTV.**

5. **Set your HDTV to the HD in setting.** This may differ depending on your TV. See the owner's manual if you are unsure.

6. **Turn on the camera, and press the Playback button.** The playback functions exactly the same as if you were looking at the LCD monitor.

 When connected to an HDMI CEC device, the camera is not able to record video or still images.

Downloading Images

After you finish taking your pictures, you're probably going to want to download them to your computer for further image editing and tweaking, posting them to the Web, or sending them to your friends and family.

Downloading your images is a fairly simple process, and there are a couple of ways to do it. The most common way is to remove the memory card from the camera and insert it into a card reader that is connected to your computer. This is probably the easiest way to get started. The other option is to use the USB cable supplied with the D7000 and connect the camera directly to the computer. Depending on your computer and the software you have installed, a program might pop up and offer to transfer the image for you. For example, Mac users might find that iPhoto recognizes the camera and opens up once the camera is connected to the computer via the USB cable.

 When you are downloading directly from the camera, the battery may become depleted more quickly.

Another option for downloading is using the Nikon Transfer 2 software that was included with the Nikon ViewNX 2 software CD. The Nikon Transfer 2 software is easy to learn and works well, and I encourage you to use it if you don't have a card reader or prefer to plug your camera directly into the computer.

The Retouch Menu

The Nikon D7000 has a very handy Retouch menu. These in-camera editing options make it simple for you to print straight from the camera without downloading it to your computer or using any image-editing software.

One great feature of using the Retouch menu is that the camera saves the retouched image as a copy so you don't lose the original image. This can be beneficial if you decide that you would rather edit the photo on your computer or if you simply aren't happy with the outcome. There are two ways to access the Retouch menu.

The first and quickest method:

1. **Press the Play button to enter Playback mode.** Your most recently taken image appears on the LCD screen.

2. **Use the Multi-selector to review your images.**

3. **When you see an image you want to retouch, press the OK button to display the Retouch menu options.**

4. **Use the Multi-selector to highlight the Retouch option you want to use.** Depending on the Retouch option you choose, you may have to select additional settings.

5. **Make adjustments if necessary.**

6. **Press the OK button to save the retouched copy.**

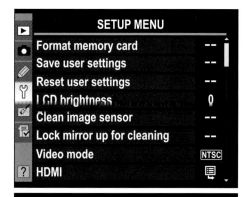

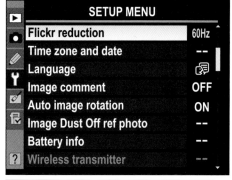

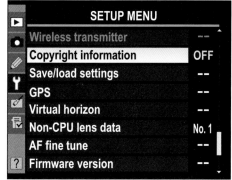

16.1 The Retouch menu

The second method:

1. **Press the Menu button to view menu options.**

2. **Use the Multi-selector to scroll down to the Retouch menu.** It's the fourth menu down and appears as an icon with a paintbrush.

3. **Press the Multi-selector right, and then use the Multi-selector up and down buttons to highlight the Retouch option you want to use.** Depending on the Retouch option you select, you may have to select additional settings. Once you have selected your option(s), thumbnails appear.

4. **Use the Multi-selector to select the image to retouch, and then press the OK button.**

5. **Make the necessary adjustments.**

6. **Press the OK button to save the retouched copy.**

Retouch Menu Options

The Retouch menu allows you to process saved images and save retouched copies. The options include ones for cropping your image, adjusting the color balance, taking red-eye out of your pictures, and even processing RAW images. This is a great feature and can be a real timesaver.

 Don't worry about losing your original images; the D7000 saves copies of the original at the same resolution for JPEGs and Large Fine JPEGs from RAW files.

When using both memory card slots, you can select images off either memory card. To switch between memory cards, press and hold the BKT button and press the Multi-selector up. A dialog screen will be displayed where you can select Slot 1 or Slot 2, highlight the desired Slot, and press the Multi-selector right to view available folders on the selected card.

D-Lighting

D-Lighting enables you to adjust the image by brightening the shadows. This is not the same as Active D-Lighting. D-Lighting uses a curves adjustment to help to bring out details in the shadow areas of an image. This option is for backlit subjects or images that may be slightly underexposed.

Once you have selected the D-Lighting option in the Retouch menu, you can use the Multi-selector to choose a thumbnail and the Zoom in button to get a closer look at the

image. Press the OK button to choose the image to retouch, and two thumbnails are displayed; one is the original image, and the other is the image with D-Lighting applied.

You can press the Multi-selector up or down to select the amount of D-Lighting: Low, Normal, or High. The results can be viewed in real time and compared with the original before saving. Press the OK button to save the

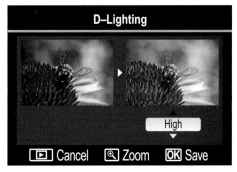

16.2 The D-Lighting option

results, the Playback button to cancel them, and the Zoom in button to view the full-frame image.

Red-eye correction

The Red-eye correction option enables the camera to automatically correct the red-eye effect that sometimes occurs when flash is used with pictures taken of people. This option is only available on photos taken with flash. When you press the OK button during preview to choose images to retouch from the Playback menu, this option is grayed out and cannot be selected if the camera detects that a flash was not used. When you attempt to choose an image directly from the Retouch menu, a message is displayed stating that this image cannot be used.

Once the image has been selected, press the OK button; the camera automatically corrects the red-eye and saves a copy of the image to your memory card.

If an image is selected that used flash but there is no red-eye present, the camera displays a message stating that red-eye is not detected in the image and no retouching will be done.

Trim

The Trim option enables you to crop your image to remove distracting elements or to crop closer to the subject. You can also use the Zoom in and Zoom out buttons to adjust the size of the crop. This allows you to crop closer in or back out if you find you've zoomed in too much.

Use the Multi-selector to move the crop around the image so you can center the crop on the part of the image that you think is most important. When you are happy with the crop you have selected, press the OK button to save a copy of your cropped image or press the Playback button to return to the main menu without saving the cropped image.

Rotating the Command dial allows you to choose different aspect ratios for your crop. You can choose the aspect ratio to conform to different print sizes. The options include

▶ **3:2.** This is the default crop size. This ratio is good for prints sized 4 × 6, 8 × 12, and 12 × 18.

▶ **4:3.** This is the ratio for prints sized 6 × 8 or 12 × 16.

▶ **5:4.** This is the standard size for 8 × 10 prints.

▶ **1:1.** This gives you a square crop.

▶ **16:9.** This is what's known as a *cinematic crop*. It is the ratio that movie screens and widescreen TVs use.

Monochrome

The Monochrome option allows you to make a copy of your color image in a monochrome format. There are three options:

▶ **Black-and-white.** This changes your image to shades of black, white, and gray.

▶ **Sepia.** This gives your image the look of a black-and-white photo that has been sepia toned. Sepia-toning is a traditional photographic process that gives the photo a reddish-brown tint.

16.3 An image converted to black and white

▶ **Cyanotype.** This option gives your photos a blue or cyan tint. Cyanotypes are a form of processing film-based photographic images.

16.4 An image converted to sepia **16.5 An image converted to cyanotype**

When using the Sepia or Cyanotype options, you can use the Multi-selector up and down buttons to adjust the lightness or darkness of the effect. Press the OK button to save a copy of the image or press the Playback button to cancel without saving a copy.

Filter effects

Filter effects allow you to simulate the effects of using certain filters over your lens to subtly modify the colors of your image. There are seven filter effects available:

▶ **Skylight.** A skylight filter is used to absorb some of the UV rays emitted by the sun. The UV rays can give your image a slightly bluish tint. Using the skylight filter effect causes your image to be less blue.

▶ **Warm filter.** A warming filter adds a little orange to your image to give it a warmer hue. This filter effect can be useful when you use flash because flash may make your images feel a little too cool.

▶ **Red intensifier.** This effect boosts the saturation of reds in the image. You can press the Multi-selector up or down to lighten or darken the effect.

▶ **Green intensifier.** This effect boosts the saturation of greens in the image. You can press the Multi-selector up or down to lighten or darken the effect.

▶ **Blue intensifier.** This effect boosts the saturation of blues in the image. You can press the Multi-selector up or down to lighten or darken the effect.

▶ **Cross screen.** This effect simulates the use of a star filter. A star filter creates a star-shaped pattern on the bright highlights in your image. If your image doesn't have any bright highlights, the effect will not be apparent. Once an image is selected for the cross screen filter, you are shown a submenu with a few options that you can adjust. You can choose the number of points on the stars: 4, 6, or 8. You can also choose the amount; there are three settings that give you more or fewer stars. You can choose three angle settings, which control the angle at which the star is tilted. You also have three settings that control the length of the points on the stars.

▶ **Soft.** This effect applies a soft glow to your images. This effect is mostly used for portraiture but can also be used effectively for landscapes.

16.6 The cross screen filter effect is applied to the bottom image.

After choosing the desired filter effect, press the OK button to save a copy of your image with the effect added.

Color balance

You can use the color balance option to create a copy of an image on which you have adjusted the color balance. Using this option, you can use the Multi-selector to add a color tint to your image. You can use this effect to neutralize an existing color tint or to add a color tint for artistic purposes.

Press the Multi-selector up to increase the amount of green, down to increase the amount of magenta, left to add blue, and right to add amber.

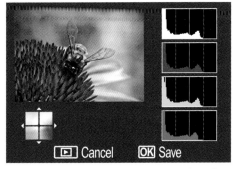

16.7 Color chart and histograms using the color balance option

A color chart and color histograms are displayed along with an image preview so you can see how the color balance affects your image. When you are satisfied with your image, press the OK button to save a copy.

Image overlay

This option allows you to combine two RAW images and save them as one. You can only access this menu option by entering the Retouch menu using the Menu button (the longer route); you cannot access this option by pressing the OK button when in Playback mode.

 To use this option, you must have at least two RAW images saved to your memory card. This option is not available for use with JPEG.

To use this option

1. **Press the Menu button to view the menu options.**

2. **Use the Multi-selector to scroll down to the Retouch menu, and press the Multi-selector right to enter the Retouch menu.**

3. **Press the Multi-selector up or down to highlight Image Overlay.**

4. **Press the Multi-selector right.** This displays the Image Overlay menu.

5. **Press the OK button to view RAW image thumbnails.** Use the Multi-selector to highlight the first RAW image to be used in the overlay. Press the OK button to select it.

6. **Adjust the exposure of Image 1 by pressing the Multi-selector up or down.** Press the OK button when the image is adjusted to your liking.

7. Press the Multi-selector right to switch to Image 2.

8. **Press the OK button to view RAW image thumbnails.** Use the Multi-selector to highlight the second RAW image to be used in the overlay. Press the OK button to select it.

9. **Adjust the exposure of Image 2 by pressing the Multi-selector up or down.** Press the OK button when the image is adjusted to your liking.

10. **Press the Multi-selector right to highlight the Preview window.**

11. **Press the Multi-selector up or down to highlight Overlay to preview the image, or use the Multi-selector to highlight Save to save the image without previewing.**

NEF (RAW) processing

The NEF (RAW) processing option allows you to do some basic editing to images saved in the RAW format without downloading them to a computer and using image-editing software. This option has limited functionality but allows you to fine-tune your image more precisely when you are printing straight from the camera or memory card.

You can save a copy of your image in JPEG format. You can choose the image quality and size that the copy is saved as, adjust the white balance settings, fine-tune the exposure compensation, and select a Picture Control setting to be applied.

16.8 NEF (RAW) processing menu screen

To apply RAW processing

1. **Enter the NEF (RAW) Processing menu through the Retouch menu.** Press the OK button to view thumbnails of the images stored on your card. Only images saved in RAW format are displayed.

2. **Press the Multi-selector left or right to scroll through the thumbnails.** Press the OK button to select the highlighted image. This brings up a screen with the image adjustment submenu located to the right of the image you have selected.

3. **Press the Multi-selector up or down to highlight the adjustment you want to make.** You can set image quality, image size, white balance, exposure compensation, and optimize the image. You can also use the Zoom in button to view a full screen preview.

4. **When you have made your adjustments, use the Multi-selector to highlight EXE and press the OK button to save changes or the Playback button to cancel without saving them.** EXE sets the changes and saves a copy of the image in JPEG format at the size and quality that you have selected. The camera default saves the image as a Large, Fine JPEG.

See Chapter 2 for more information on image size, quality, and white balance.

Resize

Resize is a handy little option that enables you to make a copy of your images that are a smaller size. These smaller pictures are more suitable for small prints or Web-sized images and for files to e-mail to friends and family.

When using two memory cards, you will be asked to choose a destination for the saved copies.

The first thing you need to do when creating a resized image is to select the Choose size option from the submenu. You have five options to choose from:

▶ **2.5M:** 1920 × 1280 pixels

▶ **1.1M:** 1280 × 856 pixels

▶ **0.6M:** 960 × 640 pixels

▶ **0.3M:** 640 × 424 pixels

▶ **0.1M:** 320 × 216 pixels

After you decide the size you want your small pictures to be, choose the Select picture option. When the Select picture option is selected, the LCD displays thumbnails of all the images in the current folder. To scroll through your images, press the

Multi-selector left or right. To select or deselect an image, press the Multi-selector up or down. You can select as many images as you have on your memory card. When all the images that you want to make a resized copy of are selected, press the OK button to make the copies.

Quick retouch

The Quick retouch option is the quickest and easiest option to use. The camera automatically adjusts the contrast and saturation, making your image brighter and more colorful, perfect for printing straight from the camera or memory card. In the event that your image is dark or backlit, the camera also automatically applies D-Lighting to help bring out details in the shadow areas of your picture.

Once your image has been selected for Quick retouch, you have the option to choose how much of the effect is applied. You can choose from High, Normal, or Low. The LCD monitor displays a side-by side comparison between the image as shot and the image retouched to give you a better idea of what the effect looks like.

Once you decide how much of the effect you want, press the OK button to save a copy of the retouched image, or press the Playback button to cancel the copy without making any changes to your picture.

Straighten

The Straighten feature enables you to fix images that may have been shot at a slight angle. When an image is selected, press the Multi-selector left and right to adjust the tilt amount. A grid overlay is displayed over the image so you can use it to align with the horizon or another straight object in the photo.

Distortion control

As you learn in Chapter 4, some lenses are prone to distortion. The Distortion control option enables you to correct for lens distortion right in camera. There are two options: Auto and Manual. Auto automatically applies any needed corrections; with Manual, you apply the effect using the Multi-selector. Press the Multi-selector right to reduce barrel distortion (wide-angles) and press the Multi-selector left to reduce pin-cushion distortion (telephotos).

 The Auto setting is recommended for use with Nikkor G- and D-type lenses only.

Fisheye

The Fisheye option does the opposite of what Distortion control does: It adds barrel distortion to the image to make it appear like it was taken using a fisheye lens. Press the Multi-selector to the left to add to the effect and to the right to decrease it. To be 100 percent honest, I think the effect looks terrible, so use at your own peril.

Color outline

The Color outline feature takes the selected image and creates an outline copy that can be opened using image-editing software, such as Adobe Photoshop or Corel Paintshop Pro, and colored in by hand. This option works best when it's used on an image with high contrast. It's a pretty cool effect and the image can even be used straight from the camera, which gives it the look of a drawing.

Color sketch

The Color sketch option makes your image look like it was drawn with col-ored pencils. Selecting Vividness allows you to increase the color satu-ration of the effect. The Outlines option allows you to change the thick-ness of the outlines of the "sketch."

16.9 Color outline

Perspective Control

This effect allows you to correct the distortion that happens when photographing tall things while looking up at them. This Retouch option lessens the effect of the distor-tion by making it appear as if the camera is parallel to the building.

Miniature effect

The Miniature effect is modeled after a technique that some people call (erroneously) the "tilt-shift effect" because it can be achieved optically with a tilt-shift lens. Quite

simply, this effect simulates the shallow depth of field normally present in macro shots. This tricks the eye into seeing something large as something very tiny. The effect only works with very far off subjects and works better when the vantage point is looking down. It's a pretty cool effect, but it only works with limited subjects.

16.10 An overhead shot of the Bonnaroo festival grounds in Manchester, Tennessee, with the Miniature effect applied. Exposure: ISO 100, f/16, 1/125 using a Nikon 10.5mm f/2.8 fisheye lens.

Edit movie

The Edit movie option allows you to make basic edits to videos that you shoot with the D7000. You have three options: choose the starting frame, choose the ending frame, and grab a still image from the video. Each edit you make is saved as a new file so there's no need to worry about making any permanent changes to your original file. To edit your video

1. **Press the Menu button.** Use the Multi-selector to select the Retouch menu.

2. **Select Edit Movie.** Press OK or Multi-selector right to view menu options.

3. **Choose the edit you want to make.** The options are Choose start point, Choose end point, or Save selected frame. Press OK or press the Multi-selector right. This pulls up a menu with all videos that are saved to the current card.

4. **Select the video.** Use the Multi-selector to scroll through the available videos. The selected video is highlighted in yellow. Press the OK button when your vidoo io oolootod.

5. **Play the video.** Press the OK button to begin playback. Press the Multi-selector up at the moment you want to make the edit. You can press the Multi-selector down button to stop playback and press left or right to go back or forward in the video clip.

6. **Make the edit.** Press the Multi-selector up to make the cut. I prefer to pause the movie by pressing the Multi-selector down so I can be absolutely sure that's where I want the edit. I then make the edit. The movie is automatically saved.

Side by side comparison

Side by side comparison allows you to view a before and after of the retouched image and the original image. You can only access this option by selecting an image that has been retouched. To use this option

1. **Press the Play button and use the Multi-selector to choose the retouched image to view.**

2. **Press the OK button to display the Retouch menu.**

3. **Use the Multi-selector to highlight Before and after, and then press the OK button.**

4. **Use the Multi-selector to highlight either the original or retouched image.** You can then use the Zoom in button to view it closer.

5. **Press the Play button to exit the Before and after comparison and return to Playback mode.**

How to Use the Gray Card and Color Checker

Have you ever wondered how some photographers are able to consistently produce photos with such accurate color and exposure? It's often because they use gray cards and color checkers. Knowing how to use these tools helps you take some of the guesswork out of capturing photos with great color and correct exposures every time.

The Gray Card

Because the color of light changes depending on the light source, what you might decide is neutral in your photograph, isn't neutral at all. This is where a gray card comes in very handy. A gray card is designed to reflect the color spectrum neutrally in all sorts of lighting conditions, providing a standard from which to measure for later color corrections or to set a custom white balance.

By taking a test shot that includes the gray card, you guarantee that you have a neutral item to adjust colors against later if you need to. Make sure that the card is placed in the same light that the subject is for the first photo, and then remove the gray card and continue shooting.

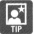 When taking a photo of a gray card, defocus your lens a little; this ensures that you capture a more even color.

Because many software programs enable you to address color-correction issues by choosing something that should be white or neutral in an image, having the gray card in the first of a series of photos allows you to select the gray card as the neutral point. Your software resets red, green, and blue to be the same value, creating a neutral mid-tone. Depending on the capabilities of your software, you might be able to save the adjustment you've made and apply it to all other photos shot in the same series.

If you'd prefer to make adjustments on the spot, for example, and if the lighting conditions will remain mostly consistent while you shoot a large number of images, it is advisable to use the gray card to set a custom white balance in your camera. You can do this by taking a photo of the gray card filling as much of the frame as possible. Then, use that photo to set the custom white balance.

The Color Checker

A color checker contains 24 swatches that represent colors found in everyday scenes, including skin tones, sky, foliage, etc. It also contains red, green, blue, cyan, magenta, and yellow, which are used in all printing devices. Finally, and perhaps most important, it has six shades of gray.

Using a color checker is a very similar process to using a gray card. You place it in the scene so that it is illuminated in the same way as the subject. Photograph the scene once with the reference in place, then remove it and continue shooting. You should create a reference photo each time you shoot in a new lighting environment.

Later on in software, open the image containing the color checker. Measure the values of the gray, black, and white swatches. The red, green, and blue values in the gray swatch should each measure around 128; in the black swatch around 10; and in the white swatch around 245. If your camera's white balance was set correctly for the scene, your measurements should fall into the range (and deviate by no more than 7 either way) and you can rest easy knowing your colors are true.

If your readings are more than 7 points out of range either way, use software to correct it. But now you also have black-and-white reference points to help. Use the levels adjustment tool to bring the known values back to where they should be measuring (gray around 128, black around 10, and white around 245).

If your camera offers any kind of custom styles, you can also use the color checker to set or adjust any of the custom styles by taking a sample photo and evaluating it using the on-screen histogram, preferably the RGB histogram if your camera offers one. You can then choose that custom style for your shoot, perhaps even adjusting that custom style to better match your expectations for color.

Glossary

Active D-Lighting A camera setting that preserves highlight and shadow details in a high-contrast scene that has a wide dynamic range.

AE (Auto-Exposure) A function of a camera where the camera selects the aperture and/or shutter speed according to the camera's built-in light meter. See also *Aperture Priority*, *Shutter Priority*, and *Programmed Auto*.

AE/AF (Auto-Exposure/Autofocus) Lock A camera control you use to lock the current metered exposure and/or autofocus setting prior to taking a photo. This allows you to meter an off-center subject and then recompose the shot while retaining the proper exposure for the subject. The function of this button is selected in the Setup menu under the Buttons heading.

AF-assist illuminator An LED light that's emitted in low-light or low-contrast situations. The AF-assist illuminator provides enough light for the camera's AF to work in low light.

ambient lighting Lighting that naturally exists in a scene.

angle of view The area of a scene that a lens can capture, which is determined by the focal length of the lens. Lenses with a shorter focal length have a wider angle of view than lenses with a longer focal length.

aperture The opening of the lens similar to the iris of an eye. The designation for each step in the aperture is called the f-stop. The smaller the f-stop (or f-number), the larger the actual opening of the aperture; the higher-numbered f-stops designate smaller apertures, letting in less light. The f-number is the ratio of the focal length to the aperture diameter.

Aperture Priority An exposure mode setting where you choose the aperture and the camera automatically adjusts the shutter speed according to the camera's metered readings. Aperture Priority is often used by a photographer to control depth of field.

aspect ratio The ratio of the long edge of an image to the short edge as printed, displayed on a monitor, or captured by a digital camera.

autofocus The capability of a camera to determine the proper focus of the subject automatically.

backlighting A lighting effect produced when the main light source is located behind the subject. Backlighting can be used to create a silhouette effect or to illuminate translucent objects. See also *frontlighting* and *sidelighting*.

barrel distortion An aberration in a lens in which the lines at the edges and sides of the image are bowed outward. This distortion is usually found in shorter focal-length (wide-angle) lenses.

bounce flash Pointing the flash head in an upward position or toward a wall so that it bounces off another surface before reaching the subject, which softens the light reaching the subject. This often eliminates shadows and provides smoother light for portraits.

bracketing A photographic technique in which you vary the exposure over two or more frames. By doing this, you ensure a proper exposure in difficult lighting situations where your camera's meter can be fooled.

broad lighting The lighting when your main light illuminates the side of the subject who's facing you.

camera shake Camera movement, usually occurring at slower shutter speeds, which produces a blurred image.

catchlight Highlight that appears in the subject's eyes.

Center-weighted meter A light-measuring device that emphasizes the area in the middle of the frame when you're calculating the correct exposure for an image.

colored gel filters Colored translucent filters that are placed over a flash head or light to change the color of the light emitted on the subject. Colored gels can be used to create a colored hue of an image. Gels are often used to match the flash output with the ambient light as well as to change the color of a background when shooting portraits or still lifes; the gel is placed over the flash head and then the flash is fired toward the background.

compression Reducing the size of a file by digital encoding, which uses fewer bits of information to represent the original subject.

Continuous Autofocus (AF-C) A camera setting that allows the camera to continually focus on a moving subject.

contrast The range between the lightest and darkest tones in an image. In a high-contrast image, the tones fall at the extremes of the range between white and black. In a low-contrast image, the tones are closer together.

dedicated flash An electronic flash unit, such as the Nikon SB-900, SB-800, SB-700 SB-600, or SB-400, designed to work with the autoexposure features of a specific camera.

depth of field (DOF) The portion of a scene from foreground to background that appears sharp in the image.

diffuse lighting A soft, low-contrast lighting.

D-Lighting A function within the camera that can fix the underexposure that often happens to images that are backlit or in deep shadows. This is accomplished by adjusting the levels of the image after it's been captured. Not to be confused with Active D-Lighting.

DX Nikon's designation for digital single lens reflex cameras (dSLRs) that use an APS-C–sized (23.6mm × 15.8mm) sensor.

equivalent focal length A DX-format digital camera's focal length, which is translated into the corresponding values for 35mm film or the FX format.

exposure The amount of light allowed to reach the sensor, which is determined by the ISO setting, the amount admitted by the aperture of the lens, and the length of time determined by the shutter speed.

exposure compensation A technique for adjusting the exposure indicated by a photographic exposure meter when factors may cause the indicated exposure to result in a less-than-optimal image.

exposure mode Camera settings that control how the exposure settings are determined. The D7000 also offers scene modes, which are automatic modes that adjust the settings to predetermined parameters, such as a wide aperture for the Portrait mode. See also *Aperture Priority*, *Shutter Priority*, and *Programmed Auto*.

fill flash A lighting technique where the Speedlight provides enough light to illuminate the subject to eliminate shadows. Using a flash for outdoor portraits often brightens the subject in conditions where the camera meters light from a broader scene.

fill lighting The lighting used to illuminate shadows. Reflectors or additional incandescent lighting or electronic flash can be used to brighten shadows. One common outdoor technique is to use the camera's flash as a fill.

flash An external light source that produces an almost instant flash of light to illuminate a scene. Also known as electronic flash.

Flash Exposure Compensation (FEC) Adjusting the flash output. If images are too dark (underexposed), you can use FEC to increase the flash output. If images are too bright (overexposed), you can use FEC to reduce the flash output.

flash modes Modes that enable you to control the output of the flash by using different parameters. Some of these modes include Red-Eye Reduction and Slow Sync.

flash output level The output level of the flash as determined by one of the flash modes.

Front-curtain sync Front-curtain sync causes the flash to fire at the beginning of the exposure when the shutter is completely open in the instant that the first curtain of the focal plane shutter finishes its movement across the film or sensor plane. This is the default setting. See also *Rear-curtain sync.*

frontlighting The illumination coming from the direction of the camera. See also *backlighting* and *sidelighting.*

f-stop See *aperture.*

histogram A graphic representation of the range of tones in an image.

hot shoe The slot located on the top of the camera where the flash connects.

ISO sensitivity The ISO (International Organization for Standardization) setting on the camera indicates the light sensitivity. In digital cameras, lower ISO settings provide better quality images with less image noise; however, a lower ISO setting requires more exposure time.

JPEG (Joint Photographic Experts Group) This is an image format that compresses the image data from the camera to achieve a smaller file size. The compression algorithm discards some of the detail when closing the image. The degree of compression can be adjusted, allowing a selectable tradeoff between storage size and image quality. JPEG is the most common image format used by digital cameras and other photographic image-capture devices.

Kelvin A unit of measurement of color temperature based on a theoretical black body that glows a specific color when heated to a certain temperature. The sun is approximately 5500K.

lag time The length of time between when the Shutter Release button is pressed and the shutter is actually released; the lag time on the D7000 is so short, it's almost imperceptible. Compact digital cameras are notorious for having long lag times, which can cause you to miss important shots.

leading line An element in a composition that leads a viewer's eye toward the subject.

lens flare An effect caused by stray light reflecting off the many glass elements of a lens. Lens shades typically prevent lens glare, but sometimes you can choose to use it creatively by purposely introducing flare into your image.

lighting ratio The proportion between the amount of light falling on the subject from the main light and the secondary light, such as 2:1 — a ratio in which one light is twice as bright as the other.

macro lens A lens with the capability to focus at a very close range, enabling extreme close-up photographs.

manual exposure Bypassing the camera's internal light meter settings in favor of setting the shutter and aperture manually. Manual exposure is beneficial in difficult lighting situations where the camera's meter doesn't provide correct results. When you switch to manual settings, you may need to review a series of photos on the digital camera's LCD to determine the correct exposure.

Matrix metering The Matrix meter (Nikon exclusive) reads the brightness and contrast throughout the entire frame and matches those readings against a database of images (more than 30,000 in most Nikon cameras) to calculate the best exposure value.

metering Measuring the amount of light by using a light meter.

NEF (Nikon Electronic File) The name of Nikon's RAW file format.

noise Pixels with randomly distributed color values in a digital image. Noise in digital photographs tends to be more pronounced with low-light conditions and long exposures, particularly when you set your camera to a higher ISO setting.

noise reduction (NR) A technology used to decrease the amount of random information in a digital image, often caused by long exposures and/or high ISO settings.

pincushion distortion A lens aberration in which the lines at the edges and sides of the image are bowed inward. It is usually found in longer focal-length (telephoto) lenses.

Programmed Auto (P) A camera setting where shutter speed and aperture are set automatically.

RAW An image file format that contains the unprocessed camera data as it was captured. Using this format allows you to change image parameters, such as white balance saturation and sharpening. Although you can process RAW files in-camera, the preferred method requires special software, such as Adobe Camera Raw (available in Photoshop), Adobe Lightroom, or Nikon's Capture NX 2 or ViewNX 2. See also *NEF*.

Rear-curtain sync Rear-curtain sync causes the flash to fire at the end of the exposure an instant before the second, or rear, curtain of the focal plane shutter begins to close. With slow shutter speeds, this feature can create a blur effect from the ambient light, which appears as patterns that follow a moving subject and the subject sharply frozen at the end of the blur trail. This setting is usually used in conjunction with longer shutter speeds. See also *Front-curtain sync*.

red-eye An effect from flash photography that appears to make a person's eyes glow red or an animal's yellow or green, caused by light bouncing from the retina of the eye. It is most noticeable in

dimly lit situations (when the irises are wide open) as well as when the electronic flash is close to the lens and, therefore, prone to reflect the light directly back.

Red Eye Reduction A flash mode controlled by a camera setting that's used to prevent the subject's eyes from appearing red in color.

rights-managed A term used to describe images for sale that are only allowed to be used for specific applications laid out in a contract.

royalty-free These types of images are bought outright and can be used without restrictions.

self-timer A mechanism that delays the opening of the shutter for several seconds after the Shutter Release button has been pressed.

short lighting When your main light is illuminating the side of the subject that's facing away from you.

shutter A mechanism that allows light to pass to the sensor for a specified amount of time.

Shutter Priority In this camera mode, you set the desired shutter speed and the camera automatically sets the aperture for you. When you're shooting action shots, it freezes the subject's motion by using fast shutter speeds.

shutter speed The length of time the shutter is open to allow light to fall onto

the imaging sensor. The shutter speed is measured in seconds or, more commonly, fractions of seconds.

sidelighting Lighting that comes directly from the left or the right of the subject. See also *frontlighting* and *backlighting*.

Slow Sync A flash mode that allows the camera's shutter to stay open for a longer time to allow the ambient light to be recorded. The background receives more exposure, which gives the image a more natural appearance.

Speedlight A Nikon-specific term for its accessory flashes.

spot meter A metering system in which the exposure is based on a small area of the image. On the D7000 the spot is linked to the AF point.

TTL (Through-the-Lens) A metering system where the light is measured directly through the lens.

vanishing point The point at which parallel lines converge and seem to disappear.

Vibration Reduction (VR) A function of the lens in which the lens elements are shifted by a mechanism in the lens to reduce the effects of camera shake.

white balance A setting used to compensate for the differences in color temperature from different light sources. For example, a typical tungsten light bulb is yellow-orange, so the camera adds blue to the image to ensure that the light looks like standard white light.

Index